A Photographer's Guide to Ohio

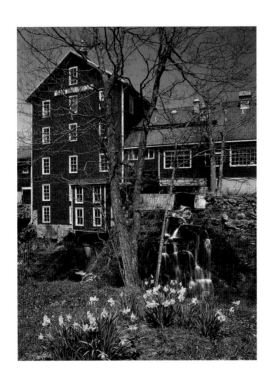

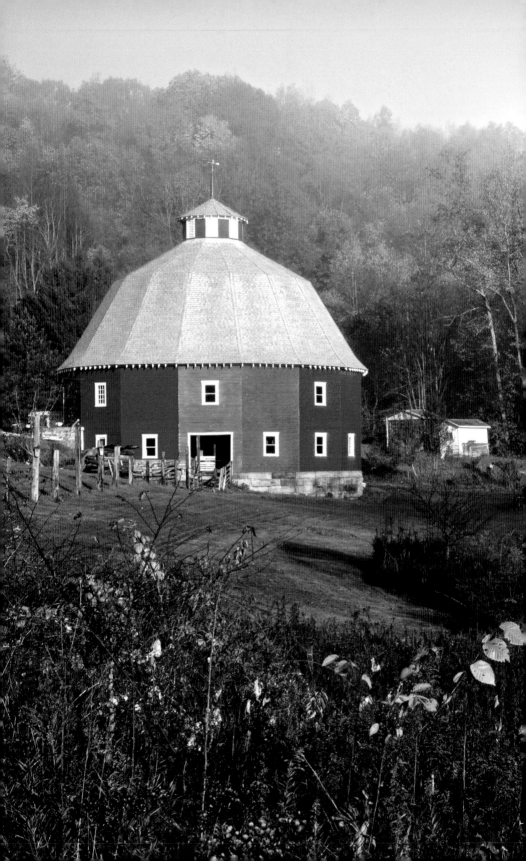

A Photographer's Guide to Ohio

Ian Adams

With a Foreword by Hope Taft

OHIO UNIVERSITY PRESS

ATHENS

Ohio University Press, Athens, Ohio 45701
www.ohioswallow.com
© 2011 by Ohio University Press
All rights reserved

Printed in the United States of America
Ohio University Press books are printed on acid-free paper ∞ ™

20 19 18 17 16 15 14 13 12 11 5 4 3 2

Display photos: page i, Clifton Mill, Greene County;
pages ii–iii, 16-sided barn, Harrison County;
pages iv–v, Jeffrey Point View, The Wilds;
page xv, Dawes Arboretum, lacebark pine.

Library of Congress Cataloging-in-Publication Data

Adams, Ian, 1946-
A photographer's guide to Ohio / Ian Adams ; with a foreword by Hope Taft.
 p. cm.
Includes bibliographical references and index.
ISBN 978-0-8214-1960-1 (pbk. : alk. paper)
1. Ohio—Guidebooks. 2. Ohio—Description and travel. 3. Landscape
photography—Ohio—Handbooks, manuals, etc. 4. Landscapes—Ohio—
Pictorial works. 5. Ohio—Pictorial works. I. Title.
F489.3.A43 2011
917.7104–dc22

 2010054479

Contents

Foreword

If you want to improve your photographs, this is the book for you. If you love nature, this is the book for you. If you like to discover out-of-the-way places in Ohio, this is the book for you. If you are a history buff, this is the book for you.

How can one book be so much to so many? Ian Adams, renowned landscape photographer, leading naturalist, and history aficionado, has written a book that will hold the interest of everyone. Ian tells you where to go, how to get there, when to photograph, and what settings and lens to use to get the best pictures of the best places in Ohio.

I first met Ian Adams at Holden Arboretum in 2005 and was a bit intimidated by my good fortune to be there at the same time he was. But my trepidation at meeting perhaps Ohio's premiere outdoor photographer was soon overcome by Ian's warm and engaging personality. We quickly became friends. My respect for his talents only increased when I learned so much from him about the world of butterflies, dragonflies, and damselflies on a field trip.

Collaborating with him on a book about the Ohio Governor's Residence and Heritage Garden, I was amazed by the breadth of his knowledge of our state; he knew immediately what parts of Ohio had inspired each area of the garden. He came in for breakfast at the Governor's Residence after one of his early-morning shoots and was able to name eighteen species of birds he had seen or heard.

One of the advantages of living in the Governor's Residence is the opportunity to travel the state and see its natural beauty. Bob and I feel that we know Ohio like the backs of our hands. Sometimes Ian and I would compare notes on what native plants were blooming in which part of the state, and I was amazed by his intimate knowledge of places that were completely unfamiliar to me.

In this book Ian reveals the special techniques he has learned by photographing Ohio for thirty years, crisscrossing the state in all seasons and lights to capture its beauty at its finest. Not only does he share details of fine photography and his favorite places to practice his art, he also adds historical detail that make these spots take on added meaning.

vii

GARDENVIEW, STRONGSVILLE — ALLIUMS

Even if you are not a photographer or a history buff, just looking at the photographs in this book will be enough to make you want to explore the state that Ian and I both call home. Sometimes it takes a person like Ian, who was not born a Buckeye, to help us see the beauty we often take for granted.

Discover the amazing diversity of landscape and architecture in the great state of Ohio through the lens of a master photographer and teacher.

Enjoy this virtual trip around the state and then use the book as a travel guide to find these places for yourself.

Try your hand at catching them in a new light or from a different angle. Improve your photography skills and broaden your knowledge of Ohio at the same time! Enjoy!

Hope Taft
First Lady of Ohio, 1999–2007

Acknowledgments

First and foremost, I would like to thank David Sanders and his talented colleagues at Ohio University Press for their interest in this book project, their expertise in editing and fine-tuning my unwieldy manuscript, their skill in selecting the photographs, and their consummate book-designing and promotional skills. I would also like to thank Wendover and Marc Brown of Browntrout Publishers; our collaboration on more than fifty Ohio calendars and two Ohio books has been the inspiration for much of the knowledge I have gained while traveling around the Buckeye State.

Fellow Ohio photographers David FitzSimmons, Jennie Jones, William Manning, Gary Meszaros, Jim Roetzel, Randall Scheiber, and Art Weber provided insight, valuable advice, and suggestions about places to include in this guide, as well as friendship and camaraderie.

I would like to thank the staffs of the following organizations for allowing me access to their property and for their generosity and support of my photography over the past three decades: Cleveland Botanical Garden, Cuyahoga Valley National Park, The Holden Arboretum, Ohio Department of Natural Resources (ODNR) Division of Natural Areas and Preserves, the Ohio chapter of The Nature Conservancy, Highland Nature Sanctuary, the Ohio Governor's Residence and Heritage Garden, Stan Hywet Hall and Gardens, and The Wilds.

Many friends provided help, advice, a fine meal, or a place to stay after a day in the field. I am especially grateful to John Baskin, Pam Bennett, Nicole Cavender, Guy Denny, Sue Gorisek, Alice Goumas and Keith Misner, Marcy Hawley, Nancy Howell, George and Katie Hoy, David and Elsie Kline, Marilyn and Kathy Ortt, Mary Anne and Tom Romito, Larry Rosche, Henry Ross, Judy Semroc, Valerie Strong and George Fedul, Bert Szabo, Hope and Bob Taft, and Marion Zehnder.

Finally, I'm always grateful for the unwavering support and encouragement of my family: Margie and Tony McCarthy; Neil, Sandi, and Stacy Adams; Kelly and Matt Schron; and my favorite feline companion, Fuji.

Introduction

During the past thirty years, I have been privileged to travel more than half a million miles in Ohio, exploring the natural, rural, historical, and garden areas of the Buckeye State. These travels have produced thousands of color photographs on film and flash card, some of which have been published in more than a dozen books and on fifty Ohio calendars produced by Browntrout Publishers. I'm often asked to name my favorite places in Ohio for taking pictures. My tongue-in-cheek response: "Wherever in Ohio I happen to be at the time!" That's an honest answer, because there are wonderful places to photograph in every corner of the Buckeye State.

Each year I conduct seminars and workshops throughout North America on digital nature, garden, and travel photography. During these programs, I discuss selecting and using digital point-and-shoot (P&S) and single-lens-reflex (SLR) cameras; optimizing exposure and depth-of-field; lighting and composition; tripods, filters, and other accessories; traveling with camera gear; fine-tuning digital photos with Photoshop and other computer software on a PC or Mac; and sharing digital photos with family, friends, and clients using email, slide programs, websites, brochures, color prints, and self-published books. A summary of this material—essentially a primer on Ohio landscape photography—is presented in the first chapter.

As I review the many subjects I have photographed in Ohio over the past quarter century, a diverse assortment of images emerges. Pink dawns, sunrise and sunset, fog, and cloud formations are irresistible subjects for my camera. I'm attracted to water in all its forms: waterfalls, rivers and streams, lakes and ponds, ice and frost patterns, dew, snowfalls, and icicles. I have a fondness for the delicate woodland wildflowers of spring and old fields full of ironweed, joe pye weed, goldenrod, asters, and butterflies in late summer. Trees have great appeal for me, from the graphic patterns of roots, branches, and bark to the splendor of spring blossoms and autumn color, as well as the myriad of mushrooms that fruit beneath the canopies of Ohio's forests. Wetlands lure me into their watery wonderlands to capture images of water lilies, insect-eating plants, frogs, and snakes. Bird photography intrigues me, but I'm even

THE SPOT, SYDNEY, SHELBY COUNTY

more captivated by the gossamer-winged beauty of butterflies, dragonflies, and damselflies. Gardens, especially informal cottage gardens full of perennials, have challenged me for years to tell their story on film and flash card.

Though I was born and raised in the suburbs, a yearning to depict America's rural heritage compels me to photograph Ohio's farms, old barns, covered bridges, gristmills, horses, cows, goats, chickens, cats, and other rural fauna. An interest in geology obliges me to aim my camera at sandstone, shale, and limestone rock outcrops, and a love of excellent architecture prompts me to photograph the courthouses, lighthouses, castles, and other finely crafted Ohio buildings fashioned from wood, brick, and stone. A penchant for early American history draws me to Civil War battlefields and town murals, and an interest in industrial archeology prompts my visits to abandoned factories and other roadside ruins.

These are the subjects that have filled the pages of Browntrout's *Wild & Scenic Ohio, Ohio Nature,* and *Ohio Places* calendars for the past twenty years, as well as numerous exhibit-format books on Ohio. This book is yet another effort to share my favorite landscape photography destinations in the Buckeye State.

I have dabbled in wildlife photography around Ohio, and a number of its natural areas that provide excellent opportunities for wildlife photography are described here. But this book isn't intended to be a comprehensive guide to Ohio wildlife photography or photography of captive animals in zoos. The Buckeye State has many talented wildlife photographers, including Steve Maslowski, Gary Meszaros, Jim Roetzel, Robert Royse, Matthew Studebaker, and Tim Daniel. Check out some of these photographers' websites if you have a serious interest in learning how to photograph Ohio's birds and other wildlife.

Inevitably, some readers will wonder why the "such and such" nature preserve, or their favorite building, isn't in the book, so a word on how I chose the places included in this guide is in order.

First, all the sites in the book are open to the public and freely accessible. Most are free, except for a few public gardens and other sites that charge a nominal entrance fee. One natural area is privately owned, but the friendly owner welcomes visitors and often provides a free informative tour.

Second, each place I describe is appealing to me from a photographic viewpoint. For the most part, I have selected natural areas with great views or with eye-catching displays of one or more kinds of wildflowers, rather than a

handful of rare or endangered plants; there are already enough admirers tramp-ling the ground around these rarities—or worse—in order to add another "picture-perfect" close-up to their photographic collections. Ohio ranks third in the nation in its number of historic sites, with more than 3,600 on the National Register of Historic Places, but only a fraction are picturesque enough to be included in this guide. I've included numerous references, so readers inter-ested in visiting other sites can use this guide as a stepping-stone for their ex-tended explorations.

Third, I have visited and photographed each of the places described in this book, most of them more than once and some of them dozens of times over the years, so you can be confident that the information in this book is based on my knowledge and experience as an Ohio traveler and photographer and not just on word-of-mouth or unconfirmed information.

For each place described, I have included directions and, if available, a telephone number and a website where you can find more information. For most of the places, I've also included a GPS location, expressed in decimal degrees (not degrees, minutes, and seconds). For waterfalls and buildings, which have a relatively small geographical "footprint," the GPS location has been established from Google Maps, because I didn't own a GPS unit until recently. For nature preserves, public gardens, and other places that cover a larger area, the GPS location given is for the visitor center or the main park-ing area.

Each place narrative includes tips on the best time or season for photogra-phy, based on my visits, and in some cases suggested ways to interpret the subject from a photographic point of view. However, you won't find specific instructions on exactly where to stand and what lens, f/stop, and shutter speed to use—this isn't a cookie cutter guide to Ohio travel photography. Use the information in this book to decide if you want to visit a place, but when you get there, explore each location visually from your own perspective and de-cide how *you* would like to interpret and photograph the scene. Travel pho-tography is a never-ending journey, and each time I return to a favorite Ohio location, I look forward to finding new ways to view the subject through my camera's lens.

Judging by the number of books appearing with titles like *Five Hundred Places to Visit in _____ before You Die*, some folks view travel, and by implica-tion travel photography, as a race. This unfortunately promotes a competitive "been there . . . done that" way of thinking that often results in spur-of-the-

moment snapshots taken from familiar vantage points, rather than imaginative and original photographs based on an in-depth visual exploration of the subject. Take your time! Resist the herd mentality of hurrying to the nearest "scenic overlook," taking a quick "point-and-shoot" photograph, then rushing back to your vehicle to move on to the next "must-visit" place. Most *National Geographic* photographers spend months on location and submit thousands of images on their assigned subject to the magazine's photo editors, who select fewer than twenty photographs for most finished articles. You may not have the luxury of devoting this much time to your Ohio photography trips, but, in the long run, the more time you spend exploring a place and the more familiar you become with it, the better will be your photographs.

A Photographer's Guide to Ohio

A Primer on Digital Landscape Photography

The primary purpose of this book is to provide a guide to Ohio's best natural and man-made landscapes for photography. However, the book is not intended to be a detailed reference manual on digital landscape photography. There are several excellent books that cover this topic in depth, and a few of my favorites are listed at the end of this chapter. In particular, I recommend John and Barbara Gerlach's *Digital Landscape Photography*, which provides excellent accounts of equipment and techniques for taking great landscape photographs. My book, *The Art of Garden Photography*, covers most of the information you will need for photographing gardens, but that book was completed in 2003, when I was still shooting mostly film, and it has limited information about digital cameras.

The rest of this chapter provides an overview of digital camera equipment and basic camera settings, techniques for optimizing sharpness and exposure, some thoughts on lighting and composition in landscape photography, and a few suggestions for fine-tuning, storing, and sharing your digital photographs. For more in-depth information, consult the references at the end of the chapter.

CAMERAS AND LENSES

Point-and-shoot (P&S) digital cameras are ubiquitous today, and they offer several advantages, including compact size, many automatic features, and affordability. The more advanced P&S cameras, such as the Canon PowerShot and Sony Cyber-shot series, provide excellent image quality and many of the features of entry-level digital single-lens reflex (DSLR) cameras.

However, P&S cameras also have many limitations, including no optical viewfinders (or optical viewfinders with quite limited coverage), small sensors,

lack of truly wide-angle and long telephoto lenses, limited depth-of-field control, extensive digital noise at high ISO settings, no facility for using filters, extremely limited flash capabilities, and, in many cases, no raw file availability. As a result, P&S cameras are fine for snapshots, family events, and postcard-size prints, but for serious landscape photography they are at a significant disadvantage compared with DSLR cameras.

Digital SLR cameras have sensors that are roughly the same size as a piece of 35mm film (FX) or about a third smaller (DX). The full-frame (FX) cameras, primarily from Nikon, Canon, and Sony, are rugged, sophisticated cameras designed for heavy use by professional photographers, and they carry a hefty price tag. The smaller advanced photo system (APS) (DX) SLR cameras are much less expensive, and are an excellent choice for most landscape photography. The only major reason to consider an FX SLR, such as the 24-megapixel Nikon D3X or Sony Alpha 900, for landscape photography is to obtain a larger sensor, which is capable of producing images that can be used to make mural-sized prints. The only drawbacks of DSLR cameras are their larger size, higher cost, and the need to remove dust from their digital sensors from time to time.

Entry-level DSLRs from Canon, Nikon, or Sony, the major DSLR manufacturers, are capable of producing professional landscape photographs, and my advice is to purchase an inexpensive DSLR camera body and invest in the best lenses you can afford. For landscape photography, your first purchase should be a wide-angle zoom lens, such as a 24–70mm (FX) or a 16–85mm (DX). A 70–200mm or 70–300mm zoom is the next lens to purchase, and these two lenses will handle virtually all of your landscape photography needs. A macro lens, preferably a 180mm or 200mm, is quite useful if you plan to do much close-up photography, and a longer telephoto lens, such as a 400mm or 500mm, is required for some types of wildlife photography. Top-grade professional lenses are made from metal alloy and are extremely durable, with superb optical quality. Consumer-grade lenses have excellent, though generally not superb, optics, are usually made from plastic, and are lighter and much more affordable.

Another important factor is the maximum aperture (f/stop) of the lens. Fast f/2 and f/2.8 lenses are important for sports photographers and photojournalists but are rarely needed for landscape photography, because lenses are usually stopped down to f/8–f/16 to obtain maximum depth-of-field. Zoom

lenses with a maximum aperture of f/4 are perfectly adequate for landscape photography and offer significant size and cost savings when compared with faster lenses.

Before you buy a digital camera, check out the thorough camera reviews at the Digital Photography Review website, http://www.dpreview.com.

TRIPODS AND OTHER ESSENTIAL ACCESSORIES

Using a tripod, if you don't already, is the single most important thing you can do to improve the quality of your landscape photographs. A sturdy tripod allows you to support heavy cameras and lenses, eliminates camera movement, facilitates the use of slow shutter speeds and small f/stops, and lets you study the image in the viewfinder carefully from a compositional viewpoint.

Tripods made from carbon fiber are lightweight and strong, but two to three times more expensive than metal tripods. The tripod should be tall enough when extended that you don't have to stoop to look through the camera, but it should also be usable a few inches from the ground to facilitate close-up photography. I have a strong preference for tripods that do not have a center post, which adds to the weight of the tripod and hinders close-up photography. Gitzo tripods are superb, but quite costly. Bogen Manfrotto offers less expensive tripods.

The best tripod heads have a ball-and-socket design, featuring an Arca-Swiss dovetail plate that grips a custom plate that is attached to the base of the camera or long lens. The two companies that specialize in tripods, tripod heads, and support plates are Really Right Stuff and Kirk Enterprises. Both provide outstanding products for supporting your cameras and lenses.

Another useful accessory is a cable release, which helps minimize vibration of the camera at intermediate shutter speeds, such as 1/15th or 1/8th second. Usually, you will need to turn off image stabilization on your camera or lens, unless your camera manual indicates otherwise.

The only optical filter that is indispensable for landscape photography is a polarizing filter; all other filters, including color-correction filters and graduated-neutral-density filters, can be easily simulated electronically, using an image editor such as Adobe Photoshop. Be sure to purchase a "circular," not a "linear," polarizer, and buy one that fits your largest-diameter lens, plus

3

inexpensive step-down rings to fit your smaller lenses. A polarizer can be used to intensify colors and reduce specular reflections from the surface of water or other wet subjects, and it can also be used as a neutral-density filter to obtain a slower shutter speed when photographing a waterfall. Rotate the polarizing filter while looking through the viewfinder to obtain the effect you want.

I also carry a calibrated WhiBal gray card or Macbeth ColorChecker card to use when precise color accuracy is critical—for example, when I am photographing flowering plants. Get the small size for portability.

DIGITAL CAMERA SETTINGS

Today's digital cameras are equipped with a bewildering array of features, settings, and options. Although a landscape photographer can safely ignore many of these options, some of them are quite important and it's critical that they be correctly set. For the most part, unless noted below, these options can be set once and thereafter rarely need to be changed.

First, adjust the *viewfinder diopter control* to match your eyesight. Unless the setting slips out of adjustment, you should have to do this only once. All DSLRs have this feature, and many P&S cameras do, as well. At my photo workshops, I'm often amazed by the number of folks who are unaware of this feature and have been putting up with a fuzzy image through their camera's viewfinder.

Set the *sensitivity* (ISO) to the camera's *native* value, usually the lowest or next to lowest value available (typically 100 or 200). The image quality is always better at the lower ISO values, and if you are using a tripod (as you should be), there's really no reason not to use the lowest ISO value. By all means use a higher ISO if you plan to hand-hold the camera or need a faster shutter speed to freeze movement of the subject, but remember that the higher the ISO value the worse the picture quality.

Set the *image size* to the maximum number of pixels available. For example, if your camera has a ten-megapixel sensor, be sure the image size is set to record ten megapixels and not a lower value. In general, the more pixels your camera records, the better the image quality.

Set the *color space* to Adobe RGB, if your camera provides this option; otherwise use the sRGB (default) setting. The Adobe RGB color space can record a slightly higher range (gamut) of colors than sRGB, so if you have the Adobe RGB option you might as well use it.

For most landscape photography, set the *white balance* to "automatic," usually the default. Most digital cameras are capable of accurately reading the white balance (i.e., color temperature) of the prevailing outdoor light, but it is important to shoot in "raw" mode, so you can adjust the white balance later on your computer if you wish. It's much harder to do this if you are shooting JPEGs rather than raw files. Occasionally, you may wish to set a specific value for the white balance, for example, when you are shooting panoramic images in which several overlapping photos will later be stitched together. In this case, it is important to use a constant setting for white balance (e.g., "sunny" or "cloudy").

I strongly recommend that you shoot *raw files*, rather than compressed JPEGs, if your camera provides this option. Raw files can record a longer tonal range than JPEGs and provide you with much more flexibility in controlling tonality and color, as well as higher resolution. Raw files are 16-bit and JPEGs are 8-bit, which in a nutshell means that you can make far more adjustments to the raw file on your computer, without compromising the picture quality, than you can with the same photo taken as a JPEG. Raw files do require an extra processing step on your computer to convert the raw file to a digital image, but this conversion facility is built into all image editors and in practice is easily carried out as part of your digital workflow.

Depth-of-field, as discussed further on, is determined partly by the f/stop (aperture) setting, so for landscape photography it's best to set the camera's *program mode* to "aperture-preferred" (A) rather than "shutter-speed-preferred" (S). In other words, you set the f/stop for each photo, based on the depth-of-field you need, and the camera's exposure meter figures out the shutter speed needed at that f/stop setting to obtain a correct exposure for the photograph.

Most digital cameras provide three options for *measuring exposure:* multi-segment (Nikon calls this matrix metering), spot, and center-weighted. I don't use center-weighted, but multi-segment (usually the default method) and spot metering can be used to obtain extremely accurate exposures. I usually use multi-segment metering, but if you are familiar with the Zone System by all means use spot metering in your landscape photography. Some subjects, such as waterfalls, which usually have many very light and very dark areas, are best metered using spot metering. Whichever method you use, adjust the exposure based on the in-camera histogram display after the photo has been taken, as described in the section on exposure control.

5

Many P&S cameras do not provide *manual focusing*, but all DSLR cameras do, and for landscape photography I recommend you use manual, rather than automatic, focusing with your DSLR. *Autofocus* can be invaluable when photographing sports or wildlife, where movement of the subject is a concern, but for the stationary subjects associated with landscape photography, I always prefer to focus manually. If you do use autofocus, make sure the autofocus sensor is placed over the part of the image that you want the camera to focus on.

CONTROLLING SHARPNESS AND DEPTH-OF-FIELD

If you want your Ohio landscape photographs to be sharp—I mean *really* sharp—begin by investing in the best-quality camera and lenses you can afford. Once armed with good equipment, there are three steps you must take in order to achieve razor-sharp pictures: eliminate camera movement, eliminate subject movement, and optimize depth-of-field.

Eliminate camera movement by always using a sturdy tripod. This is the single most important action you can take to improve the sharpness of your landscape photographs. The only exceptions should be locations where tripods are prohibited, such as a few Ohio public gardens, or places where you don't want to draw attention to yourself, such as county fairs or other events that attract many people. If your camera provides image stabilization, be sure it is switched on if you plan to hand-hold the camera. Except for a few high-end cameras and lenses, image stabilization should be switched off when using a tripod. If your camera has a mirror lock-up facility, use it, preferably in conjunction with a cable release, whenever you use a tripod.

Buildings don't move, but flowers, leaves, grasses, and animals do, and you need to wait until these subjects have stopped moving to ensure sharp photographs. This can be irksome on a windy day, but there will usually be lulls in the movement of a subject if you are patient. These enforced waiting periods provide excellent opportunities to slow down, reflect on the blessings in your life, and simply enjoy being outdoors in the Buckeye State. Bear in mind that there is often less wind early in the morning than at other times of the day, and the lighting may be better.

Eliminating camera and subject movement still doesn't guarantee a sharp photograph. You must focus on the right part of the subject and select the

f/stop needed to obtain the depth-of-field you want. Some subjects, such as wide-angle vistas, usually look best if everything in the picture is in focus. Other subjects, such as close-ups of flowers or portraits of animals and people, benefit from a shallow depth-of-field, in which the main subject is sharp but the background is diffuse so that the subject stands out.

The depth-of-field increases as you stop down a lens. Most camera lenses are at their sharpest when stopped down two to three f/stops from the maximum aperture. For example, a wide-angle lens with a maximum aperture of f/2.8 will be sharpest at about f/5.6 or f/8. At higher f/stop values, such as f/22 or f/32, the depth-of-field will be higher but the sharpness will be less, due to an optical effect called diffraction. So try to avoid using the smallest f/stops on your lens unless absolutely necessary. I take most of my scenic photos with my Nikon and Sony DSLRs at f/stops between f/8 and f/16. With P&S cameras, f/4 or f/5.6 usually provides adequate depth-of-field when shooting scenic vistas.

To maximize depth-of-field in a scenic photo, focus on a point about half-way up the picture frame. Don't focus on the closest point or on the distant horizon; both of these settings waste valuable depth-of-field. Technically, you should focus on a point about a third of the way into the scene, called the *hyperfocal distance*, but focusing on a point roughly halfway up the picture frame will optimize your depth-of-field in most scenic photos.

The great depth-of-field inherent in P&S camera zoom lenses can be a problem when shooting close-ups, because it is often hard to produce a diffuse, out-of-focus background that allows the subject to stand out. To *minimize* depth-of-field with P&S cameras, use the longest telephoto setting on the zoom lens that will still allow you to use the "macro" setting, and set the f/stop to the maximum aperture. With DSLR cameras, use the longest macro lens (preferably) or telephoto lens possible, and use the widest aperture (usually f/4 to f/8) that will keep the main subject in focus but render the background as blurred.

EXPOSURE CONTROL

The exposure is the amount of light received by the camera's digital sensor when you take a photograph. If too much light reaches the sensor, highlight detail will be lost and the picture will look washed out. This is called over-exposure. If too little light reaches the digital sensor, the picture will appear too dark and shadow detail will be lost. This is called underexposure. The

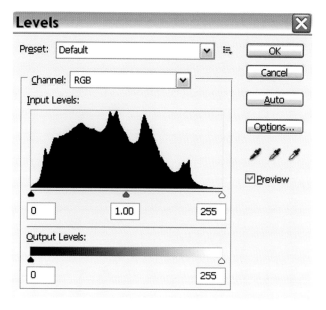

FIGURE 1

best exposure is the longest exposure that can be given without losing detail in the highlights.

The two factors that determine exposure are the shutter speed and the aperture, or f/stop. The longer the shutter speed, the more light reaches the digital sensor. The smaller the f/stop, the less light reaches the sensor. Different combinations of shutter speed and f/stop can be used to produce the same exposure. For example, a shutter speed of 1/60th second and an f/stop of f/8 produce the same exposure as a shutter speed of 1/30th second and f/11, or 1/15th second and f/16. The combination of shutter speed and f/stop you select should be based on the depth-of-field you need, as well as the shutter speed required to stop any subject movement.

Your digital camera's exposure meter reads the light reflected from the scene through the lens and suggests a shutter speed, based on the f/stop you have selected, to achieve the correct exposure. When you have taken the photograph, you can find out whether it was correctly exposed by examining a display on the LCD screen on the back of your camera called a *histogram*.

Figure 1 shows a histogram—a graph representing the distribution of all the pixels in a photograph, from pure black, shown on the left of the histo-

gram, to pure white, shown on the right. Consult your camera's manual to find out how to display a histogram on the LCD screen after an exposure has been taken. Typically, this is done via a thumbwheel setting after you have pressed the "playback" button on the back of the camera.

The shape of the histogram will vary, depending on the subject and the exposure. The number of peaks will be determined by the nature of the subject, and isn't important from an exposure viewpoint. What is important is whether there are any *gaps* at either end of the histogram, and whether there are any *vertical bars* on the left-hand or right-hand side of the graph.

A gap on the right or a bar on the left indicates that the picture is too dark, shadow detail may have been lost, and you need to increase the exposure. A gap on the left or a bar on the right means that the image is too light and important highlight detail may have been lost, so you need to decrease the exposure. Gaps on both the left and the right simply indicates a low-contrast subject, and no exposure correction is needed.

Figures 2, 3, and 4 are photographs of Baltimore checkerspots, my favorite Ohio butterflies, taken in June 2009, in northeast Ohio. In each case, I have superimposed the histogram for each photograph in the top right-hand corner. Figure 2 shows correctly exposed butterflies. Note that the pixels are distributed across the entire graph and that there are no gaps or vertical bars at either end of the histogram. Figure 3 shows a photograph that is dark and underexposed: note that the pixels are concentrated on the left of the graph and that there is a long gap on the right. The exposure must be increased. Figure 4 shows a photograph that is washed out and overexposed. There is a gap on the left and a vertical bar on the right, indicating that highlight detail has been lost, or "clipped." The exposure must be decreased.

How do we adjust the exposure? In landscape photography, it's important to keep the f/stop fixed so that the depth-of-field will not be affected. So, the shutter speed needs to be increased or decreased. This is done using the *exposure compensation control*, which is typically a plus/minus toggle switch on the top or back of the camera used in conjunction with a thumbwheel to increase or decrease the exposure. If you are using an aperture-preferred mode setting (A) as recommended, the exposure compensation control will change the shutter speed. A +1 setting will double the exposure, and a −1 setting will halve the exposure.

Generally, in landscape photography we want to preserve highlight detail, if necessary at the expense of shadow detail. This is done by "exposing

9

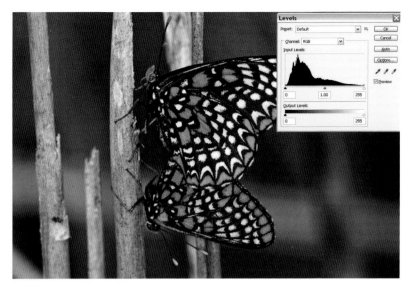

FIGURE 2

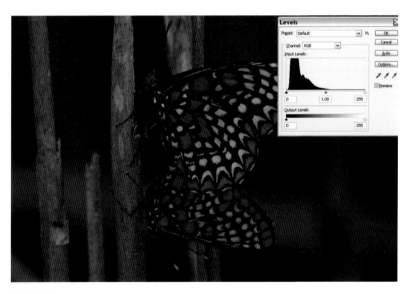

FIGURE 3

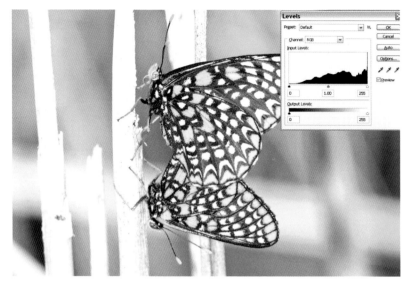

FIGURE 4

to the right," which means giving the longest shutter speed that does not result in clipped highlights, indicated by a vertical bar on the right side of the histogram.

Figure 5 shows a correctly exposed photograph of a misty morning in Marietta, one of my favorite Ohio river towns. We can adjust the contrast to taste later at home, using Photoshop or another image editor.

Most DSLR cameras and some P&S cameras provide additional histograms for each of the three primary color channels, red, green, and blue. This provides a finer level of exposure control than the composite (RGB) histogram. Adjust the exposure to eliminate any clipping in the red, green, or blue channels. Some DSLR cameras also offer the option of displaying blinking lights, which indicate when highlight or shadow detail is being clipped, as part of the histogram.

I can't overemphasize the benefits of learning how to interpret in-camera histograms and use them to precisely control exposure with your digital camera. Take the time to acquire this important skill, and watch your exposures improve!

11

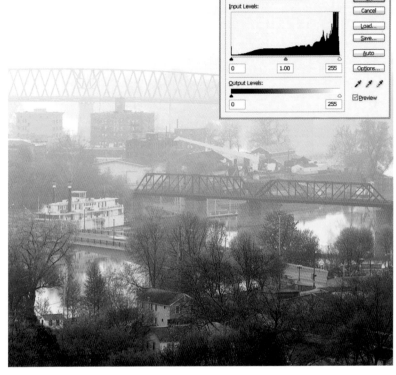

FIGURE 5

LIGHTING

Photography is derived from two Greek words, *phos* (light) and *graphé* (draw), so photography literally means to "draw with light." Understanding light and how it affects a scene is a critical skill in landscape photography.

Beginners in photography often think that bright sunny weather at midday is ideal lighting for landscape photography, but experienced landscape photographers know that such light is flat and yields washed-out colors. Early morning and late afternoon light is usually much more interesting, and these are the times I generally prefer for serious landscape photography. Colors are warmer and more saturated, and there is usually less wind, which can be the bane of scenic photography.

Another myth in photographic lighting is that the best light for outdoor photography should be frontal light, coming from "over your shoulder." Nothing could be further from the truth, because frontal lighting is flat, lacks contrast, and does little to delineate shape or texture. Frontal lighting is boring and ho-hum; you should, for the most part, try to avoid it in landscape photography. It's also difficult to avoid casting a shadow on the foreground of the scene if the light is behind you.

Sidelight, in which the scene is illuminated from the left or the right as you face the subject, is usually far more interesting, especially early and late in the day when the sun is low in the sky, causing long shadows that help define the shape of things as well as highlight textures in snow, sand, rock, and other surfaces. Sidelight increases contrast and enhances the impression of depth. It is especially effective for highlighting details in buildings, bridges, barns, and other manmade structures early and late on sunny days. Sidelight, especially when the sun is positioned at a 90-degree angle to the direction in which the camera is pointed, also maximizes the effectiveness of a polarizing filter.

Backlighting, also known as *contre-jour* (French for "against day"), in which the camera is pointed at the light source behind the subject, is the most dramatic kind of lighting, and it works well for translucent subjects, such as ice or leaves, or when you wish to render a subject as a silhouette. With backlit and, to a lesser extent, sidelit subjects, your camera meter may have a tendency to underexpose the photograph, so check your in-camera histograms carefully and make any needed exposure adjustments.

Occasionally, you may wish to photograph in extremely "contrasty" lighting, either outside on a bright sunny day or inside a building where the lighting is quite subdued, except for the daylight streaming in through the windows. Digital cameras, even shooting raw files, are not able to record these scenes with huge tonal ranges in a single exposure. However, the recent development of High Dynamic Range (HDR) software packages allows the merging of several bracketed exposures to produce a single image that provides good detail in both highlights and shadows. Photoshop provides an HDR facility, but the most popular HDR package by far is Photomatix. I'm using HDR more and more in my scenic photography, and I recommend that you download a trial copy of Photomatix if you would like to pursue this exciting new tool.

13

COMPOSITION

The great photographer Edward Weston once defined composition as "the strongest way of seeing." Assuming Weston was correct (and I believe he was), how can we train ourselves to figure out the "strongest" arrangement of the lines, forms, tones, and colors that make up a photograph?

Strong compositions are created, not found, by the photographer. Once you have located an attractive subject, you need to devote some time and effort to designing a composition that showcases the subject in the most effective manner. As you learn how to apply guidelines, principles, and rules of thumb relating to composition, your photographs will gradually improve and the compositional process will become more and more intuitive.

You can begin by studying the work of professional nature photographers whose photographs you especially admire. Your purpose should not be to slavishly copy the approach of these masters, but to learn how they compose their great photographs so you can apply some of their compositional techniques in your own pictures. My list of admired landscape photographers includes Ansel Adams, Eliot Porter, Jack Dykinga, Tom Till, Carr Clifton, John Sexton, William Neill, Art Wolfe, Craig Blacklock, Tim Ernst, Paul Rezendes, and Larry Ulrich. Wildlife photographers I esteem include Art Wolfe (again), Gary Meszaros, Arthur Morris, Franz Lanting, David Doubilet, Mike Nichols, John Shaw, and Daniel J. Cox. I also enjoy the impressionistic nature photography of Freeman Patterson and Tony Sweet.

Simplicity is often an ingredient of great nature photographs, so strive to isolate a subject in the picture frame and to remove all distracting elements from the photograph so the viewer's attention will be focused squarely on the subject. Will a horizontal or vertical composition work best? Where in the picture frame should the main subject be placed? Should the horizon be positioned high or low in the frame? If the subject is a wildflower portrait, is the background diffuse and unobtrusive so that it enhances the subject and does not compete with it? Are there any tonal mergers or other distractions, such as a flat white sky, that will reduce the impact of the photograph?

Use a tripod whenever practical, but don't be in too much of a hurry to set it up when you find an appealing subject. Hand-hold the camera with a zoom lens attached, so you can explore different camera orientations, positions, focal lengths, and depth-of-field settings. When you have designed an effective composition, examine it critically to see if any picture elements can be

strengthened or need to be eliminated because they are distracting. In particular, check the corners and edges of the picture frame and use the depth-of-field control on your camera to ensure there are no elements that will divert the viewer's attention from the subject.

DIGITAL WORKFLOW

When you get home after your Ohio photography trip, you'll want to transfer your digital photos from your camera's memory card to your PC or Mac, organize the photos, and process them with image editing software. This is usually referred to as *digital workflow.*

Provided that your PC or Mac is no more than a few years old, it will probably be more than adequate for processing your digital photographs. If you plan to spend several hours or more each week working on your digital photos, invest in the largest, best-quality LCD monitor you can afford, and be sure to calibrate the monitor, using a calibration hardware/software package such as Pantone's ColorMunki or ColorVision's Spyder. LCD monitors are quite stable, so you won't need to calibrate your monitor more than two to three times each year. Calibration ensures that your monitor's brightness, contrast, and color rendition are all set to optimal levels.

You will also need an *image editor* software package to process your digital photos. The de facto industry standard is Adobe's Photoshop (PC and Mac), but this powerful and complex package, used universally by professional photographers and graphic designers, costs many hundreds of dollars and has a steep learning curve to boot. Adobe's newer image editor, Lightroom (PC and Mac), and Apple's Aperture (Mac only) are functionally equivalent, cost much less, and are much easier to learn than Photoshop. Neither Lightroom nor Aperture provides all the bells and whistles of Photoshop, but they are more than adequate for the weekend or casual photographer. Another option is Adobe Photoshop Elements (PC and Mac) or Corel PaintShop Photo Pro, which are both easy to learn and cost about $100. For more information on the relative features and benefits of these image editors, Google the phrase "Photoshop vs. Lightroom" or a similar comparison, and review the detailed comparisons available on numerous websites. Although I'm impressed by Lightroom and recommend it to participants at my photography seminars and workshops, I continue to use Photoshop for most of my image editing,

15

partly because I have almost a terabyte of digital photographs stored in dozens of folders that I'm reluctant to convert into a Lightroom database because of the time and effort involved.

In essence, digital workflow involves converting your raw files, cropping the images if necessary, removing any dust spots or other digital imperfections, fine-tuning the tonality and color of each image, sharpening the photos, adding "metadata" that describes the content of each photograph, plus organizing and storing your digital photos as TIFF "master files" which can be used in a variety of ways discussed in the next section. There are also many other software packages, designed to be used as "plug-ins" to image editors such as Photoshop or Lightroom, that offer specific tools for sharpening digital photos (e.g., Photo-Kit Sharpener), processing high dynamic range (HDR) photographs (Photomatix), removing digital noise (Nik Dfine), or providing special effects (Nik Viveza). There are dozens of excellent books on Photoshop and Lightroom, and I've included one or two of my favorites at the end of this chapter.

SHARING YOUR OHIO PHOTOS WITH FAMILY, FRIENDS, AND CLIENTS

When you have processed and fine-tuned your digital photos and saved them as TIFF master files, you may want to share them with family, friends, or clients via email, slide shows, or websites, as color prints, or even as a self-published book.

Photos that you plan to send as email attachments should be sized to 600–1000 pixels in the longest dimension (width or height) using your image editor, sharpened, and saved as compressed JPEG files (Quality 6–8) in the sRGB colorspace.

These same JPEGs can be used to create a slideshow of a collection of your digital photos, using special commands available in Lightroom, Aperture, and other image editors. Or, you can export the JPEGs from your image editor and use them to create a slideshow in a presentation software package such as Microsoft's PowerPoint, Apple's Keynote, or Photodex ProShow Gold. I use PowerPoint for my slide presentations and photography workshops and seminars and have found it to be very satisfactory.

If you want to present a slide program to a large group of people, you will need to purchase or borrow a digital slide projector. Most slide projectors have

a resolution of 1024×768 pixels (XGA), and a few have a higher resolution of 1400×1050 pixels (WSXGA), including the Canon REALiS line of digital projectors, which I have used for several years for all my group presentations. It's best to size your JPEGs to the maximum resolution of the projector you will be using; I size horizontal photos to 1400 pixels wide and vertical images to 1050 pixels high. Sharpen the JPEGs using your image editor and convert them to the sRGB color space, which is optimal for any multimedia display that will be viewed on a screen.

The Internet is rapidly becoming the most popular way to disseminate and share photos, either via your own website or using a proprietary system such as Flickr, Picasa, or Facebook. It's easy to upload your favorite photos to these websites, but you should be aware that some of these sites, including Picasa and Facebook, require you to accept terms and conditions that grant the owner of the website (e.g., Google) broad access to the content of your photographs. This may not be an issue for weekend or casual photographers, but it is definitely a concern to professional photographers who want to control access to their images. Be sure to read the "Terms and Conditions" of the site carefully before you tick the "Accept" box. Also you should be aware that Facebook reduces the resolution of any photographs you upload to its website, so be sure to save your original photos elsewhere unless you want to lose them forever.

If you have your own website, you can upload your digital photos and create one or more galleries of your images. Some image editors, including Lightroom and Aperture, will automatically generate the HTML or Flash programs needed to create a basic website gallery, or you can use a proprietary software package to develop and manage your website galleries, such as ImageFolio, which I use to create and maintain the galleries on my website: http://www .ianadamsphotography.com. Packages like ImageFolio can also be used to sell your photographs through your website.

Another popular way to share your photography is to make color inkjet prints. The past decade has seen a dramatic improvement in the quality, cost effectiveness, and longevity of inkjet prints, and superb printers are available from Epson, Canon, and Hewlett-Packard (HP) in sizes from 8.5 inches to 72 inches in width. I have used an Epson Stylus Pro 9600 and 9800 for almost a decade to produce hundreds of color prints up to 40×60 inches for corporate and private clients, and I have been thrilled with the quality of the prints and the reliability and durability of Epson printers. These inkjet printers use

17

pigmented inks and can be used on a wide variety of glossy and matte papers, as well as on canvas. The archival life of these pigmented inks and papers often exceeds a hundred years.

An ongoing challenge when producing color inkjet prints is to ensure that your color prints match the photographs that you view on your computer's LCD monitor. This process is called *color management*. In essence, it involves always using a carefully calibrated monitor in conjunction with accurate paper/ink "profiles" created for each type of paper you plan to print on with your inkjet printer. These profiles are usually included with the inkjet printer, or you can download them from the printer manufacturer's website.

Another way to share your photographic collections is with a self-published book. Web-based, print-on-demand publishing services such as Blurb, Lulu, and MyPublisher allow you to download free software that provides templates you can use to design your own book. You upload the completed templates together with your photographs and purchase a single copy of the book as a proof. After you have used the proof to fine-tune your book, you can buy as many copies as you need or even sell your book online using the publisher's website. Waterfall explorer Tina Karle has used Lulu.com to self-publish several guides to Ohio waterfalls listed in the reference section of the Waterfalls chapter.

STORING YOUR DIGITAL PHOTOS

How do you store your digital photos? Can you find any photo quickly and easily? And if, heaven forbid, you suffered a disaster in the form of a flood or fire, do you have another copy of your important digital photographs?

I asked myself these questions a couple of years ago, and the answers were not reassuring. To begin with, most of my digital photos were stored on several external hard drives, but some were only on my computer's main hard drive. I had some, though not all, of the images backed up on CD/DVD. The computer and external drives, plus the CD/DVDs, were stored in my basement office at home. Also stored there were more than 50,000 35mm, 6×8cm, and 4×5-inch color transparencies, filed in nine four-drawer metal filing cabinets. Although my basement office is sealed against flooding and has a couple of fire sensors connected to my security alarm system, a major fire could potentially wipe out almost thirty years of professional photography.

All computer hard drives eventually fail, and storing important information and digital photographs on your computer's main hard drive is asking for trouble. In addition, digital photographs eat up lots of disk storage, which eventually will degrade your computer's performance. Today most professional photographers store their digital photographs on external hard drives, preferably using a RAID (Redundant Array of Independent Disk) configuration that provides a backup of all data stored on the external drives. RAID is efficient but can be complicated to set up and maintain, unless you are a computer expert.

After a few hours of online research, I settled on a Drobo, a data robot storage system developed and marketed by Data Robotics, Inc. I purchased the largest version, with four 1-terabyte Western Digital SATA drives, expandable to 16 terabytes, for a little over $1,000. Drobo automatically makes a backup of all data entered, and there is absolutely no programming involved. Simply transfer your digital files to the Drobo and Drobo does the rest. New, larger drives can be added when needed, and if a drive ever fails, Drobo goes to work to recreate the data from the other drives.

I spent a couple of weeks reorganizing my digital photos into about forty major folders, then copied the folders to the Drobo, which used up roughly 25 percent of the available storage. This represents about six years of digital photography, so there's plenty of space left on my Drobo for many more years of work. To guard against the (unlikely) possibility of the Drobo unit failing, I also purchased an extended warranty.

To further ensure against fire, flood, or theft, I installed backup software on my PC. Each month I copy the entire contents of the Drobo (currently about 850 gigabytes) to a 1-terabyte external drive, which is kept at another location. The Drobo has a fast FireWire 800 connection to my PC, which allows me to use the Drobo as primary online storage for my digital photographs. I also burn a copy of my digital photos on CD/DVD as an additional safeguard.

So far, I'm very pleased with the Drobo, and so are many other users: more than 100,000 Drobo units have been sold worldwide to date.

REFERENCES

Adams, I. 2005. *The Art of Garden Photography*. Portland: Timber Press.
Data Robotics, Inc. http://www.drobo.com—Elegant, cost-effective data storage hardware and software.

Detrick, A. L. 2008. *Macro Photography for Gardeners and Nature Lovers: The Essential Guide to Digital Techniques*. Portland: Timber Press.

Digital Photography Review. http://www.dpreview.com—Excellent camera reviews.

Evening, M. 2009. *Adobe Photoshop CS5 for Photographers*. Boston: Focal Press.

——. 2009. *The Adobe Photoshop Lightroom 3 Book: The Complete Guide for Photographers*. Berkeley: Peachpit Press.

Gerlach, J., and B. Gerlach. 2010. *Digital Landscape Photography*. Boston: Focal Press.

Imaging Resource. http://www.imaging-resource.com—Good reviews of cameras and lenses.

The Luminous Landscape. http://www.luminous-landscape.com—Excellent camera and other photography equipment reviews.

Thom Hogan's Nikon Field Guide and Nikon Flash Guide. http://www.bythom.com—Great information on landscape photography and Nikon cameras and lenses.

20

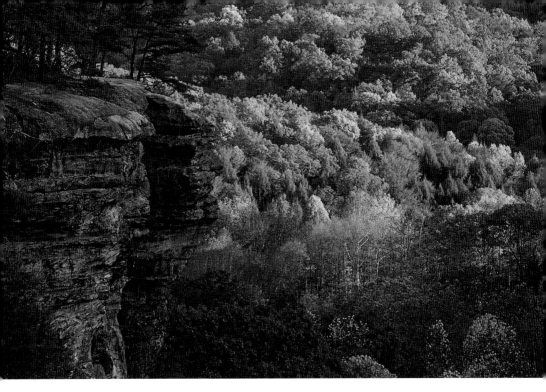

Scenic Vistas

Ohio is not a mountainous state like some of its Appalachian neighbors to the east or the Rocky Mountain, Sierra Nevada, and Cascade Range states to the west. In fact, our highest elevation, the 1,549-foot summit of Campbell Hill in Logan County, doesn't have a view at all. But there are many Ohio vantage points where you can enjoy a grand view of a town, a city, or a natural or rural area. This chapter describes nineteen of Ohio's best scenic vistas and offers some tips for photographing them.

You can drive to most of these overlooks or reach the viewpoint after a short walk. The East Rim Trail at Conkle's Hollow State Nature Preserve and Mount Pleasant in Lancaster are both short but strenuous hikes, and the trail to Buzzardroost Rock in Adams County will give you a good workout.

Please note that at each of the eighteen overlooks described, except for the Perry's Victory Memorial, your feet will be firmly planted on the ground, and

ABOVE: CONKLE'S HOLLOW STATE NATURE PRESERVE, HOCKING COUNTY

I have not included any views from the tops of Ohio's tallest buildings, such as the Terminal Tower in Cleveland or the Carew Tower in Cincinnati. Visit these lofty man-made lookouts if you enjoy the steel, glass, and concrete panoramas that they provide.

PHOTOGRAPHING SCENIC VISTAS

Anyone can take a quick photo from a scenic overlook with a cell phone or a point-and-shoot camera. Want proof? Just type in the name of the location in "Google Images," and you can scroll through hundreds of lackluster images that may prove the shooter has "been there, done that" but don't rise above the level of a casual snapshot. Like most worthwhile endeavors, creating a fine photograph of a scenic vista requires planning, preparation, skill, and effort.

Before you visit a scenic overlook, find out which direction it faces. This will help you decide what time of day would be best for photography. For example, if the overlook faces west, morning light will illuminate the vista, but in the afternoon you will be shooting into the light and the scene will be silhouetted. Conversely, overlooks that face east will favor afternoon light for photography. With overlooks facing south, you will be looking into the light during the middle of the day, so early morning or late afternoon lighting will be best. The same goes for north-facing overlooks, where the midday light will be behind you. Of course, if you want to shoot sunrise or sunset from an overlook or shoot directly into the light to obtain a backlit effect, these lighting suggestions won't apply. Generally, I prefer early morning or late afternoon lighting, when shadows are long, colors are more intense, there is less wind, and fewer people are around.

Weather is another important factor when photographing from Ohio's overlooks. The hot, muggy days of summer, when winds are commonly from the south, bring hazy skies that render distant objects faint and heavy foliage on trees, blocking the view. Summer foliage is also a uniform green and not terribly photogenic. In spring and fall, foliage color is more varied, fewer leaves block the view, and weather fronts from the west and northwest bring clearer skies and more attractive cloud formations. Winter lighting can also be favorable for shooting vistas, but snowy or icy conditions may make it harder to get to the overlooks. Some places, like the East Rim Trail at Conkle's Hollow, are

closed during winter because of the hazardous walking conditions. If you decide to hike to an overlook in these conditions, be sure to dress warmly and wear Yaktrax or similar crampons on your boots to avoid slipping on icy trails.

A wide-angle zoom lens, such as the 16–85mm Zoom Nikkor (DX) or 24–70mm Zoom Nikkor (FX), plus a 70–200mm zoom lens, will cover most of your needs when shooting from overlooks. A longer lens, such as a 300mm or 400mm, can also be useful to isolate parts of the vista and help to compress perspective, and I often take my 200–400mm Zoom Nikkor along on visits to Ohio overlooks. A polarizing filter can help to minimize haze and intensify colors.

Lugging around a sturdy tripod is a chore, but it's essential for photographing scenic vistas. A tripod allows you to use low ISO settings for better quality images, as well as smaller f/stops and longer shutter speeds. Using a tripod also forces you to slow down and allows you to examine the image carefully in the viewfinder before pressing the shutter release. Usually, you'll need to switch off image stabilization on your camera or lens when using a tripod. I also invariably use a cable release and lock up the camera's mirror to maximize the stability of the camera during the exposure.

Expansive vistas from overlooks can make good panoramic photographs. When shooting a series of overlapping images for a panoramic, remember to use the same f/stop and shutter speed settings for each photograph in the series. Use your camera's exposure meter to estimate the correct exposure, based on the f/stop needed to achieve adequate depth-of-field, then switch the camera to "M" (manual) mode and use the controls on your camera to set the f/stop and shutter speed required.

Cascade Valley Overlook, Summit County

Location: Off Sackett Avenue in Cascade Valley/South, east of Cuyahoga Street, about 2 miles west of downtown Cuyahoga Falls. Tel: (330) 867-5511
Website: http://www.summitmetroparks.org
GPS Coordinates: 41.124731N 81.520192W

From the parking lot on Sackett Avenue the flat, easy Overlook Trail leads half a mile to the top of a steep shale slope, below which the Cuyahoga River makes a sharp U-turn on its way downstream to the Cuyahoga Valley National Park. Forested hillsides and the steep shale slopes dominate the scene, and only a few buildings are visible along the horizon. An observation platform provides a bird's-eye view that is at its best in autumn, when the fall color

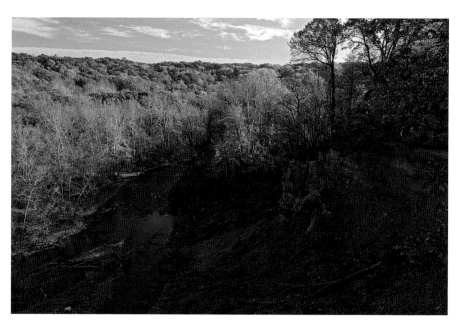

CASCADE VALLEY OVERLOOK, SUMMIT COUNTY

can be spectacular. The overlook faces southeast, so early morning or late afternoon generally provide the best lighting opportunities. Great blue herons can often be seen hunting along this remote section of the Cuyahoga River.

Cincinnati from Devou Park, Kentucky

Location: In Devou Park near the Drees Pavilion, 790 Park Lane, Covington, KY 41011.
 Tel: (859) 431-2577
Website: http://www.dreespavilion.com
GPS Coordinates: 39.08257N 84.526519W

Cincinnati has more scenic vistas than any other major Ohio city, thanks to the lofty hills that surround the Queen City on all sides and give the downtown area the appearance of being in the crater of a dormant volcano. One of the finest views of Cincinnati isn't from Ohio, but from Devou Park, which is perched on a bluff across the Ohio River in Covington, Kentucky.

Finding Devou Park can be a bit tricky if you aren't familiar with the area, but if you follow the driving directions to the Drees Pavilion given on the website listed above, you shouldn't have a problem. Walk down the hill from the parking lot to the observation area, which provides a great view of downtown Cincinnati, just over a mile away as the crow flies.

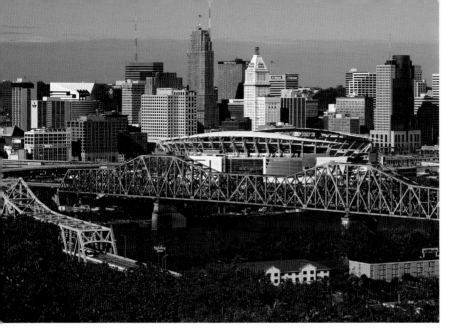

CINCINNATI FROM DEVOU PARK, KENTUCKY

The lookout at Devou Park is south, and a little west, of downtown Cincinnati. During the middle of a sunny day, the Cincinnati skyline will be frontally lit, with minimal shadows to provide any definition in the buildings. Early morning and late evening, when the city buildings will be etched with shadows, provide far better lighting from this vantage point. You'll need a 70–200mm zoom lens to fill the picture frame with the downtown area, or you can back up, use a wider lens, and include a few of the trees near the observation deck in your photograph. This is also a great place for a panoramic photograph of the Queen City.

Cincinnati from Holy Cross Immaculata Church, Mount Adams

Location: 30 Guido Street, Cincinnati, OH 45202. Tel: (513) 721-6544
Website: http://www.hciparish.org
GPS Coordinates: 39.107108N 84.496614W

Holy Cross Immaculata Church sits atop a hill in Mount Adams, and the viewing area at the top of the steps near the front of the church offers what many folks believe is the finest view of downtown Cincinnati. I concur, and have visited this inspiring viewpoint often during my visits to the Queen City. The architectural contrast between the concrete and glass skyscrapers along the city skyline and the century-old Italianate buildings below the 1859 Holy

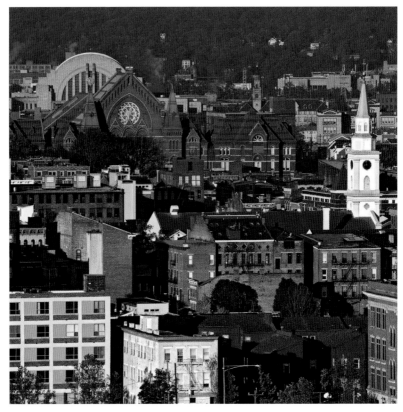

CINCINNATI FROM MOUNT ADAMS

Cross Immaculata Church enhances the bird's-eye view. It's easy to get confused in the maze of narrow, one-way streets in Mount Adams, so use Mapquest or your GPS to get directions from your starting point and follow them carefully.

This viewpoint faces west, so unless you want to photograph sunset over the city the best light is usually just after sunrise on a sunny or partly cloudy day. You'll need a wide-angle lens to include some of the older buildings in the foreground as well as the downtown buildings, or you can zero in on the city skyscrapers with a longer focal-length lens.

Cleveland and the Flats from Tremont

Location: On University Road near I-90 bridge, Tremont. Tel: (216) 575-0920
Website: http://www.restoretremont.com
GPS Coordinates: 41.484938N 81.689467W

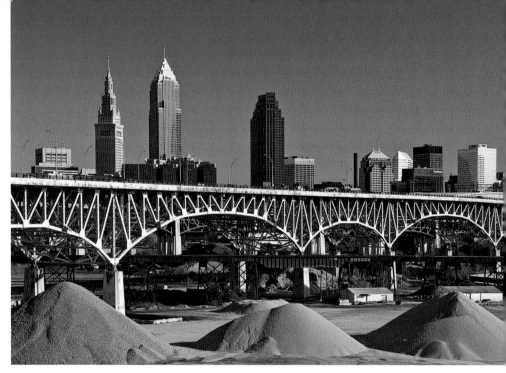

CLEVELAND AND THE FLATS FROM TREMONT

Tremont is a historic community that sits on a steep hill southwest of downtown Cleveland. Because of its vantage point high above the Cuyahoga River and the Industrial Flats, the eastern edge of Tremont provides one of the finest views of downtown Cleveland.

Tremont was originally called University Heights, a tribute to Cleveland University, which was founded here in 1851 and operated in Tremont until 1853. Many of the streets in the neighborhood, "Professor," "College," "University," and "Literary," recall this brief period in Tremont's history. There are also many significant architectural buildings here that reflect the area's Eastern European, Greek, Polish, and Appalachian heritage, including the striking onion domes of the Russian Orthodox St. Theodosius Cathedral, which is a prominent feature of the Tremont skyline.

There is no formal overlook here, but along several sections of University Road, just east and west of the high bridge that carries Interstate 90 across the Industrial Flats, there is a fine view of downtown Cleveland, albeit surrounded by the old factories and piles of sand, gravel, coal, and other minerals in the foreground. Cleveland is an industrial city, and I find this gritty setting an appropriate element of photographs taken in this neighborhood.

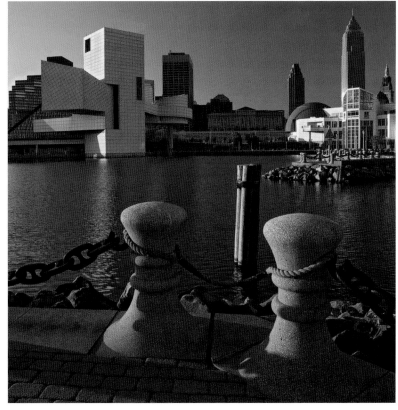

CLEVELAND FROM VOINOVICH PARK

Cleveland from Voinovich Park

Location: 800 E. 9th Street, Cleveland, OH 44114
Website: N/A
GPS Coordinates: 41.5099N 81.697322W

In contrast to the Rust Belt views of Cleveland from the hills of Tremont, Voinovich Park, named for Senator and ex-Mayor of Cleveland George V. Voinovich, offers a modern, lakefront vista of the city. The skyline here includes Burke Lakefront Airport, the Steamship *William G. Mather* Maritime Museum, the Rock and Roll Hall of Fame, the Great Lakes Science Center, and the new Cleveland Browns Stadium, intermingled with the skyscrapers of downtown Cleveland. The main viewing direction is south, so early morning and late evening views usually provide the best lighting conditions. This area can be very crowded in the evening, especially if the Cleveland Browns,

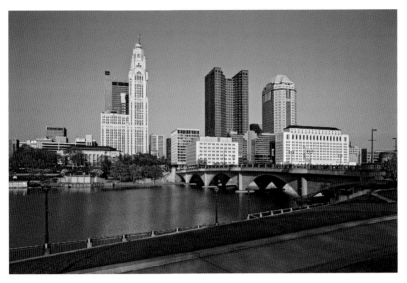

COLUMBUS FROM GENOA PARK

Indians, or Cavaliers have a home game or there is another downtown event scheduled. I prefer to photograph in Voinovich Park around sunrise, when there are no crowds and you can park for free near the park.

Columbus from Genoa Park

Location: Genoa Park is on the west bank of the Scioto River adjacent to the Broad
 Street bridge in downtown Columbus.
Website: N/A
GPS Coordinates: 39.961869N 83.006008W

Columbus may be Ohio's largest city, but the topography of the area is flat, and it is hard to find good vantage points for views of the city center, especially from the east side. My favorite place from which to photograph downtown Columbus is Genoa Park, which hugs the west side of the Scioto River for several hundred yards along Washington Boulevard near the Broad Street bridge and COSI. There is plenty of parking and an excellent view of the skyscrapers of downtown Columbus to the east across the river. A row of fountains and numerous trees alongside the river make good foreground subjects for wide-angle views with the city buildings in the background. Late afternoon or evening light on a clear day is ideal, but you can also find some good angles early in the morning looking north from the southern sections of the park. The Broad Street bridge provides another attractive foreground for vistas

29

of the city skyline, and there are good views of the Scioto River and a replica of the *Santa Maria*, the flagship of Christopher Columbus, which is moored near the northeast corner of the bridge.

About a mile north of Genoa Park is Confluence Park, where the Olentangy and Scioto Rivers meet. There is another fine view of downtown Columbus from the Riverclub Restaurant in this park, which is accessed from State Route 315.

East Rim Trail, Conkle's Hollow State Nature Preserve, Hocking County

Location: 24858 Big Pine Road, Rockbridge, OH 43149. Tel: (614) 265-6453
Website: http://www.dnr.state.oh.us/Home/Preserves/ConklesHollow/
GPS Coordinates: 39.457114N 82.57488W

The 2-mile Rim Trail at Conkle's Hollow State Nature Preserve in the Hocking Hills in southeast Ohio is one of the finest hikes in the Buckeye State, and the vistas from the 200-foot sandstone cliffs on the East Rim are as grand as any in the state. However, you'll need to exert some effort to reach them.

From the parking area near Big Pine Road, follow the signs to the East Rim Trail, which begins up a long wooden stairway, followed by a trail that climbs steeply. After fifteen to twenty minutes, depending on your age, fitness, and the amount of camera gear you are carrying, you'll arrive at the first of several sandstone overlooks, where there are spectacular views of Conkle's

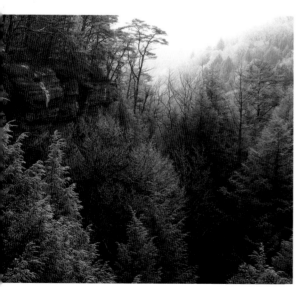

Hollow to the south, west, and north. The Rim Trail continues to an overlook near a waterfall at the head of the gorge and then south along the West Rim and down the hillside to the trailhead.

Early morning and late afternoon are my favorite times to be on the Rim Trail, and all the major vistas are from the East Rim. There are Virginia pines and chestnut oaks at the rock outcrops; try to include them in some of your photographs.

CONKLE'S HOLLOW STATE NATURE PRESERVE, HOCKING COUNTY

This is also a great place to use your 70–200mm zoom lens to isolate sections of the forested hillside along the hollow, especially in early spring or fall when there are many varied hues in the foliage.

After you have been to the overlooks along the East Rim Trail, be sure to take the half-mile Gorge Trail along the bottom of the hollow to a headwall with a waterfall, where the trail ends and you must retrace your steps. Seasonal waterfalls cascade over the tall cliffs, and many species of ferns and spring wildflowers may be found along this easy trail.

Jeffrey Point Birding Station, The Wilds

Location: On State Route 284, between Zion Ridge Road and International Road, 6.5
 miles west of Cumberland in Muskingum County. Tel: (740) 638-5030
Website: http://www.thewilds.org
GPS Coordinates: 39.830169N 81.756785W

Draw lines on a map of southeast Ohio from Marietta to Cambridge, Cambridge to Zanesville, and Zanesville back to Marietta. In the center of the triangle of land that these lines enclose, southwest of the old mining town of Cumberland, is some of the wildest country in Ohio, with some of the longest views. In the center of this area, on almost 10,000 acres of land once ravaged by strip mining, is a remarkable place called The Wilds.

Founded in 1984 on land donated by the Central Coal Company, a division of American Electric Power Company, The Wilds is

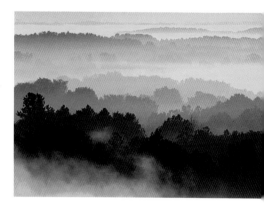

JEFFREY POINT BIRDING STATION, THE WILDS

the largest conservation and captive breeding facility for rare and endangered animals in America. Open to the public from spring through fall, The Wilds is home to white and Indian rhinos, zebras, giraffes, bison, Bactrian camels, and several antelope and deer species, together with carnivores that include cheetahs, African hunting dogs, and dholes. These animals live in vast enclosures surrounded by electrified fences that remind you a bit of *Jurassic Park*. During the warmer months, you can take a safari with a guide who will educate you about the terrain and the animals that live there. I've had the good fortune to photograph at The Wilds for several years, and it is a fascinating place to visit.

31

The primary terrain here consists of extensive grasslands, punctuated by numerous lakes and ponds that were created decades ago when the area was strip-mined. There are many vantage points for photography, both within The Wilds and on the many country roads in the nearby vicinity. One overlook that affords a great view of The Wilds and is easy to get to is the Jeffrey Point Birding Station. It's a great place to photograph sunrise, especially when mist fills the hollows in the grasslands, and the area looks like a scene from *High Plains Drifter*. The extensive grasslands and ponds are popular wintering sites for several species of hawks and bald and golden eagles; birders come from miles around in winter and spring to visit this prime birding location.

There is a parking area at the Jeffrey Point Birding Station, which is open dawn to dusk throughout the year. In addition to admiring the great views, bring binoculars so you can enjoy the resident birds during your visit.

Lancaster from Mount Pleasant

Location: In Rising Park, Bainter Circle, off High Street, Lancaster, OH 43130.
 Tel: (740) 687-6651
Website: http://www.lancasterparks.com/
GPS Coordinates: 39.724974N 82.595056W

About a mile north of Lancaster, near the Fairfield County Fairgrounds, rises a 250-foot hill called Mount Pleasant, capped by sheer sandstone cliffs on its southwest slopes. The top of these cliffs provides a panoramic view of Lancaster, and, on a clear day, you can see the city of Columbus, 30 miles to the northwest.

Mount Pleasant is in Rising Park, where a short but steep trail leads from the parking area to the top of the cliffs. Lancaster is to the south, so avoid midday or you will be looking directly into the sun. In addition to telephoto shots of the city, try to take some wide-angle views with sections of the cliffs included in the foreground to give a sense of scale and depth.

Lancaster's most famous native son was General William Tecumseh Sherman, who was born here in 1820 and served under General Ulysses S. Grant in the Civil War. Sherman's successful use of ruthless "scorched earth" policies against the Confederacy has earned him a reputation as the first "modern general." You can visit his birthplace, the Sherman House, at 138 E. Main Street in downtown Lancaster.

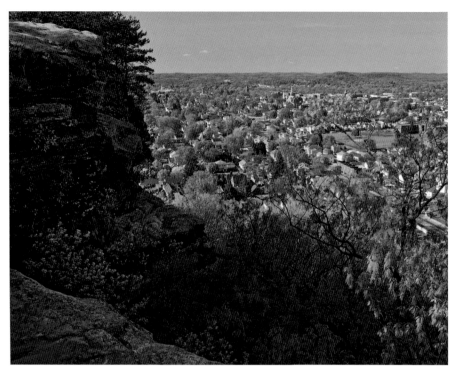

LANCASTER FROM MOUNT PLEASANT

Marietta from Lookout Point, Harmar Heights

Location: On Bellevue Street, near the intersection with Bartlett Street, on Harmar Hill, about 1.5 miles west of downtown Marietta. Tel: (740) 373-5178
Website: http://www.mariettaohio.org
GPS Coordinates: 39.417204N 81.466097W

Marietta, founded at the junction of the Ohio and Muskingum Rivers in 1788 by Rufus Putnam and other Revolutionary War veterans, is Ohio's oldest city and the first permanent settlement in the Northwest Territory. The city has retained much of its early riverboat-town charm, and is one of my favorite Ohio photography destinations. In mid-April, pink dogwoods and flowering crabapples line the streets next to the stately Victorian houses that are common in this city. Several bridges spanning the Muskingum and Ohio Rivers provide good vantage points for photography, and there are many architectural and historical gems in Marietta, including the picture-postcard Marietta College; the Campus Martius Museum; the Ohio River Museum, with the

33

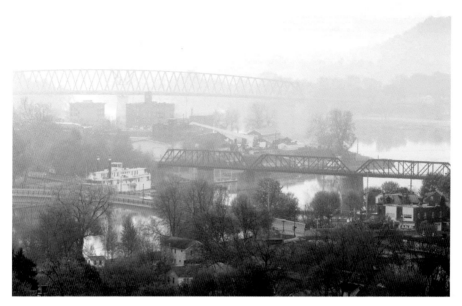

MARIETTA MISTY MORNING

picturesque *W. P. Snyder Jr.* sternwheeler; the stately Lafayette Hotel; and Mound Cemetery, which is the resting place for more Revolutionary War officers than any other site in America.

A popular and photogenic annual event in Marietta on the September weekend after Labor Day is the Ohio River Sternwheel Festival, during which thirty to thirty-five authentic sternwheel boats visit the city and tie up along the Ohio River near the Rufus Putnam Landing. The festival gets crowded during the day and in the evenings, but it's a fine opportunity for paddleboat fans to obtain great photographs of these picturesque boats.

Most local folks would agree that the best view of Marietta is from Lookout Point on Harmar Hill, across the Muskingum River about 1.5 miles west of downtown Marietta. There is a plaque at the overlook, with information on the many points of interest in the vista to the west and south. Misty mornings, sunrise, and sunset are good times to photograph from this elevated lookout. Early morning is the best time to photograph the red and white *W. P. Snyder Jr.* sternwheeler from the east bank of the Muskingum River at the Ohio River Museum.

Ohio Brush Creek Valley from Buzzardroost Rock

Location: Edge of Appalachia Preserve, 4274 Waggoner Riffle Road, West Union, OH
45693. Tel: (937) 544-2880
Website: http://www.cincymuseum.org/explore_our_sites/edge_appalachia
GPS Coordinates: 38.766575N 83.450739W

Just north of the Ohio River, a few miles east of West Union in rural Adams County, is one of Ohio's largest nature preserves, the Richard and Lucile Durrell Edge of Appalachia Preserve System. Jointly managed by the Ohio chapter of The Nature Conservancy and the Museum of Natural History & Science at Cincinnati Museum Center, this 14,000-acre area along the valley of Ohio Brush Creek includes wooded hills, prairies, rock outcroppings, and clear streams with rapids and small waterfalls. It is home to more than one hundred species of rare animals and plants. One of the jewels of the Edge of Appalachia preserve is Buzzardroost Rock, which crowns a hillside 500 feet above the valley of Ohio Brush Creek and provides a great view. The 3-mile hike (there and back) to Buzzardroost Rock is the longest and steepest hike in this chapter, but the view is worth it, and there are wildflowers and other subjects to photograph along the trail.

To reach the trailhead, drive 5.8 miles east on State Route 125 from its intersection with State Route 41 near West Union to Weaver Road, then 0.9 miles on Weaver Road to a parking area. From the trailhead, the 1.5-mile trail crosses State Route 125 and heads uphill at a steady incline through cedar glades and rocky woodlands to a fenced overlook on the top of Buzzardroost Rock. Along the way, especially in spring, you'll pass dozens of species of wildflowers. Allow an hour and a half to two hours or more for this hike, especially if you are carrying a tripod and camera gear.

The view is to the south and west, so an early morning hike will usually provide the best lighting for photographing the vista of forested hills and a few open fields near the banks of Ohio Brush Creek. Birders will enjoy listening to the songs of more than a dozen wood warblers during April, when these diminutive birds head north through this area, but you'll need long lenses (at least 500mm), skill, and plenty of patience to obtain frame-filling photos of these elusive little birds.

BUZZARDROOST ROCK VIEW, ADAMS COUNTY

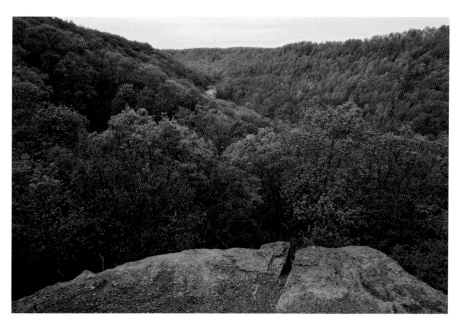

Paint Creek Overlook, Buzzards Roost Nature Preserve, near Chillicothe

Location: 514 Red Bird Lane (off Polk Hollow Road), Chillicothe, OH 45601.
　Tel: (740) 775-2247
Website: http://www.svbnc.org/Earl H. Barnhart Nature Preserve.html
GPS Coordinates: 39.325743N 83.070939W

Ross County has more miles of rivers, tributaries, and creeks than any other Ohio county, and Paint Creek is one of the wildest and most scenic of these streams. Just west of Chillicothe, Ohio's first state capital, Paint Creek flows through a deep gorge with shale and sandstone cliffs, now preserved as the 1,332-acre Earl H. Barnhart Buzzards Roost Nature Preserve. To reach the preserve, turn south from Route 50 on Polk Hollow Road just west of Chillicothe, drive 1.8 miles, then turn right on Red Bird Lane to a dead end with a parking area.

From the trailhead, the 0.42-mile South Point Lookout Trail takes you through woods rich in spring wildflowers to an overlook, where you can view the 600-foot-deep Paint Creek Gorge to the north and west. Early morning in early spring or late fall, when the view is not blocked by extensive foliage, provides the best lighting for photographing this vista. The preserve is named for the turkey vultures that roost along the gorge.

While you are in the Chillicothe area, you might want to visit Adena Mansion and Gardens, the home of statesman Thomas Worthington, who helped Ohio gain statehood in 1803. Also nearby are many Indian mounds, especially at Mound City, where you can learn about the Hopewell Indians who lived in this area from 200 B.C. to A.D. 500. There are artifact collections, and the history of these early Ohioans is fascinating, but the grassy mounds look like a manicured golf course, and, so far, I haven't found a way to make an interesting photograph of them. Adena Mansion and Gardens includes an attractive Georgian house and farm buildings and is much more photogenic.

Perry's Victory and International Peace Memorial, Put-in-Bay

Location: 93 Delaware Avenue, Put-in-Bay, OH 43456. Tel: (419) 285-2184
Website: http://www.nps.gov/pevi/contacts.htm
GPS Coordinates: 41.654071N 82.811489W

At the eastern end of South Bass Island in western Lake Erie, in the resort town of Put-in-Bay, rises a 352-foot Doric column called Perry's Victory and International Peace Memorial. This imposing monolith, built in 1912–15, commemorates the Battle of Lake Erie on September 10, 1813, when a small American fleet led by Commodore Oliver Hazard Perry defeated and captured a much larger squadron of British warships, essentially wresting control of Lake Erie from the British. After the short but decisive encounter, Perry reported "Dear General (Harrison): We have met the enemy and they are ours. Two ships, two brigs, one schooner and one sloop. Yours with great respect and esteem, O.H. Perry."

During the late spring and summer tourist season, the memorial is open most days, and you can take an elevator to a parapet on top of the monument that offers a 360-degree panoramic view of the Lake Erie Islands. From the middle of October until April, the memorial is open only by appointment. The memorial was scheduled to be closed in 2010 for major repairs to the column, so check out the website to obtain current information.

Ripley from the Rankin House State Memorial

Location: 6152 Rankin Hill Road, Ripley, OH 45167. Tel: (937) 392-1627
Website: http://www.ripleyohio.net/htm/rankin.htm
GPS Coordinates: 38.750605N 83.843281W

High on Liberty Hill, which overlooks the Ohio River and the town of Ripley in Brown County, stands a small stone house. This is the Rankin House, which provides one of the finest views around of the Ohio River.

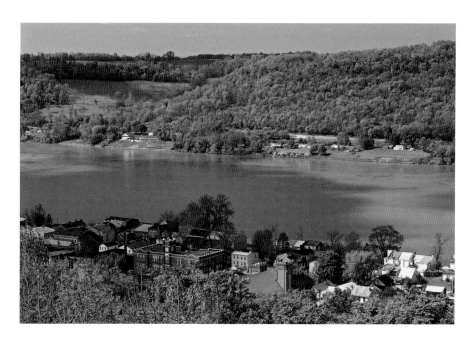

RIPLEY FROM RANKIN HOUSE

On a clear day you can see seven bends of the Ohio River, as well as a bird's-eye view of Kentucky and Ripley, famous for tobacco farming and a major center of the Underground Railroad, which helped slaves fleeing north from the South in the years prior to Emancipation. Many of the inhabitants of Ripley helped the runaway slaves, but the most famous was the Reverend John Rankin, whose 1828 house was a major "station" on the Underground Railroad.

The Rankin House is reached by turning onto Rankin Hill Road, just west of Ripley, and climbing a steep hill to a parking area. The house itself, which contains many items of furniture and other artifacts, is open during the warm months from midmorning through afternoon. But you can visit the site earlier or later to admire and photograph the view from the top of the steps below the house, which make an excellent foreground for wide-angle shots of the Rankin House. You'll need a telephoto lens to isolate Ripley and the Ohio River, best photographed early or late when shadows provide modeling and texture. I prefer a sunny day to ensure a blue sky and attractive reflections in the Ohio River. The Rankin House faces south, so it receives good lighting for photography in the morning and evening.

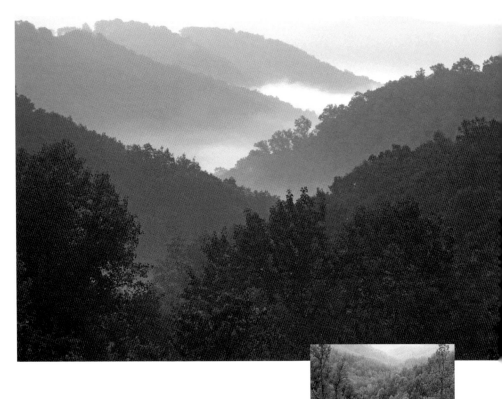

Shawnee State Forest

Location: Shawnee State Forest, 13292 U.S. Hwy. 52, West
 Portsmouth, OH 45663. Tel: (740) 858-6685
Website: http://www.ohiodnr.com/forestry
GPS Coordinates: 38.689975N 83.127887W (Picnic Point)

The 63,000-acre Shawnee State Forest in Scioto and Adams Counties is the largest of Ohio's twenty state forests. Bobcats, black bears, and timber rattlesnakes live here, though your chances of encountering one of these elusive critters are slim. When mist lies in the hollows of these remote hills, Shawnee State Forest earns its nickname as the "Little Smokies of Ohio." Shawnee has a 60-mile backpack trail, more than 75 miles of other foot trails, over 100 miles of paved and graded dirt roads, and an 8,000-acre wilderness area.

39

I have never found good fall color at Shawnee State Forest, but it's a great place to visit in late April, when there are dozens of kinds of wildflowers in bloom and many songbird species migrate through the forest en route to their northern nesting grounds. By far the best way to experience spring in Shawnee

ABOVE: SHAWNEE STATE FOREST

State Forest is to participate in Flora-Quest, a three-day event based at the lodge in Shawnee State Park during the last weekend of April each year. During Flora-Quest, up to twenty area naturalists lead hikes into the forest to observe wildflowers, migrating birds, butterflies, and other denizens of the forest. I had the pleasure of conducting a photo workshop and serving as a keynote speaker at Flora-Quest in April 2009, and I heartily recommend the event as a wonderful way to meet interesting people and learn more about the flora and fauna of this extensive area. The Edge of Appalachia Preserve is nearby, and staff and visiting naturalists from Adams County conduct walks in this area during Flora-Quest. For more information, visit the Flora-Quest website.

Shawnee State Forest has some fine views, but logging operations, an extensive ice storm in February 2003, and a 3,000-acre fire in April 2009 have taken their toll on the forest and reduced the number of scenic overlooks, which are scattered along the hundred or so miles of graded dirt roads that crisscross the ridges and valleys of the forest. Download a map of the state forest from the website before you visit, so you can study the area and highlight a few places to explore.

One vista worth a visit is Picnic Point, in the eastern section of the state forest south of State Route 125, which provides a view of the Ohio River Valley. Another, more expansive, lookout is near the communications tower on Forest Road 5 in the southern section of the forest. Shawnee State Park has a nature center staffed by knowledgeable people who can provide some orientation and show you where the best views are in the forest.

Tinker's Creek Gorge Scenic Overlook, Bedford Reservation

Location: On Gorge Parkway, just east of Overlook Lane, in Bedford Reservation south
 of Cleveland. Tel: (216) 635-3200
Website: http://www.clemetparks.com
GPS Coordinates: 41.377487N 81.558983W

Stand at the scenic overlook along Gorge Parkway in Bedford Reservation, and look north. Below your feet, Tinker's Creek has carved a 200-foot-deep gorge, with forested hills as far as the eye can see. This is an urban wilderness; the overlook is only a dozen miles as the crow flies from Public Square in downtown Cleveland.

Tinker's Creek, the largest tributary of the Cuyahoga River, is named for Joseph Tinker, principal boatman for the survey crew of Moses Cleaveland. The steepness and rockiness of the gorge discouraged farming, and today

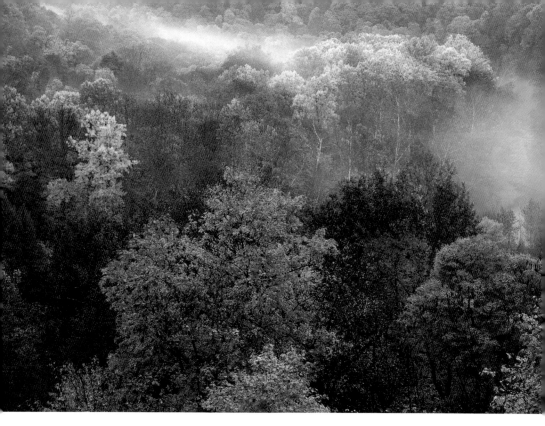

TINKER'S CREEK GORGE, BEDFORD RESERVATION

the area is preserved as a National Natural Landmark in Bedford Reservation, one of the jewels in the Cleveland Metroparks, also known as Cleveland's "Emerald Necklace." The gorge can be admired from the overlook, or you can hike along sections of the top of the gorge and the valley of Tinker's Creek.

Because the overlook faces north, it is best photographed in the early morning or the late afternoon on a sunny or partly cloudy day, when long shadows add definition and depth to the scene. Mid- to late October, when fall color is usually at its peak in northeast Ohio, is my favorite time for photography here, especially if patches of early morning mist float over the gorge. You'll need a wide-angle lens to include some of the trees and shrubs near the overlook as foreground elements, or use a telephoto to isolate sections of the gorge and distant hillsides. I have visited this overlook dozens of times, and it ranks as one of the finest vistas in northeast Ohio.

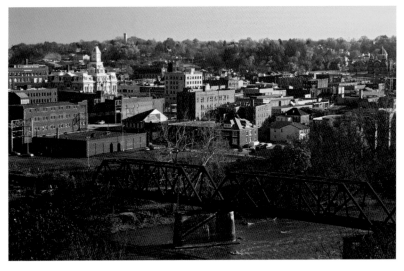

ZANESVILLE FROM PUTNAM HILL PARK

Zanesville from Putnam Hill Park

Location: On Grandview Avenue, Zanesville, OH 43701. Tel: (740) 455-0609
Website: http://www.visitzanesville.com/businesses/putnam_hill_park
GPS Coordinates: 39.937367N 82.012382W

Zanesville, the county seat of Muskingum County east of Columbus, is named for Ebenezer Zane, who constructed a frontier road through this part of Ohio in 1796 and 1797. Zanesville lies on the National Road and was Ohio's second capital from 1810 to 1812. One of Zanesville's most famous structures is an unusual Y-shaped bridge, called the "Y-Bridge," which spans the junction of the Licking and Muskingum Rivers. Another imposing building is the 1874 Muskingum County Courthouse on Main Street.

Putnam Hill Park is a small area southwest of downtown Zanesville on a high bluff overlooking the Y-Bridge and the city. From the overlook, you get an excellent view of Zanesville to the northeast and the Y-Bridge, which is due north of the park. Unfortunately, although you can get a good record shot of the Y-Bridge, the background is marred by storage tanks and other industrial buildings that detract from the scenic quality of the view. Downtown Zanesville, however, makes an attractive photograph from this vantage point, preferably early or late on a sunny day. As with many of these vistas, you can use a wide-angle lens to frame the city with some of the foliage near the overlook, or use a telephoto to isolate a section of the city buildings.

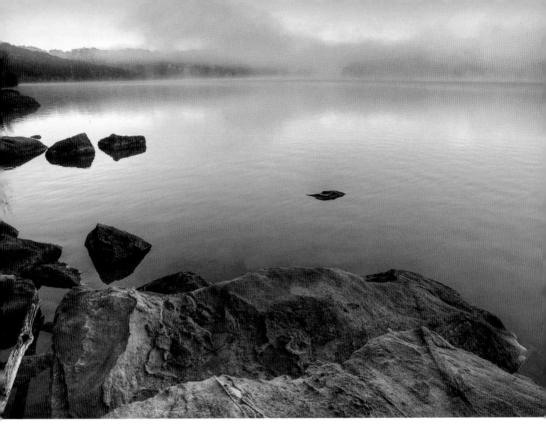

Natural Areas and Preserves

An airline traveler flying across Ohio at 30,000 feet, observing the patch-work quilt of farm fields, woodlands, rivers, roads, towns, and cities, could be forgiven for thinking that Ohio does not flaunt its natural areas. We cannot boast the scenic grandeur of the American West or the rugged coastline of New England. Indeed, only a tiny fraction of the Buckeye State has escaped the hand of man and remains essentially unchanged from presettlement times. Virtually all of Ohio's old-growth forest has been cut, and more than 90 per-cent of its wetlands have been drained for farming or development.

Despite this loss, Ohio still has much to offer the nature photographer. More than a million acres of woodlands are preserved in the Wayne National Forest and twenty smaller state forests spread around the Buckeye State. Ohio

43

has 134 state nature preserves, 74 state parks covering 160,000 acres in 60 counties, and 108 state wildlife areas encompassing 135,000 acres. There are also 700 miles of state scenic rivers, hundreds of city and county parks, and thousands of privately owned natural areas. These diverse natural regions are home to 1,800 species of plants, 51 mammals, 418 birds, 66 reptiles and amphibians, 135 species of butterflies, 164 kinds of dragonflies, tens of thousands of other insects, and dozens of rare and endangered species in many of these groups.

Space constraints allow us to include only a small sample of these places, but the twenty-three locations listed below, drawn from each of Ohio's five major regions and representing each major type of habitat, will provide you with a good idea of what is available to the nature photographer in the Buckeye State. I am primarily a landscape photographer, so the emphasis is on scenic areas, but many individual plants and animals that are of special interest to the nature photographer are mentioned below, as well.

TIPS ON PHOTOGRAPHING NATURAL AREAS

There are at least three elements to a great nature photograph:

1. A beautiful or interesting subject

The more time you spend in the field, the more nature subjects you will find for photography. And the more knowledgeable you become about trees, shrubs, wildflowers, ferns, mammals, birds, reptiles, amphibians, butterflies, dragonflies, and other insects, the more easily you will be able to pinpoint natural subjects for your camera and lens. This chapter will introduce you to some of Ohio's most beautiful and diverse natural areas, and the references at the end of the chapter will help you expand your knowledge of these places and the diverse animals and plants that live in them.

2. Great lighting

Dull light makes for a dull photograph, regardless of the attractiveness of the subject and the strength of the composition. That's why masters of landscape photography like David Muench, Paul Rezendes, and Jack Dykinga often rise in the middle of the night to ensure that they reach their preselected viewpoint well before sunrise to take advantage of the magical, but fleeting, light that sometimes occurs at the beginning of the day. And if great light doesn't materialize, these dedicated—some would say obsessed—photographers will often

stay in the same vicinity for days, hoping for a few seconds of glorious light that will render their chosen scene immortal.

Experienced landscape photographers study weather patterns and learn how to predict when the best lighting is likely to occur. Usually, this is early or late in the day or when a weather front passes through and virtually never in the middle of clear, blue-sky days, when the lighting is harsh and flat. On sunny or partly cloudy days, the best light usually occurs from about a half-hour before sunrise to about an hour after sunrise and from about an hour before sunset to roughly a half-hour after the sun has gone down. These are the periods that most often produce the "sweet light" that landscape photographers crave.

Many of Ohio's natural areas and preserves are woodlands, and the complex patterns of light and shade created by bright sunlight streaming through the forest canopy are usually too complex and chaotic to allow the photographer to produce an effective composition. Cloudy skies eliminate these highlights and shadows and reduce the visual complexity of forest scenes so that effective pictures can be created. Fog or mist further reduces this visual complexity, adds a mood of mystery, and, to me, is always a gift for woodland photography. Cloudy or misty skies also provide the best lighting for most close-ups of wildflowers, ferns, mushrooms, and other woodland subjects.

Summer meadows and many wetlands, on the other hand, are open areas and are usually best photographed early or late on sunny or partly cloudy days. Again, mist or fog can add a great mood to these scenes. Unless, that is, you are looking for butterflies or dragonflies, which are most active during warm, sunny weather. Recent innovations in High Dynamic Range (HDR) photography have made it technically possible to handle extreme contrast ranges in lighting, but that doesn't mean that these extreme lighting conditions are any less harsh and generally unappealing.

3. A strong composition

One of the characteristics that distinguish landscape photographs taken by an expert photographer from those taken by a beginner is the quality of the composition: the way in which the viewpoint, lines, forms, tones, spaces, perspectives, and colors are arranged within the picture frame to create a photograph that is pleasing to the eye. Beginners tend to include too many picture elements, take hurried snapshots, and quickly move on to find the next subject. Expert photographers work methodically and meticulously to create a

finely composed photograph, and they take the time to explore the subject in depth.

Natural areas are complex places, filled with numerous animals, plants, and other elements that are often arranged in a chaotic fashion. Your challenge in photography is to select the subjects you want to include in the photograph and arrange all the picture elements to make order out of chaos. Each of us views the world in a unique way, based on our experiences, emotions, and point of view. As the great Canadian photographer and writer Freeman Patterson noted, "The camera always points both ways. In expressing the subject, you also express yourself."

When you feel the urge to take a photograph in a natural area, first, determine its main attraction. Is it an animal, a group of wildflowers, a waterfall, a river, a stream, a pond, a group of trees, a reflection, an abstract pattern, or even a mood evoked by your surroundings? When you have figured out the answer, your challenge is to compose the photograph in a way that isolates, emphasizes, and highlights the subject that attracted your attention.

Handhold your camera with a zoom lens as you explore different orientations, viewpoints, and lens focal lengths to determine the precise viewpoint and angle that creates the most effective composition. If your subject is a wide-angle vista, look for strong elements to place in the foreground, and decide whether the horizon, if the scene has one, should be placed high, low, or somewhere in between. Make sure your horizon is level, and look for leading lines or framing elements to draw the viewer's attention to the main subject. If your subject is a telephoto view of a group of trees or wildflowers, move the camera around until you find a composition in which the picture elements appear to be in balance. Use your depth-of-field control to find out what f/stop is needed to render the scene in sharp focus with adequate depth-of-field. Adjust your viewpoint to eliminate, or at least minimize, distracting white skies on overcast days.

Photography equipment buffs and manufacturers may be disappointed that I haven't devoted any space to cameras, lenses, filters, and other photography gear in the paragraphs above. That's because virtually any brand and model of digital SLR camera, equipped with an inexpensive kit lens, is capable of producing professional results if used by a skilled photographer to capture a beautiful nature subject enhanced by great lighting and a strong composition. Although the camera companies and online photography forums would like you to believe otherwise, there is no new camera or lens feature, gadget, or gizmo that will provide you with a competitive edge in photography, and no

AEP RECREATION LANDS—CYPRESS TREES

sleight of hand or skill in Photoshop can turn a lackluster image into an award-winning photograph without deception, cheating, or subterfuge.

AEP Recreation Lands, Morgan, Muskingum, and Noble Counties

Location: See AEP Recreation Lands Map. Tel: (614) 716-1000
Website: http://www.aep.com/environmental/recreation/recland/
GPS Coordinates: 39.699152N 81.731139W (Miner's Memorial Park)

From 1969 to 1991, when coal was king in the hills of Morgan, Muskingum, and Noble Counties in southeast Ohio, a 13,000-ton behemoth known as Big Muskie walked the earth. Built by Bucyrus-Erie and operated by the Central Ohio Coal Company, a division of American Electric Power (AEP), Big Muskie was a walking dragline, 500 feet long and 22 stories tall, equipped with a bucket that was big enough to hold two Greyhound buses placed side by side. During its 22 years of operation in Ohio, Big Muskie removed more than 600 million cubic yards of topsoil, uncovering 20 million tons of coal. Big Muskie was scrapped in 1991, but its huge bucket, weighing 460,000 pounds, was preserved

47

48

and is the centerpiece of a Miner's Memorial Park near the junction of State Routes 78 and 83 in Morgan County, 8.5 miles east of McConnelsville. Nearby are more than 30,000 acres of restored strip-mined land, known as the AEP Recreation Lands, offering some unique opportunities for nature photographers.

Most of the Recreation Lands are open grassland populated with autumn olive and other invasive shrubs, peppered with more than 350 lakes and ponds gouged out during mining operations but now full of fish and other aquatic species. Several state highways pass through the area, which is crisscrossed by a maze of dirt roads. In dry weather, most of these roads are drivable in regular passenger vehicles, but in wet or winter weather, many of the roads are impassable quagmires. A free permit is needed to enter the AEP Recreation Lands, and this document may be downloaded from the AEP website, along with a map of the area. AEP Recreation Lands is a large and remote area, with few distinctive geographical features, and it is easy to get lost here, so make sure you familiarize yourself with the AEP map and carry a GPS as an extra navigational aid. There are nice vistas along State Route 83 south of Cumberland, State Route 284 north of State Route 78, and the large area accessed from Prouty Road east of State Route 340 and south of International Road.

There are places in this area where you can see for miles, but the lack of landmarks makes this a challenging region for scenic photography. Bird photographers, however, will find much of interest here. The open grasslands are prime nesting territory for eastern meadowlarks, bobolinks, savannah sparrows, grasshopper sparrows, and Henslow's sparrows, and in winter the same grasslands attract rough-legged hawks, harriers, golden eagles, prairie falcons, short-eared owls, and other raptors. In summer, the many lakes and ponds are populated with darners, skimmers, dancers, bluets, and other dragonflies and damselflies, and numerous butterflies frequent the grasslands. Of course, you will need long lenses, patience, and skill to photograph these winged beauties.

Be sure to visit the Big Muskie bucket at the Miner's Memorial Park on State Route 178. The sheer size of the bucket is mind-boggling, and it makes an interesting challenge for photography. The Wilds, described on pages 31–32, is also in this area.

Arc of Appalachia Preserve System

Location: 7629 Cave Road, Bainbridge, OH 45612. Tel: (937) 365-1935
Website: http://www.highlandssanctuary.org
GPS Coordinates: 39.226806N 83.348984W

ARC OF APPALACHIA — ROCKY FORK CREEK

In 1995, Nancy Stranahan and Larry Henry, ex-employees of the Ohio State Parks system, were running a retail bakery business in Columbus but dreaming about helping to preserve the last few remaining Ohio fragments of the vast eastern temperate forest that once covered most of Ohio. In that year, they established Highlands Nature Sanctuary along a section of the Rocky Fork Gorge, west of Chillicothe in Highland County. Fifteen years later, their original 47-acre purchase has grown to twelve preserves encompassing more than 2,500 acres in five counties between the Scioto River and the western edge of the Appalachians in southwest Ohio — the Arc of Appalachia Preserve System.

The terrain in the Arc of Appalachia Preserve System includes a scenic section of the pristine Rocky Fork Creek, which flows through Rocky Fork Gorge between cliffs of dolomite limestone up to 100 feet tall. Other preserves feature old-growth deciduous woodlands, tallgrass and shortgrass prairies, and the second-largest cave system in Ohio, operated for decades as a tourist attraction known as Seven Caves and now being managed as a natural

49

cave system. An Appalachian Forest Museum, featuring displays and educational programs that tell the story of America's eastern temperate forest, has recently been established.

The primary attractions here for the nature photographer are scenic vistas of the Rocky Fork Gorge and a magnificent display of spring wildflowers beginning in mid-March with the arrival of hepatica, spring beauty, and the diminutive snow trillium, followed by many other wildflowers, reaching a peak in mid- to late April. An annual Wildflower Pilgrimage weekend, with guided trips to many of the preserves, is held in mid-April each year. For an entrance fee of $6.00 ($3.00 for children), visitors can hike several trails at Highlands Nature Sanctuary, and, for a small additional fee, obtain a permit for self-guided hiking on 14 miles of other trails in the preserve system, which is open to the public on weekends in April, May, September, and October, and daily from June to August.

Cedar Bog State Nature Preserve, Champaign County

Location: 980 Woodburn Road, Urbana, OH 43078. Tel: (937) 484-3744 and
 (800) 860-0147
Website: http://www.cedarbog.org
GPS Coordinates: 40.056915N 83.79204W

Cedar Bog is one of Ohio's most unusual natural areas, a 426-acre remnant of a much larger wetland that formed when the Wisconsinan glacier retreated north after covering this section of Ohio. The name "bog" is a misnomer; Cedar Bog is actually a fen, fed by glacial springs and dominated by sedges, grasses, and other wetland plants. Part of the fen includes a stand of northern white cedars, coniferous trees reminiscent of areas in Canada and New England hun-

dreds of miles north of Cedar Bog. Many rare plants may be found growing here, as well as unusual reptiles like the eastern massasauga rattlesnake and spotted turtle. A rare damselfly, the seepage dancer, and two uncommon butterflies, the Milbert's tortoise-shell and swamp metalmark, are found in the fen. A boardwalk traverses the main section of the fen and the woodlands that surround it.

The terrain at Cedar Bog is flat and the preserve is not especially scenic from a photographer's viewpoint, but the unusual plant and animal life make Cedar Bog

CEDAR BOG — SHOWY LADY'S SLIPPERS

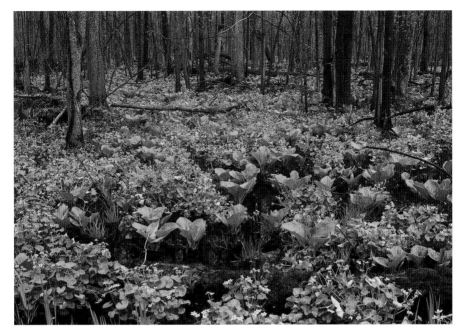

CEDAR BOG — MARSH MARIGOLDS

well worth a visit, especially in early spring and summer. In mid-April, one of the largest displays of skunk cabbage and marsh marigold in Ohio covers several acres in the southern section of the preserve and can be easily photographed from the boardwalk. In late May through early summer, several species of orchids bloom in the fen meadows, including the spectacular showy lady's-slipper orchid with its pink and white blooms.

The preserve is open during posted hours, and a small admission fee is charged. Check the Cedar Bog website to make sure the preserve will be open when you visit, and bring mosquito repellent during summer, when biting insects can be troublesome.

A few miles northwest of Cedar Bog in Champaign County is Kiser Lake State Park, which has some interesting lake views, and Davey Woods State Nature Preserve, a 103-acre old-growth forest preserve with large oaks and tulip trees and a fine display of spring wildflowers. A few miles southeast of Cedar Bog, near New Moorefield, is Prairie Road Fen State Nature Preserve, another fen meadow with a boardwalk and a beautiful display of prairie flowers in midsummer. A permit from ODNR's Division of Natural Areas and Preserves is needed to visit this preserve.

CLEVELAND METROPARKS, SOUTH CHAGRIN — SQUAW ROCK

Cleveland Metroparks (The Emerald Necklace)

Location: Cuyahoga County
Website: http://www.clemetparks.com
GPS Coordinates: Multiple sites

The Cleveland Metroparks was established in 1917, the brainchild of engineer William Stinchcomb, and is the oldest park district in Ohio. Stretching from Rocky River on Cleveland's West Side, south to Mill Creek, then east to Hinckley and Brecksville and northeast to Bedford and North and South Chagrin, seventeen parks covering more than 20,000 acres are joined by parkways and other roads to form an "Emerald Necklace" 80 miles long, encircling the city of Cleveland. The Cleveland Zoo is also part of the Cleveland Metroparks. The Metroparks' website provides a wealth of information to help you plan your visits, and you can download trail maps for each of the parks. There are 60 miles of paved, all-purpose trails and hundreds of miles of foot trails in the Cleveland Metroparks.

From a photographer's viewpoint, there are excellent opportunities in each of the parks, including fine displays of wildflowers, miles of rivers and streams, rugged gorges, wetlands, waterfalls, sandstone and shale cliffs, and lakes and ponds. Wildlife is commonly encountered in all these parks, especially white-tailed deer, and many bird species can be seen, particularly during spring and fall migration. I have photographed in the Cleveland Metroparks for more than thirty years, and the following locations, described from west to east, are some of my favorite areas for nature photography.

In the northern section of Rocky River Reservation there are excellent wildflower displays from mid-April through late May in the Mastick Woods area and great views of the Rocky River from the Stinchcomb–Groth Memorial Scenic Overlook. Be sure to visit the nature center in the southern section of Rocky River Reservation and hike the steep Fort Hill Loop Trail to impressive views of the river from the top of 100-foot shale cliffs. Farther south along the parkway is the Berea Falls Overlook. Lake Isaac, a glacial lake in Big Creek Reservation, is a waterfowl refuge surrounded by marshes and woodlands that attract deer and other wildlife. Trails connect Lake Isaac to Lake Abram, another glacial pond 2 miles north.

Hinckley Reservation, the southernmost park in the Emerald Necklace, is renowned for the buzzards (turkey vultures) that return to the area each year in early spring. The sandstone cliffs of Whipp's Ledges rise 350 feet above Hinckley Lake, crowned with large beech trees that photograph well against a blue sky. In late April and early May, the woodlands along West Drive, south of Johnson's Picnic Area, are full of hepatica, spring beauty, trout lily, large white trilliums, and many other wildflowers, and Louisiana waterthrushes and other migrating songbirds sing in the woodland canopy.

In Brecksville Reservation, due south of Cleveland and halfway around the necklace, some park roads are closed at night on cool, rainy evenings in early spring to allow salamanders to migrate to the vernal pools where they breed. There are several gorges in this hilly, wooded park, including the rugged Chippewa Creek Gorge, which is lined with hemlocks and huge boulders. Further east, Bedford Reservation's Tinker's Creek Overlook is one of northeast Ohio's finest vistas, and numerous small tributaries of Tinker's Creek cascade down the steep slopes into Tinker's Creek Gorge. Nearby Viaduct Park, with Great Falls of Tinker's Creek, is also worth a visit.

At South Chagrin Reservation, just north of Solon, be sure to hike the Squaw Rock Loop past a beautiful waterfall on the Chagrin River to view Henry

53

Church's 1885 carving of an American Indian woman and a snake in a block of Berea sandstone. At North Chagrin Reservation, enjoy the beauty of Buttermilk Falls and Squire's Castle, a century-old gatehouse to a country estate that was never completed. Feargus B. Squire built the castle in the 1890s. Near the North Chagrin Nature Center, Sunset Pond attracts bird photographers from afar during mid- to late October, when handsome wood ducks and other waterfowl pose in watery reflections of peak fall color. A series of wetlands and meadows along Chagrin River Road attract many species of butterflies and dragonflies during the summer months.

Clifton Gorge State Nature Preserve, Greene County

Location: 2331 State Route 343, Yellow Springs, OH 45387. Tel: (937) 767-7947
Website: http://www.dnr.state.oh.us/tabid/882/default.aspx
GPS Coordinates: 39.800148N 83.836103W

In the small village of Clifton, south of Springfield in Greene County, the Little Miami River flows through a deep, 2-mile gorge lined with cliffs and huge slump blocks of Silurian dolomite limestone. This section of the Little Miami River was designated in 1968 as Ohio's first National Wild and Scenic River, and it was established as the state's first Scenic River in 1969. The 286-acre Clifton Gorge State Nature Preserve is the most scenic canyon in western Ohio and should be on every Ohio nature photographer's "must visit" list.

Many kinds of ferns grow on the limestone cliffs, and in early April the slump blocks and hillsides along the gorge are covered with one of Ohio's most spectacular displays of spring wildflowers, including multicolored hepatica, spring beauty, snow trillium, Dutchman's breeches, squirrel corn, bluebells, and many other species. These ephemeral blossoms are best photographed on a cloudy day with minimal wind, or you can use a large diffusion screen to create your own shade and

CLIFTON GORGE — LITTLE MIAMI RIVER

windbreak on a sunny day. Follow the Narrows Trail along the north rim of the gorge, where several overlooks provide great views of the Little Miami River, or hike down into the canyon on the Gorge Trail, which passes 35-foot Amphitheater Falls and several smaller cascades. A picturesque section of rapids appears along the river near Steamboat Rock. Winter is also a photogenic time in the gorge, especially after a wet snowfall that clings to the trees. In summer, the dense foliage in the gorge is a uniform shade of green and scenic photography is less attractive, but, in late fall, light returns to the canyon and autumn color paints the hillsides.

Downstream from Clifton Gorge State Nature Preserve, the Little Miami River continues for another couple of miles through John Bryan State Park, where an abundance of redbud trees bloom in April. Nearby is Glen Helen Nature Preserve, a 1,000-acre natural area with more waterfalls, a spring, and 400-year-old trees. When you have finished exploring these areas, enjoy a visit to the nearby Clifton Mill or a meal at the Winds Cafe in Yellow Springs.

Metro Parks (Columbus and Franklin County Metropolitan Park District)

Location: Franklin County. Tel: (614) 891-0700
Website: http://www.metroparks.net
GPS Coordinates: Multiple sites

Columbus Metro Parks was established in 1945 and is Ohio's largest county park system, with fifteen natural-area parks totaling 24,800 acres in seven central Ohio counties that encircle the city of Columbus. Clear Creek State Nature Preserve, near Lancaster in Fairfield County, covers 4,700 acres and is the largest dedicated state nature preserve in Ohio. Among other Columbus Metro Parks are Slate Run Living Historical Farm, described on page 152, and Inniswood Metro Gardens, described on page 109.

Battelle Darby Creek, west of Columbus, covers 7,000 acres including a 22-mile section of Big Darby Creek, one of Ohio's most pristine rivers. My favorite trail for photography is the 0.8-mile Cobshell Trail, which includes a hilltop vista of Big Darby Creek and other good views along the trail near the river.

Blacklick Woods in the eastern suburbs of Columbus includes a 100-acre beech-maple forest and a small buttonbush swamp that is picturesque in early spring, when a variety of wildflowers and other plants bloom around the vernal pools. Farther north, the Walden Waterfowl Refuge at Blendon Woods attracts many duck species, and the park has an excellent display of fall color in mid- to late October.

55

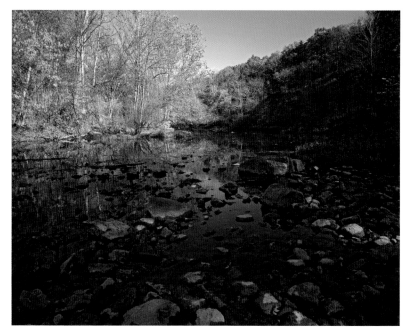

BATTELLE DARBY CREEK METRO PARK—BIG DARBY CREEK

Chestnut Ridge, southeast of Columbus in Fairfield County, reaches an elevation of 1,050 feet and is considered to be the furthest-outlying ridge of the Appalachian foothills in Ohio. There are sandstone outcrops and a view of the Columbus skyline 20 miles away. North of Columbus, Highbanks Metropark has mounds built by Adena Indians, prehistoric earthworks, and an overlook with a view of the Olentangy River below the steep shale cliffs for which Highbanks is named. West of Columbus, Prairie Oaks includes several miles of frontage along Big Darby Creek and 400 acres of prairies and grasslands.

Pickerington Ponds includes 416 acres of ponds and wetlands that are a magnet for birds and other wildlife. More than two hundred species of birds have been observed here, and four observation decks provide good vistas of the ponds. Be sure to visit the mural at Ellis Pond created by local schoolchildren.

Clear Creek Metro Park is in southern Fairfield and northern Hocking Counties near the village of Rockbridge. Most of the park's 5,255 acres is preserved as Clear Creek State Nature Preserve, the largest dedicated state nature preserve in Ohio. More than 800 varieties of plants can be found here, as well as 150 bird species. There are fine views of pristine Clear Creek and many rugged cliffs and outcrops of sandstone along it. More than 20 miles of

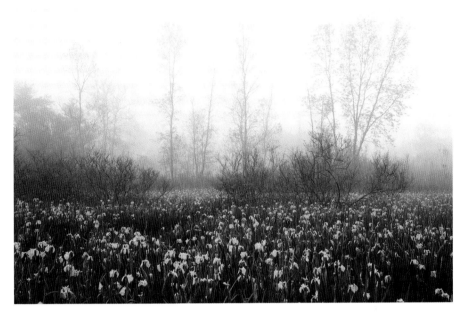

CUYAHOGA VALLEY NATIONAL PARK—IRISES IN MIST

trails provide access to the diverse natural communities in the area, including one of Ohio's few colonies of native rhododendrons.

South of Clear Creek, Rockbridge State Nature Preserve features Ohio's largest rock arch, a sandstone span near the Hocking River that is 100 feet long and 10 to 20 feet wide. If possible, visit Rockbridge in spring after a rainfall and enjoy the abundant wildflowers and a photogenic waterfall that cascades over a section of the rock arch.

Cuyahoga Valley National Park

Location: 15610 Vaughn Road, Brecksville, OH 44141. Tel: (330) 657-2752 (program information), (800) 445-9667 (visitor information)
Website: http://www.nps.gov/cuva/index.htm
GPS Coordinates: Multiple sites

The American Indians called it "Ka-ih-ohg-ha," meaning "crooked." The 95-mile Cuyahoga River is born in the wetlands of Geauga County, runs south through Kent, cascades through a rocky gorge in Cuyahoga Falls, then turns north to meander for 22 miles through the 33,000-acre Cuyahoga Valley National Park (CVNP) before entering the Industrial Flats and flowing into Lake Erie at Cleveland.

57

I have lived near the Cuyahoga Valley for more than thirty years, and many of my photographs of this area have been showcased in Browntrout's *Wild & Scenic Ohio* and *Ohio Places* calendars, as well as in a book, *Cuyahoga Valley National Park* (Twin Lights Publishers, 2005) coauthored with wildlife photographer and friend Jim Roetzel. You may want to review the photographs in the book to get a sense of the photographic potential in the national park.

Nature photographers will enjoy the fine displays of spring wildflowers in Brecksville and Bedford Reservations, and more than two hundred species of birds and a plentiful population of white-tailed deer, beaver, coyote, wild turkey and many other animals offer numerous opportunities for wildlife photography. History buffs will enjoy a visit to Hale Farm and Village or a hike or bike ride on the 20-mile Towpath Trail along the banks of the old Ohio and Erie Canal.

Many of the most photogenic places in the Cuyahoga Valley National Park are described in more detail in other chapters of this book, including several waterfalls: Great Falls of Tinker's Creek in Viaduct Park, Blue Hen Falls and Brandywine Falls in the center of the park, Bridal Veil Falls in Bedford Reservation, and Mill Creek Falls in Garfield Heights. Hale Farm and Village, the Tinker's Creek Overlook in Bedford, and Everett Road Covered Bridge are also described in other chapters of this guide.

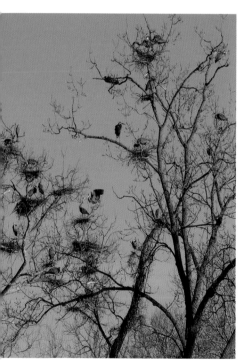

There are two active blue heron nesting sites in the Cuyahoga Valley. The largest, with more than a hundred nests, is along Bath Road on the southern boundary of CVNP between Riverview Road and Akron-Peninsula Road; the other is north of Station Road and Route 82 near the Cuyahoga Valley Railroad. Nest building occurs mostly during February and March, when the herons perform elaborate courtship displays. Young herons may be seen in the nests between late May and July. The southern heronry is much more accessible for photography, and there is a viewing area on Bath Road. You will be facing south, so early morning or late afternoon on a sunny day will usually provide the best light for photographing the herons.

CUYAHOGA VALLEY NATIONAL PARK — BLUE HERONS

In early May, be sure to visit the impressive display of Virginia bluebells along Furnace Run, north of the Everett Road Covered Bridge and east of Wheatley Road. Later in May, there is a spectacular display of yellow iris just east of the Towpath Trail near Pancake Lock (Lock 26). North of Pancake Lock a boardwalk carries the Towpath Trail across an active beaver pond, which has excellent opportunities for scenic and bird photography, especially during the peak of spring bird migration in mid-May. This is a popular area for hikers and cyclists, especially at weekends, so try to visit during the week around sunrise to avoid the crowds and benefit from better lighting for photography.

One of the finest views in the Cuyahoga Valley is at Ritchie Ledges, a mile-long outcrop of sandstone cliffs southeast of Peninsula, accessible from the Ledges parking area near Truxell Road. This area is especially attractive in mid-October, when fall color is at its peak, or in winter after a fresh snowfall.

Railroad buffs will enjoy a ride on the Cuyahoga Valley Scenic Railroad, which runs from Akron through the valley to Independence. History lovers will enjoy a visit to the restored buildings, including an old gas station, at Boston Mills, the village of Peninsula in the center of the national park, and some of the many old canal locks along the Ohio and Erie Canal.

Dysart Woods, Belmont County

Location: Dysart Woods Road, Belmont, OH 43718. Tel: (740) 593-1126
Website: http://www.plantbio.ohiou.edu/index.php/facilities/dysart/
GPS Coordinates: 39.982156N 81.000935W

Dysart Woods is a fifty-acre tract of old-growth oak woodland, one of the few remnants of the original forests that once covered the unglaciated hills of southeast Ohio. Dysart Woods is owned and managed by Ohio University as a living laboratory; oak and tulip poplars more than four feet in diameter and 140 feet high—some of Ohio's oldest and largest trees—can be found here.

To reach Dysart Woods from Belmont, which is east of Barnesville, drive south on Route 147 for about 5 miles, turn right at the Dysart Woods sign, and drive about 0.8 mile to a parking area near the trailhead for the Red and Blue Trails. These two trails, one on either side of the road, can be combined to make a hilly loop of about 1.5 miles. There are large trees along both of the trails, and in April and May the woods are filled with carpets of wildflowers. On the Red Trail, near the northwestern edge of the woods, once stood a giant tulip poplar that was felled by lightning in 1995. That tree, one of the largest in Ohio, had a diameter of 64 inches and was estimated to be more than 400 years old. Only a small section of the decaying trunk remains after fifteen years.

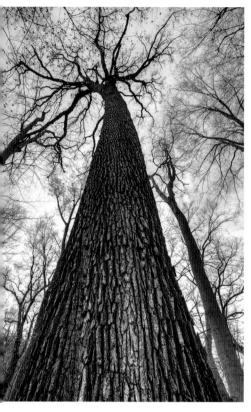

DYSART WOODS OAK

Spring is an excellent time to photograph the woodland wildflowers and large trees at Dysart Woods, and the oak and tulip tree foliage is also quite attractive in late fall. Try using a wide-angle lens and shooting straight up the trunk of the large trees while standing close to the base of the tree to emphasize the size of the tree and achieve a "cathedral" effect. Be sure to keep the tree vertical and centered in the picture frame, and avoid distracting white skies. You'll need to focus on a point partway up the tree trunk and stop down to f/16 or f/22 to achieve good depth-of-field with this type of composition.

Other places worth visiting for photography in Belmont County include the Dickinson Cattle Company north of Barnesville on State Route 800, the impressive Belmont County Courthouse in St. Clairsville, Blaine Hill Bridge east of St. Clairsville on the old National Road, and Barkcamp State Park near Barnesville, where a nineteenth-century barn displays a Mail Pouch mural painted by the legendary barn painter Harley Warrick, who lived in Belmont County until his death in 2000. The mural end of the barn faces southwest and is best photographed in morning light.

Fowler Woods State Nature Preserve, Richland County

Location: 13 miles north of Mansfield, on Olivesburg-Fitchville Road (CR 77), just south
 of the junction with Noble Road, 1.25 miles east of State Route 13. Tel: (614) 265-6453
Website: http://www.dnr.state.oh.us/location/fowler_woods/tabid/889/Default.aspx
GPS Coordinates: 40.973763N 82.469863W

Fowler Woods State Nature Preserve is a 187-acre tract of beech-maple and buttonbush swamp forest with one of Ohio's finest displays of spring wildflowers in April and May. Especially notable are the acres of marsh marigolds that carpet the wet areas in the woods in mid-April. Later in April and May the forest floor is blanketed with many ephemeral wildflowers, including trilli-

ums, Dutchman's breeches, squirrel corn, jack-in-the-pulpit, violets, spring beauty and phlox. In mid-May, masses of wild geraniums bloom along the 1 1/4-mile boardwalk trail that circles through the woods. There is another large stand of wild geraniums along the edge of the woods south of the parking lot on Olivesburg-Fitchville Road.

Visit Fowler Woods on a cloudy or partly cloudy day to avoid harsh shadows. From the paved parking area on Olivesburg-Fitchville Road, walk through the field to the boardwalk trail, and turn right to hike the boardwalk in a counterclockwise direction, which will quickly bring you to the marsh marigolds and other excellent wildflower areas. There's less to draw the photographer here in summer, fall, or winter—*spring* is the best time to visit Fowler Woods for photography.

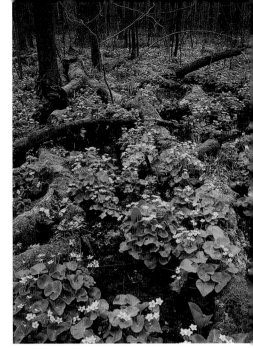

FOWLER WOODS — MARSH MARIGOLDS

Goll Woods State Nature Preserve, Fulton County

Location: From Archbold, travel north on State Route 66 for 1.5 miles, then 3 miles west on Township Road F, then .25 mile south on Township Road 26 to the Goll Woods parking lot. Tel: (614) 265-6453
Website: http://www.ohiodnr.com/location/dnap/goll_woods/tabid/942/Default.aspx
GPS Coordinates: 41.554458N 84.361356W

By the early 1800s, most of Ohio had been settled, except for the Great Black Swamp, a forested area 120 miles long and 30 to 40 miles wide, covering 12 counties in northwest Ohio and eastern Indiana. Most of the swamp was drained in the late 1800s to become some of the most fertile farmland in the country, but a 321-acre tract of wet woods, north of the main area of the Great Black Swamp and originally acquired by settler Peter Goll in 1837 for $1.25 per acre, was saved from the lumberman's axe by five generations of the Goll family, who called the area the "Big Woods." The Big Woods were purchased by the State of Ohio in 1966 and dedicated in 1975 as Goll Woods State Nature Preserve, the largest intact remnant of the swamp forest that typified the nearby Great Black Swamp.

61

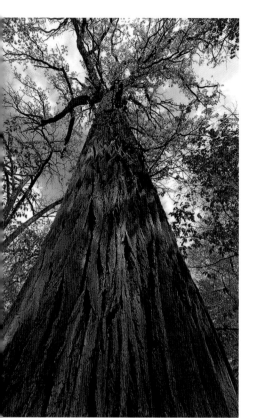

GOLL WOODS STATE NATURE
PRESERVE — BURR OAK

From the parking lot, hike the flat 1.5-mile loop of the Cottonwood and Burr Oak Trails to view the huge burr, white, and chinkapin oaks, some of them almost 5 feet in diameter and more than 120 feet tall. April and early May are the best times to visit Goll Woods, which has an excellent display of spring wildflowers. From late May through early fall, the swamp forest is buzzing with hungry mosquitoes, so bring insect repellent if you visit during this period.

The flat terrain and abundant shrubs and saplings in the woodland understory make Goll Woods a challenging place to photograph. How do you best photograph the large oak trees that are center stage here? First, try to find trees where you can stand close to the base and aim your camera directly up the trunk of the tree to compose a vertical "cathedral" shot. You can also try taking horizontal shots with a wide-angle lens, with part of the lower trunk of one of the oak trees in the left section of the frame and one or more smaller distant trees in the right section of the picture. Finally, consider taking some photographs with one or more people at the base of the tree, perhaps looking up into the branches, to provide a sense of scale.

While you are in the Goll Woods area you may wish to visit the attractive Lockport Covered Bridge, located about a mile west of the preserve on Township Road 26. This impressive bridge is 167 feet long and was built in 1999. It's best photographed in the afternoon. Back in Archbold, be sure to visit the Sauder Farm and Village, described on page 151.

Guy Denny Prairie, Knox County

Location: 6021 Mount Gilead Road, Fredericktown, OH 43019-9513. Tel: (740) 694-6087
Website: N/A
GPS Coordinates: 40.466877N 82.637005W

Tucked away near Fredericktown on the Knox County/Morrow County border in central Ohio is one of Ohio's unique natural areas, a splendid tall-

GUY DENNY PRAIRIE — NESTING BOX

grass prairie. What is amazing about the prairie is that it was created by one man, Guy Denny, a naturalist who worked for 33 years in the Ohio Department of Natural Resources (ODNR) Division of Natural Areas and Preserves (DNAP), serving as chief from 1995 until his retirement in 1999.

Guy Denny's "garden" is a 21-acre Ohio tallgrass prairie, seeded by hand over 12 years, and filled with more than 250 species of Ohio and other midwestern prairie grasses and wildflowers. The prairie is burned each spring to top kill woody invasive species, and Denny often assists other prairie owners in spring burns to help maintain their prairies. Denny's home sits in the middle of the prairie near a wood, separated from the prairie by mowed firebreaks. There are also two small ponds on the property.

Guy Denny is one of Ohio's finest field naturalists, and an expert on how to establish and maintain a prairie garden using native plants. He emphasizes techniques for planting to ensure beauty and color throughout the year, including group sowing of wildflowers to keep the prairie area from becoming dominated by grasses after several years of growth. Denny served as a consultant during the establishment of the Ohio Heritage Garden at the

63

Ohio Governor's Residence in Columbus, described in the "Public Gardens" chapter of this book.

Although there are flowering plants here from early spring through fall, the peak of the wildflower display is from mid-July to mid-August, when at least seventy species of prairie plants are in bloom. Denny welcomes visitors by appointment, and, if he is available, he will be happy to give you a guided tour of the prairie.

There are wonderful opportunities here to take portraits of the many prairie flowers, grasses, butterflies, and dragonflies, so be sure to bring your close-up gear. Scenic vistas of the prairie are best taken early or late on a sunny or partly cloudy day, when there is less wind and softer lighting. Most of the tall prairie flowers, such as compass plant and prairie dock, have yellow flowers that look great when photographed against a blue sky from a low angle. Many of the most striking flowers, like purple coneflower, bergamot, blazing star, and royal catchfly, have been seeded en masse along the perimeter of the prairie and make excellent foregrounds for wide-angle photos.

Johnson Woods State Nature Preserve, Wayne County

Location: 13420 Fox Lake Road, Marshallville, OH 44645. Tel: (614) 265-6453
Website: http://www.dnr.state.oh.us/location/dnap/johnson_woods/tabid/898/Default
.aspx
GPS Coordinates: 40.885528N 81.745756W

A few miles north of Orville in rural Wayne County stands one of Ohio's largest and finest old-growth forests. Known originally as Graber Woods, 155 acres of the woodland was given to Ohio's Division of Natural Areas and Preserves in 1994 by Clela Johnson and renamed Johnson Woods in honor of her late husband, Andrew C. Johnson. Some of the huge white, red, and black oaks are 120 feet tall and 15 feet around at the base, and a few are more than 400 years old. Many of the largest oaks are dying, having reached the end of their biological lifespan, and are being replaced by sugar maple, beech, and other more shade-tolerant trees.

From mid-April through late May there is an excellent display of spring wildflowers, and a variety of forest-loving birds, including the hooded warbler, ovenbird, scarlet tanager, wood thrush, Acadian flycatcher, and pileated woodpecker, nest here. Johnson Woods is a great place to photograph fall color in mid-October, and many kinds of mushrooms can be found along the mile-long boardwalk during summer and early fall. Pits created at the base of

fallen trees in the preserve have filled with water and provide habitat for amphibians and water sources for mammals and birds.

Kelleys Island, Ottawa County

Location: North of Marblehead in Ottawa County. Tel: (419) 746-2360
Website: http://www.kelleysisland.com/
GPS Coordinates: 41.598711N 82.710242W

The 4.6-square-mile Kelleys Island, due north of Marblehead in northwest Ohio, is the largest of the Lake Erie Islands in the United States and the most interesting from a photographic viewpoint. The island is reached by ferry services from Marblehead and Sandusky on the Ohio mainland during most of the year, but in winter, if this area of Lake Erie freezes, access is only by air. There are a variety of accommodations available, and in summer the island is a popular tourist destination.

The most famous natural feature on Kelleys Island is the Glacial Grooves, a 400-foot-long, 35-foot-wide trough of furrows scoured out of the Columbus limestone by the retreating glaciers about 18,000 years ago. Marine fossils 350 to 400 million years old can be seen in the rock surface of the grooves, which are the largest in the world. The grooves are aligned northwest to southeast

KELLEYS ISLAND SHORELINE

and are best photographed in the morning. Metal railings surround the grooves, but several viewpoints allow most of the fencing to be excluded from your photograph.

Much of the northern third of Kelleys Island is part of Kelleys Island State Park, including a large limestone quarry with unusual rock formations, the ruins of old limestone kilns, and several miles of hiking trails. The northwest coastline of the island is an example of an *alvar,* a stretch of rocky shoreline with a unique assemblage of plants. The North Shore Alvar runs roughly east to west and photographs well early or late in the day under a blue sky. The 17-mile rocky coastline of the island has many excellent vantage points for scenic vistas; my favorite places are along East Lake Shore Drive and Monagan Road on Long Point in the northeast corner of the island.

There are also several picturesque buildings on Kelleys Island, including the 1867 Kelley Mansion, which features a spiral staircase and, during the summer months, a suit of armor on display near the front door. The front of the mansion faces south. There are two winery ruins on the island; the larger one is on private land, but there is a smaller one along Division Street, about a half-mile north of Chappell Street. On the south coast of the island is Inscription Rock, a large block of limestone with the remains of a petroglyph carved by American Indians. Unfortunately, most of the "inscription" has weathered away and there is virtually nothing left to photograph.

Kitty Todd State Nature Preserve, Lucas County

Location: 10420 Old State Line Road, Swanton, OH 43558. Tel: (419) 867-1521
Website: www.dnr.state.oh.us/location/dnap/kittytodd/tabid/949/Default.aspx
GPS Coordinates: 41.618051N 83.791702W

Kitty Todd State Nature Preserve is a splendid success story of the restoration and conservation of more than eight hundred acres of sand dunes, oak savanna, and wet prairie in the Oak Openings region of northwest Ohio. The preserve is owned and managed by the Ohio Chapter of The Nature Conservancy and is named for Nature Conservancy board member and Toledo conservationist Kitty Todd.

The Oak Openings are home to more than a hundred state-listed rare and endangered plants, including yellow-fringed orchid, grass pink orchid, plains puccoon, and wild lupine, the host plant for the caterpillars of the diminutive Karner blue, the poster child for butterfly conservation in Ohio. The federally endangered Karner blue was extirpated from the Buckeye State by the late 1980s, but thanks to habitat restoration and the reintroduction of more than

KITTY TODD STATE NATURE PRESERVE — LUPINES

2,500 Karner blues by staff and volunteers from The Nature Conservancy, Ohio Division of Wildlife, Toledo Zoo, and many other groups during the past decade, this tiny butterfly is once again thriving in the Oak Openings. Other rare butterflies that have benefited from the reestablishment of wild lupine are the Persius duskywing and the frosted elfin. For birders, one of the major attractions is the lark sparrow, which nests in the Oak Openings region.

Mid- to late May is usually prime time for the blooming of the wild lupine, but call the Nature Conservancy field office to find out what plants are in bloom around the preserve and whether the Karner blues are on the wing. Adult Karner blues are about the size of your thumbnail, extremely elusive, and easily confused with the much more common eastern tailed-blue butterflies. A 180mm or 200mm macro lens will allow you to approach these frisky butterflies and also produce a nice diffused background in your photograph. Don't bother with a tripod — by the time you set one up, the Karner blues will have fluttered off to another wild lupine plant. Hand-hold your camera and use either a high ISO setting of 400 or 800 or a ring flash, such as the Nikon SB21.

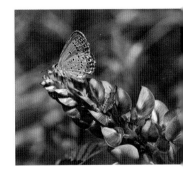

KITTY TODD STATE NATURE PRESERVE — KARNER BLUE

The wild lupine is a beautiful wildflower, and the staff at Kitty Todd can direct you to the best displays. Try wide-angle vistas as well as close-ups of individual plants. If you're lucky—and persistent—you should be able to get photographs of the Karner blues nectaring on the flowers of the wild lupine. A second brood of Karner blues emerges later in the summer, but by then the wild lupine will no longer be flowering. However, there are nice displays of black-eyed Susan, bee balm, yellow-fringed orchid, and other attractive wild-flowers in July and August, and many other butterflies will be on the wing. It can be buggy at Kitty Todd, so be sure to bring mosquito repellent.

Lake Hope State Park, Vinton County

Location: 27331 State Route 278, McArthur, OH 45651. Tel: (740) 596-5253
Website: http://www.lakehopestatepark.com
GPS Coordinates: 39.325013N 82.34936W

Two hundred years ago the area around what is now Lake Hope State Park in Vinton County might have evoked a line from William Blake's poem *Jerusalem*: " . . . among those dark Satanic mills." Coal mines peppered the area, and most of the trees in these forested hills had been cut to make charcoal to feed the fires of more than two dozen sandstone iron furnaces in what is known as the Hanging Rock region of southeast Ohio. By the early 1900s, the furnaces had closed down, and during the last century an extensive oak-hickory forest has grown up around the remnants of the mining and iron smelting days of the early 1800s.

Like all lakes in southeast Ohio, the 121-acre Lake Hope is man-made, constructed by damming Big Sandy Creek in the 1930s. There is an extensive system of hiking trails in Lake Hope State Park and the surrounding Zaleski State Forest, which is the second-largest state forest in Ohio. There are abundant displays of spring wildflowers here in April and May, especially along the floodplain of Raccoon Creek, but the main reason I included Lake Hope in this chapter is because of the spectacular display of pink water lilies that cover large expanses of the lake in June and July.

The pink water lilies are a color variant of the fragrant water lily, or American white water lily (*Nymphaea odorata*), that is native to the United States. Water lilies spread rapidly, and acres of the lake are covered with a mat of these beautiful flowers in early and midsummer. There is a fine display of the water lilies in an inlet of Lake Hope alongside State Route 278 east of the park entrance, and a much more extensive population in the eastern section of the lake along the Peninsula Trail. Bear in mind that the water lily flowers close

LAKE HOPE STATE PARK
ABOVE: WATER LILIES

up at night, so try to time your visit from mid-morning to late afternoon.

While you are in the Lake Hope area, be sure to visit the Lake Hope Furnace and nearby Moonville Tunnel in Zaleski State Forest, described on page 160.

Lakeside Daisy State Nature Preserve, Ottawa County

Location: On Alexander Pike, 0.5 miles south of State Route 163 in Marblehead.
 Tel: (614) 265-6453
Website: http://www.ohiodnr.com/location/dnap/lakeside_daisy/tabid/903/Default
 .aspx
GPS Coordinates: 41.535223N 82.727101W

The Lafarge North America Marblehead Quarry in northwest Ohio on the Marblehead Peninsula produces four million tons of crushed limestone each year, making it one of the largest limestone quarries in the United States. Along Alexander Pike, which bisects the quarry, the prevailing terrain is mostly rock, like a lunar landscape punctuated by a few shrubs and piles of detritus from the quarrying operations. But, in mid-May, large expanses of the old quarry turn into a carpet of yellow blossoms as hundreds of thousands of Lakeside Daisies burst into flower.

The Marblehead Peninsula is the only site in the United States where this dandelion-like flower blooms, making the Lakeside Daisy one of Ohio's rarest plants. Local residents Colleen Taylor and Ruth Fiscus worked with Ohio's Division of Natural Areas and Preserves to acquire 19 acres of the old quarry

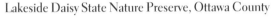

LAKESIDE DAISY STATE NATURE PRESERVE

from the Standard Slag Company (now Lafarge North America), and the area was dedicated as Lakeside Daisy State Nature Preserve in 1988. For most of the year, access to the preserve requires a permit, but during May, when the Lakeside Daisies are blooming, the preserve is open to the public. There is a parking area on the east side of Alexander Pike, where you can walk into the old quarry. The daisies all bloom at about the same time, and the effect is like a yellow carpet spread out on the surface of the quarry. Close-up opportunities are a dime a dozen, and small cedar trees and limestone boulders add interest in scenic vistas of the flowers.

South of the Marblehead peninsula, near the town of Castalia, the 2,272-acre Resthaven Wildlife Area includes the largest prairie remnant in Ohio, and numerous rare plants, including the small white lady's-slipper orchid.

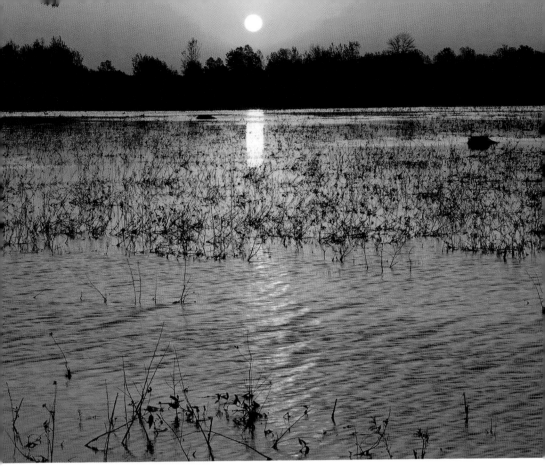

MAGEE MARSH — SUNRISE

Magee Marsh Wildlife Area/Ottawa National Wildlife Refuge

Location: Black Swamp Bird Observatory, 13551 West State Route 2, Oak Harbor, OH
 43449. Tel: (419) 898-4070
Website: http://www.bsobird.org
GPS Coordinates: 41.605213N 83.192968W

Stretching along the south coast of Lake Erie from Toledo to Port Clinton are the remnants of the once-vast Lake Erie marshes. Magee Marsh Wildlife Area and the adjacent Ottawa National Wildlife Refuge offer outstanding opportunities for birding and wildlife photography.

The 2,200-acre Magee Marsh Wildlife Area is a bird-watcher's paradise, especially during the peak of spring migration in mid-May, when thousands of birders and photographers visit the famous Bird Trail, a series of boardwalks

71

that wind through a seven-acre woodland just south of Lake Erie. On a good day, when a "wave" of migrating songbirds arrives in the marsh, more than a hundred species of warblers, flycatchers, thrushes, orioles, tanagers, vireos, and many other perching birds can be seen in a day, often at eye level, as they feed in the marshy woodlands. During July and August, hundreds of acres of swamp rose mallow bloom along the causeway through the marsh, and many waterfowl and wading birds frequent the area. In winter. short-eared owls hunt in the marshes, and bald eagles are often seen flying overhead.

West of Magee Marsh is the 9,000-acre Ottawa National Wildlife Refuge, which includes Cedar Point National Wildlife Refuge and the offshore West Sister Island, which harbors the largest wading bird nesting colony on the U.S. Great Lakes. Cedar Point NWR and West Sister Island are off-limits to the public, but the main section of Ottawa NWR may be explored using a system of hiking trails along dikes that separate the major water impoundments, and on one day each month an Auto Trail is opened to birders and photographers. In 2009, bald eagles established 215 nests in Ohio, and most of them were built in this area in the Erie marshes.

At the entrance to Magee Marsh Wildlife Area, close to State Route 2, is Black Swamp Bird Observatory (BSBO), which should be your first stop when you visit Magee Marsh for the first time. Visit the BSBO website to find out what birds have been seen in the marsh, and check out the books, maps, and other bird-oriented merchandise on display. If you are here during spring migration, you'll be rubbing shoulders with many expert birders, including the legendary Kenn Kaufman and his wife Kimberly, who is executive director of BSBO.

The fenced Bird Trail is quite narrow, and during May there may be hundreds, and sometimes thousands, of birders and photographers jostling for position, making it impossible to spread the legs of a tripod without blocking the boardwalk. Instead, many bird photographers walk the edge of the woods and a pond just north of the Bird Trail, where there is much more room for photography. The BSBO website includes Kenn Kaufman's regular migrant-bird-numbers predictions for the upcoming days, based on the weather forecast and his daily visits to the area. Mosquitoes can be a pest here during late spring and summer; be sure to bring repellent if you visit during those times.

In winter, the marsh vegetation fades to a tawny brown, and good scenic photos can be obtained early or late on sunny days from the causeway that bisects Magee Marsh. Short-eared owls may sometimes be seen hunting along the edges of the causeway, and, in winter, you may have the area to yourself.

OAK OPENINGS PRESERVE — SASSAFRAS

Metro Parks, Serving Summit County

Location: Summit County. Tel: (330) 867-5511
Website: http://www.summitmetroparks.org
GPS Coordinates: Multiple sites

Metro Parks, Serving Summit County was established as the Akron Metropolitan Park District in 1921, making it the second-oldest metropolitan park district in the Buckeye State. Today, Summit Metro Parks manages 10,000 acres in 13 developed parks, 6 conservation areas, and 18 miles of the Ohio and Erie Canal Towpath Trail. There are more than 120 miles of hiking and bridle trails in Summit Metro Parks; check their comprehensive website for details.

Here are some of my favorite places for photography in Summit Metro Parks:

Cascade Locks, north of downtown Akron, features a series of locks on the Ohio and Erie Canal and the historic Mustill House, as well.

Cascade Valley–North includes one of northeast Ohio's most spectacular views at the Overlook above the Cuyahoga River, described on page 23–24. The Oxbow Trail has a fine spring wildflower display, and there is a picturesque

73

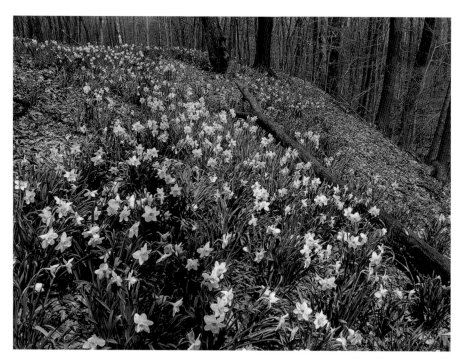

SUMMIT METRO PARKS — FURNACE RUN — WAGNER DAFFODIL TRAIL

Indian signal tree, a large bur oak shaped like a trident, in the Chuckery area of the park.

Deep Lock Quarry, along Akron-Peninsula Road in the Cuyahoga Valley, includes Lock 28, which at 17 feet deep was the tallest lock on the Ohio and Erie Canal. Nearby is an old quarry where blocks of Berea sandstone were cut for use in the locks along the canal.

Firestone Metro Park's Willow Trail includes a section of the Tuscarawas Race and Tuscarawas River, both excellent places for spring wildflowers as well as migrating songbirds in April and May.

Gorge Metro Park is the most rugged area of the Summit Metro Parks, featuring tall cliffs of Berea sandstone flanking the Cuyahoga River gorge for 2 miles.

SUMMIT METRO PARKS — FURNACE RUN — BLUEBELLS

There are interesting rock patterns, spectacular icicles in winter, rare wild-flowers, and several miles of hiking trails that will give you a good workout as well as excellent opportunities for photography.

The Wagner Daffodil Trail is a great place to shake off the winter blues in mid-April, when hundreds of daffodils bloom along the loop trail, which is named for Harold Wagner, who once owned this land and was the first director of the Akron Metropolitan Park District. A couple of weeks later, just west of the Daffodil Trail, one of the area's finest displays of Virginia bluebells blooms along the floodplain of Furnace Run, a tributary of the Cuyahoga River.

Ohio Caverns, Champaign County

Location: 2210 East SR 245, West Liberty, OH 43357. Tel: (937) 465-4017
Website: http://www.ohiocaverns.com
GPS Coordinates: 40.237872N 83.698314W

Ohio Caverns is the largest and most picturesque of Ohio's cave systems. The caverns are located near West Liberty, on the northern edge of Champaign County, and were discovered in 1897 by Robert Noffsinger, a seventeen-year-old farmhand. Since then, more than 2 miles of passageways, varying in depth from 30 feet to 103 feet underground, have been explored.

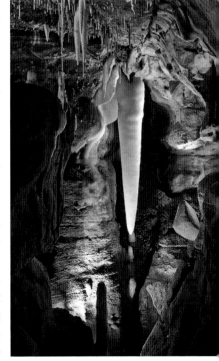

The Columbus Grey Limestone from which the caverns are formed was deposited about 400,000 years ago, and many of the blue, white, orange, and reddish-black stalactites and stalagmites that adorn the floor and ceiling of the caverns are estimated to be 200,000 years old. The 1-mile regular tour, which lasts about an hour, twists and turns past a variety of formations with names like The Crystal Sea, Natural Bridge, The Palace of the Gods, The Jewel Room, and The Crystal King, which is almost 5 feet long, weighs 400 pounds, and is the largest free-hanging stalactite in Ohio.

Ohio Caverns are open year-round, and there is a modest entrance fee. Still photography is allowed but video photography is prohibited in the caverns. Most of the major cave formations are professionally lit, but it is still quite dark in the caverns and a tripod is highly recommended to ensure camera stability during the OHIO CAVERNS

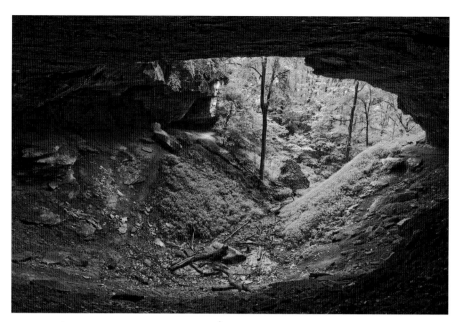

SALT FORK STATE PARK—HOSAK'S CAVE

multisecond time exposures needed. Do not use on-camera flash, which will produce garish lighting with overexposed formations and inky black shadows. This is an excellent place to practice your High Dynamic Range (HDR) photography skills, using a series of bracketed time exposures taken on a tripod and processed with HDR software such as Photomatix.

The passageways at Ohio Caverns are narrow and dimly lit, with low ceilings in places, and it is easy to bang your head, or your camera gear, so be sure to take your camera off the tripod and stow it in your camera bag before walking to the next section of the caverns.

Salt Fork State Park, Guernsey County

Location: 14755 Cadiz Road, Lore City, OH 43755. Tel: (740) 439-3521
Website: http://www.stateparks.com/salt_fork.html
GPS Coordinates: 40.10626N 81.527753W

Salt Fork State Park is the largest park in Ohio, covering 17,229 acres of land and a 2,952-acre lake. There is an abundant population of white-tailed deer, wild turkey, ruffed grouse, red fox, and gray squirrels, and many species of birds can be seen in the park. Spring wildflowers are plentiful in the woods,

and the extensive meadows along the park roads are full of ironweed, joe pye weed, goldenrod, asters, and other wildflowers in summer and early fall, especially near the park entrance on State Route 22. In late fall, the hillsides of oak and hickory around the lake turn gold, and there are excellent scenic photography opportunities, especially early in the morning when mist lies thick over the surface of the lake.

A hidden gem at Salt Fork State Park is Hosak's Cave, a sandstone-recess cave in the northern section of the park. Confederate general John Hunt Morgan is reputed to have holed up in the cave with his troops during his famous "raids" into Ohio during the Civil War. A small waterfall cascades over the lip of the cave, which is reached by a short trail. My favorite vantage point for photography is in the back of the cave, looking out to include some of the foliage that surrounds the cave. This is a good subject on which to practice your High Dynamic Range (HDR) skills.

Smith Cemetery and Bigelow Cemetery State Nature Preserves

Location: West of Plain City in Union and Madison Counties. Tel: (614) 265-6453
Website: http://www.summitmetroparks.org
GPS Coordinates: 40.103206N 83.323887W (Smith Cemetery SNP)
 40.10982N 83.419213W (Bigelow Cemetery SNP)

In presettlement times most of Ohio was covered in deciduous forest, but in a few areas west of Columbus, notably in the headwaters of Big Darby and Little Darby Creeks, the terrain was more open, with burr oak savannas and tallgrass prairies up to 10 feet high in midsummer. The prairie sod in these "Darby Plains" was deep, tough, and usually too wet or too dry to till, and the ground defied the best efforts of many of the early settlers who arrived in the early 1800s from New England, Pennsylvania, and Canada. John Deere's introduction of the steel plow in 1837 revolutionized farming, and over the next 150 years almost every acre in the Darby Plains was tilled for corn or soybeans. Today, virtually the only remnants of the once vast Darby Plains are two tiny pioneer cemeteries west of Plain City in Madison and Union Counties. The life spans etched on gravestones are harsh reminders of the young age at which many of the settlers died, but in summer the bleached headstones are swathed by luxuriant displays of purple coneflower, bergamot, rosinweed, royal catchfly, and other tallgrass-prairie wildflowers that escaped the pioneers' plow.

To reach the 2-acre Smith Cemetery State Nature Preserve, drive 2 miles west from Plain City on State Route 161, turn south on Kramer Road, cross

77

the border from Union County to Madison County, where Kramer Road becomes Converse Road, and turn west on Boyd Road for half a mile to the preserve, which is reached by a short path. The tiny half-acre Bigelow Cemetery State Nature Preserve is 8 miles west of Plain City on State Route 161, then half a mile south on Rosedale Road to the preserve.

Nearby, south of Milford Center along Connor Road, the 7-acre Milford Center Prairie State Natural Area, stretching along an old railroad right-of-way for 1.5 miles, features more than fifty varieties of prairie plants.

The prairie wildflowers bloom in July and August, making midsummer the optimal time to visit these prairie preserves. Bring insect repellent to fend off the abundant mosquitoes that thrive in the dense, wet prairie grasses and your macro lens to capture close-ups of the wildflowers, butterflies, spiders, and other tiny critters that live in the preserves.

Tappan Lake and Clendening Lake, Harrison County

Location: West of Cadiz, in Harrison County. Tel: (877) 363-8500
Website: http://www.mwcd.org
GPS Coordinates: 40.315867N 81.125157W (Tappan Lake);
 40.246296N 81.202276W (Clendening Lake)

The greatest natural disaster in Ohio's history took place in March 1913, when the Great Flood inundated many areas of the Buckeye State, killing more than 500 people. The following year, the Ohio General Assembly created the Conservancy Act, which authorized the establishment of conservancy districts around the state to provide flood protection, create and manage water supplies, and develop recreational opportunities. In eastern Ohio, most of this work was carried out by the Muskingum Watershed Conservancy District (MWCD), established in 1933 for flood control and conservation along the three main tributaries of the Muskingum River: the Walhonding and Tuscarawas Rivers and Wills Creek. This is Ohio's largest watershed, covering 8,000 square miles, or about 20 percent of the state.

To meet its flood control and conservation objectives, MWCD built ten permanent reservoirs: Atwood, Beach City, Charles Mill, Clendening, Leesville, Piedmont, Pleasant Hill, Seneca, Tappan, and Wills Creek. These large lakes provide excellent fishing, boating, and other recreational activities, as well as picturesque areas for photography. Any of the lakes can provide opportunities for scenic photography if the conditions are right, but my favorites, traveling from north to south, are Tappan Lake and Clendening Lake in Harrison County and Seneca Lake in Guernsey and Noble Counties.

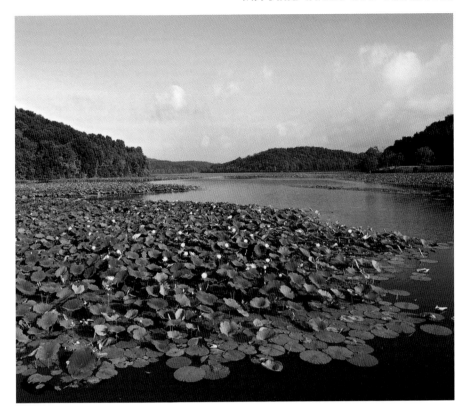

TAPPAN LAKE

State Route 250 hugs the northern shoreline of Tappan Lake, which lies between Uhrichsville and Cadiz in Harrison County. There is a spectacular display of American lotus during July and August at the eastern end of the lake, on either side of the causeway at the north end of Deersville Road (County Highway 55). Another fine stand of American lotus blooms along a northern inlet of Tappan Lake near Lower Clearfork Road (County Highway 22), about a half-mile north of State Route 250. The causeway is also an excellent location for sunrise and sunset photography.

From the village of Deersville, a few miles south of Tappan Lake, County Highway 21 meanders south through farmland to Clendening Lake, Ohio's largest undeveloped lake, with a 43-mile shoreline. State Route 799 skirts the eastern edge of Clendening Lake for several miles, and there are some beautiful vistas along the highway, especially in spring and fall. There is a parking area on the north side of State Route 799 west of the causeway, with a trail

down through the woods to the shoreline, where some large boulders make excellent foregrounds for wide-angle vistas of the lake. Early morning is my favorite time here, especially when mist gathers over the lake. You will probably have the lake to yourself, except for a few fishermen.

Further south, in Guernsey and Noble Counties, is Seneca Lake. The northern and western section of the lake has a developed shoreline, but there are some picturesque areas in the eastern section of the lake, along State Routes 313 and 147, including another large stand of American lotus during midsummer.

Toledo Metroparks, Lucas County

Location: Lucas County. Tel: (419) 407-9700
Website: http://www.metroparkstoledo.com
GPS Coordinates: Multiple sites

Surrounding the city of Toledo are 8,000 acres of metropolitan parks in Lucas County that include scenic stretches of the Maumee River, a famous battlefield, a working canal lock and sawmill, and a large nature preserve harboring more rare and endangered plants than any other area in the Buckeye State.

The Oak Openings Preserve is by far the largest of the Toledo Metroparks, with more than 3,000 acres of oak savanna, barren sand dunes, and tallgrass and wet prairies inhabited by more than a thousand varieties of plants. It's easy to lose your way in this area, so download a trail map from the Toledo Metroparks website before you visit to get a sense of the terrain. Among the most picturesque areas are the sand dunes, just east of Girdham Road, where gnarly black oaks and bracken ferns punctuate the landscape and earthstars, small mushrooms shaped a bit like a starfish, litter the sands in summer. Fall color is excellent here in October, with red maple, sassafras, and black gum highlighting the scene. After rainy periods in summer and early fall, there are many kinds of mushrooms fruiting in the woods that make great close-up subjects.

Side Cut Metropark gets its name from the Side Cut Canal, built in the 1840s to connect the Maumee and Erie Canal with the Maumee River. Several of the original canal locks can be seen here, as well as a pristine stretch of the Maumee River along River Road. There are broad expanses of shallow rock ledges and rapids, known as a riverine alvar, that are quite attractive when the water levels in the river are low, and large numbers of wading birds,

waterfowl, and gulls make this an excellent place for bird photography. Nearby is the site of the Battle of Fallen Timbers, where General "Mad" Anthony Wayne won a decisive victory against the American Indian tribes led by war chief Blue Jacket.

The highlight at Farnsworth Metropark is Roche de Boeuf, where there are splendid views of the rapids of the Maumee River, often frequented by herons, shorebirds, and fishermen when walleye are in season. At Providence Metropark, 8 miles west near Grand Rapids, remnants of the former canal town that existed here include the Isaac Ludwig Mill and a fully operational original canal lock and a mule-drawn replica of a mid-1800s canal boat that are demonstrated by costumed interpreters.

Secor Metropark has an excellent display of dogwood and redbud in spring, as well as a restored tallgrass prairie. Be sure to visit the National Center for Nature Photography, established by ex-Toledo Metroparks public information manager, photographer, and writer Art Weber. There are gallery exhibits of nature photographs by many well-known professional nature photographers, as well as slide programs and photography workshops. The center is open on weekends.

REFERENCES

Adams, I., and J. Fleischmann. 1994. *The Ohio Lands.* San Francisco: Browntrout Publishers. This was my first major photography book on Ohio; it includes more than 200 color photographs taken around the Buckeye State.

Adams, I., and J. Roetzel. 2005. *Cuyahoga Valley National Park.* Rockport, MA: Twin Light Publishers. This book features photographs of the natural areas, wildlife, and historical sites in Ohio's only national park.

Daniels, J. C. 2004. *Butterflies of Ohio Field Guide.* Cambridge, MN: Adventure Publications. This is an excellent, well-illustrated, portable guide to Ohio's butterflies.

Lafferty, M. B., ed. 1979. *Ohio's Natural Heritage.* Columbus: The Ohio Academy of Science. This excellent introduction to the natural history of Ohio is out of print but available on CD. Used print copies can be found at Amazon.com.

McCormac, J. S., and G. Kennedy. 2004. *Birds of Ohio.* Auburn, WA: Lone Pine Publishing.

McCormac, J. S., and G. Meszaros. 2009. *Wild Ohio: The Best of Our Natural Heritage.* Kent, OH: Kent State University Press. Forty of Ohio's best natural areas, described concisely by one of Ohio's best field naturalists and illustrated with fine photography by Gary Meszaros.

ODNR Division of Natural Areas and Preserves. *Directory of Ohio's State Nature Preserves*. This is a spiral-bound notebook with a description of Ohio's 121 state nature preserves, plus maps and directions for the preserves that are open to the public.

82

Ostrander, S., ed. 2001. *The Ohio Nature Almanac*. Wilmington, OH: Orange Frazer Press. This is a monumental book (550 pages), full of useful information about all things natural in Ohio.

Platt, C., and G. Meszaros. 1998. *Creatures of Change: An Album of Ohio Animals*. Kent, OH: Kent State University Press.

Rosche, L., and J. Semroc. 2008. *Dragonflies and Damselflies of Northeast Ohio*. Cleveland: Cleveland Museum of Natural History. This incredibly detailed and well-illustrated book covers more than 80 percent of Ohio's dragonflies.

Studebaker, M. 2007. *A Guide to Ohio's Best Places for Bird Photography* (A Birds as Art Site Guide): http://www.birdsasart.com/siteguides.htm. This is a useful guide to Buckeye State hot spots for bird photography, written by an expert Ohio bird photographer.

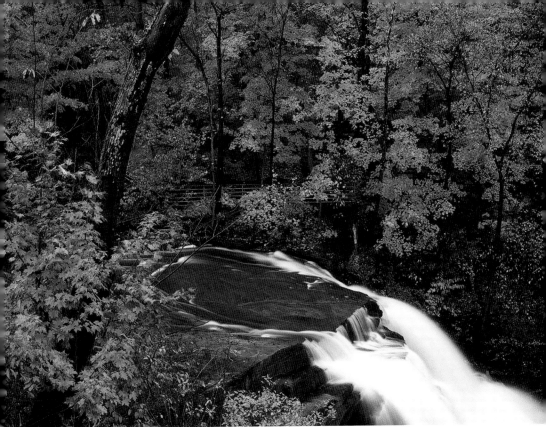

Waterfalls

For most photographers, waterfalls hold a special allure. The challenge of finding them, the anticipation as the sound of the falls signals its appearance around the next bend in the trail, and the beauty of the falling water all enhance the photographic experience. Waterfalls provide a measure of relaxation and rejuvenation; they are refreshing retreats from today's fast-paced, high-tech world.

In comparison with the majestic cascades of the Appalachian and Rocky Mountains and those of the Pacific Coast states, Ohio's waterfalls are modest in size but often more intimate. A few in the state attain a height of 50 to 60 feet, but 15 to 25 feet is much more common. Most of Ohio's waterfalls are

83

BRANDYWINE FALLS, CUYAHOGA VALLEY

concentrated in the hillier, more rugged terrain of northeast, southeast, and southwest Ohio. There are few waterfalls in northwest Ohio and only a handful in central Ohio.

Tina Karle, an Ohio waterfall aficionado, has identified several hundred waterfalls in the Buckeye State, and her books, 200 *Hikeable Waterfalls of Ohio* and 70 *Waterfall Hikes around Dayton, Ohio*, both published by www .lulu.com, are indispensable aids to locating Ohio waterfalls. Another valuable resource is a website, *Great Lakes Waterfalls and Beyond* (http://gowaterfalling. com), which lists twenty-one of Ohio's major waterfalls. Note that the GPS coordinates latitude and longitude listed for each Ohio waterfall on this website, and in this book, are in decimal degrees, whereas those given in Karle's Ohio waterfall books are expressed in degrees, minutes, and decimal minutes.

TIPS ON PHOTOGRAPHING WATERFALLS

Spring, fall, and winter are generally the best seasons for waterfall photography in Ohio. Most waterfalls are in heavily wooded areas, and dense foliage often blocks the view of waterfalls and creates high-contrast lighting in summer. Spring and fall provide more open lighting and more attractive foliage on trees and shrubs surrounding the waterfall. Winter can also be a great time for waterfall photography, especially when the waterfall is partially frozen, and icicles have formed on the rocks. More information on photographing icicles in Ohio is included at the end of this chapter.

In late summer and early fall, many smaller Ohio waterfalls are virtually dry, making photography less attractive. An equally challenging situation is when an unusually large volume of water is roaring over a falls after a period of heavy rain. These torrential conditions obliterate the delicate details of the waterfall and render the water muddy and unattractive. Occasionally, you may wish to photograph a swollen waterfall to convey a sense of nature's power.

I generally prefer cloudy or partly cloudy lighting when photographing waterfalls, which are inherently "contrasty" subjects that display a broad range of tonality, from bright highlights in the white areas of the water to inky black hues in the shadows. This contrast increases dramatically on sunny days, making it hard to retain detail in highlights and shadows. Bright sunlight also creates patterns of light and shade that amplify the visual complexity of the waterfall and make it much harder to create strong compositions.

Damp days can be great for waterfall photography. Gentle showers or drizzle help to lower contrast and increase color saturation. This is especially true for sedimentary rocks, such as sandstone, limestone, or shale, which can be quite bright when dry. A thin coating of water reduces the reflectance of these rocks by several f/stops, allowing more of the rock's natural color and texture to emerge.

Judging the correct exposure for a waterfall photo can be tricky, but the availability of in-camera histogram displays allows you to fine-tune your exposure. Be sure to "expose to the right," avoid clipping highlight and shadow detail, and shoot in raw file mode to maximize the dynamic range of the photograph and provide the most flexibility to fine-tune the tonality and color of your waterfall photos later on your computer.

Use a fast shutter speed to convey power and freeze movement in the water and slower shutter speeds to portray movement. Shutter speeds of 1/250 second or faster will freeze the water, and speeds of 1/30 or 1/60 second render the waterfall much as the eye perceives it. Shutter speeds of 1/15 second or slower result in a definite sense of movement in the image, and with slow shutter speeds of several seconds, the water becomes ethereal and some of the delicate textural detail may be lost. I generally prefer to use shutter speeds of ¼ second to 2 seconds for waterfall photography, which preserves most of the textural details of the falls but imparts a little movement to the water — a nice contrast with the harder, more angular shapes of rocks, tree trunks, and foliage. Bracket your exposures, varying the shutter speed, so you can choose the frame that provides the most pleasing rendition of the water. Of course, with a digital camera you can examine the images on your camera's LCD and adjust the shutter speed to taste. A sturdy tripod and a cable release are prerequisites for sharp photographs at slow shutter speeds.

A circular polarizing filter is a useful accessory when photographing waterfalls. A polarizer can be used to minimize or eliminate specular reflections from wet rocks and increase color saturation. Also, because polarizing filters require an exposure increase of 1 to 2 f/stops, they can also serve as neutral-density filters and facilitate the use of slower shutter speeds to emphasize movement in the water. Because the lowest ISO setting on most digital cameras is 200 or 100, it may be difficult to use slow shutter speeds without overexposing the waterfall, especially on bright days, so carry a polarizing filter when you're photographing waterfalls.

On a cautionary note, remember that waterfalls can be slippery, hazardous places, where a false step can result in a serious injury . . . or worse! Please exercise great care when hiking near waterfalls, and resist the temptation to climb on wet rocks to gain a better viewpoint. When working close to a falls, be sure to check the front of your lens for water droplets from time to time before taking pictures.

The following section describes fifteen of Ohio's largest and most photogenic waterfalls.

Ash Cave, Hocking Hills State Park

Location: The parking area for Ash Cave is on State Route 56, about half a mile west of State Route 374 in the Hocking Hills south of Logan. From the parking area, a paved quarter-mile handicapped-access trail goes north to Ash Cave.
Height: 90 feet
GPS Coordinates: 39.396N 82.546W

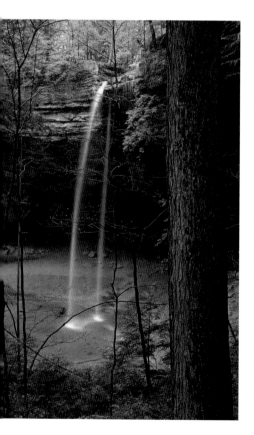

The Hocking Hills has one of the largest concentrations of waterfalls in the Buckeye State, and scores of torrents cascade over the sandstone cliffs in the gorges after a heavy spring rain. Ash Cave is a huge sandstone recess, 700 feet across and almost 100 feet tall, and the waterfall plummets 90 feet from the lip of the overhang. Nearby are large sandstone boulders and some of the tallest hemlock trees in Ohio. In dry weather, the waterfall virtually disappears, but in cold winters with plenty of precipitation, the waterfall sometimes freezes to form a solid column of ice stretching from the ground to the lip of the overhang. Ash Cave is named for the piles of ash found here by early settlers, left by Native Americans who used the cave as a shelter.

You will need a wide-angle lens to capture the waterfall and cave in its entirety, and there are many good angles, including an excellent

ASH CAVE WATERFALL, HOCKING HILLS

vantage point on the hillside just south of the falls, where you can include the giant hemlock trees to provide a sense of scale. Another trail climbs up the eastern side of the cave and circles the cave to the west, where there is a view looking down on the falls from the trail, which hugs the edge of the overhang (be careful—don't get too close to the edge!). Dwarf-crested iris and other wildflowers bloom along the trails in spring, and the songs of migrating black-throated green, parula, and other wood warblers can be heard in the forest.

Great Falls of Tinker's Creek, Viaduct Park, Bedford

Location: In Viaduct Park, at the junction of Willis Street and Taylor Road in Bedford, south of Cleveland in Cuyahoga County. Viaduct Park is part of Bedford Reservation in the Cleveland Metroparks. A paved quarter-mile trail leads from the parking lot to a viewing area above the falls.

Height: 15 feet

GPS Coordinates: 41.38361N 81.5325W

Tinker's Creek, a tributary of the Cuyahoga River, flows through a rocky gorge before vanishing into a tunnel through an arch under an 1865 viaduct en route to Tinker's Creek Gorge in Bedford Reservation. Scattered in the area are the ruins of a small nineteenth-century town that grew up near Tinker's Creek. Great Falls is an attractive waterfall; it's only 15 feet high but nearly 80 feet across during high water. There is some pollution in Tinker's Creek due to its urban setting, but this does not diminish the scenic value of the waterfall and its historic setting.

An overlook provides striking views from the top of the falls, and it is possible to scramble down the rocks to the base of the waterfall, where you can use the rocks as foreground elements for wide-angle views of the falls or use a longer lens to isolate sections of this wide cascade. In nearby Bedford Reservation, another scenic waterfall, Bridal Veil Falls, is well worth a visit.

GREAT FALLS—TINKER'S CREEK

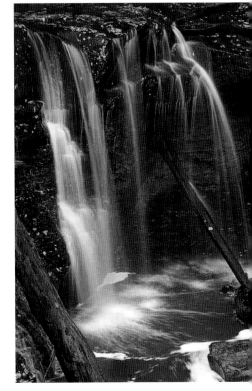

Blue Hen Falls, Cuyahoga Valley National Park

Location: Near Boston Mills Road about 1 mile west of Riverview Road in the Cuyahoga Valley National Park, between Cleveland and Akron.

Height: 20 feet

GPS Coordinates: 41.25833N 81.57306W

Blue Hen Falls is a charming cascade in a peaceful, picturesque setting in the heart of the 33,000-acre Cuyahoga Valley National Park in northeast Ohio. From the parking area, a short trail winds down through the forest, crosses a footbridge, and continues to a fenced viewing area overlooking the falls. The falls tumble over a Berea sandstone overhang into a plunge pool 20 feet below, where the less-resistant Bedford shale is being slowly eroded away. Downstream are large sandstone boulders that are covered in red, orange, and yellow maple leaves in early fall. These leaf-covered rocks and nearby ferns make an attractive foreground for wide-angle views of the falls from below, and the viewing area above the falls offers many additional angles. This waterfall is at its best after rain has increased the volume of water in the creek above the falls.

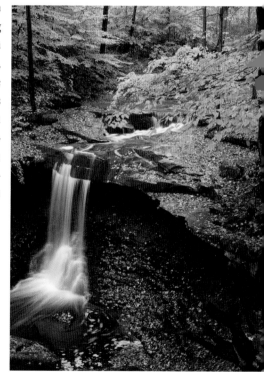

The late Ohio Congressman John Seiberling, who worked long and hard to establish the Cuyahoga National Recreation Area in 1975, once posed for a portrait below Blue Hen Falls, which he told me was his favorite place in the Cuyahoga Valley. The trail continues downhill along Spring Creek for half a mile to a larger waterfall, Buttermilk Falls, on the grounds of the Boston Mills Ski Resort.

BLUE HEN FALLS

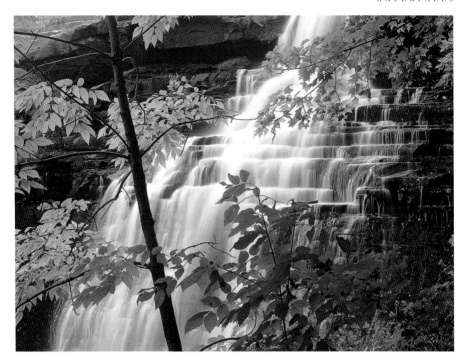

BRANDYWINE FALLS

Brandywine Falls, Cuyahoga Valley National Park

Location: On Brandywine Road near Interstate 271, south of Northfield Center Township
 in the Cuyahoga Valley National Park between Cleveland and Akron.
Height: 60 feet
GPS Coordinates: 41.27694N 81.53833W

Brandywine Falls is one of the tallest and most impressive waterfalls in the state and a favorite destination for visitors to Cuyahoga Valley National Park. From a large parking area on Stanford Road, an elevated boardwalk follows the south rim of the gorge along Brandywine Creek to a fine view of the falls, and steps lead down to another boardwalk leading to a viewing area opposite the middle section of the falls. At the top of the falls are the ruins of a mill, one of several built near the falls during its heyday as the centerpiece of Brandywine Village, which was established during the early 1800s. Nearby is the Inn at Brandywine Falls, a historic Greek Revival farmhouse, where hosts George and Katie Hoy offer comfortable lodging and serve delicious breakfasts with liberal helpings of local lore and George's humorous poems.

89

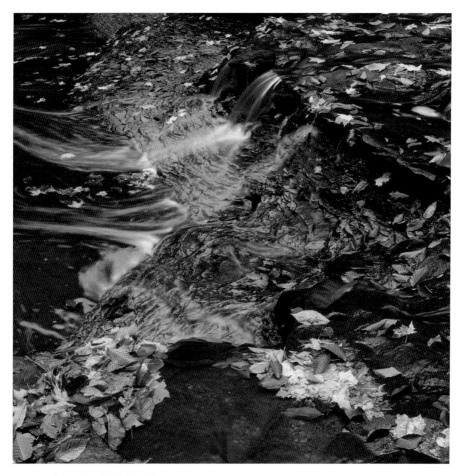

BRIDAL VEIL FALLS

Fall color can be spectacular in this area, and there are many viewpoints on both sides of the falls where red maples and other trees with attractive autumn foliage can be used to frame views of the cascades. Brandywine Falls is a popular setting for wedding-party photography and can be quite crowded on weekends during summer and fall, so try to visit during the week or early in the morning if you want to experience the falls without plenty of company. The falls face west and are shaded in early morning, and cloudy days, misty days, or late evenings on sunny days provide the best lighting for photographing this imposing waterfall.

Bridal Veil Falls, Bedford Reservation

Location: On Gorge Parkway 1.4 miles northwest of Egbert Road and about 1 mile east of
 Overlook Lane in Bedford Reservation south of Cleveland.

Height: 30 feet

GPS Coordinates: 41.3732N 81.549W

From the Bridal Veil Falls parking area in Bedford Reservation, a wooden staircase leads downhill to a footbridge over the top section of Bridal Veil Falls, which tumbles over a short, steep section of Bedford shale, followed by a slide down a 30-foot shale ramp and another steep drop as the stream works its way down the hillside in the Tinker's Creek Gorge, a National Natural Landmark. Several overlooks provide vantage points along each section of this charming cascade. In fall, golden foliage alongside the stream is mirrored in the pools above the falls, which is lined with hemlock trees. In addition to wide-angle vistas of the entire waterfall, try using a telephoto lens/zoom to isolate some of the swirls and leaf patterns below the top section of the falls. Wet weather provides the volume of water needed to enjoy this falls, which can virtually disappear in dry summers.

Nearby along Gorge Parkway, and described elsewhere in this book, is the Tinker's Creek Gorge Overlook, one of the finest natural vistas in the Buckeye State.

East and West Falls of the Black River, Elyria

Location: The West Falls are at the south end of Cascade Park and can be reached by a
 1.2-mile trail that is partly paved and leads to an observation deck. The East Falls are
 a mile away, near Lake Avenue, and can be viewed from an observation area close to
 the Elyria Police Station.

Height: Both about 40 feet

GPS Coordinates: 41.3691N 82.1073W (East Falls)
 41.3719N 82.1120W (West Falls)

Two of Ohio's largest waterfalls are on the Black River in the industrial town of Elyria, about 30 miles west of Cleveland. Next to the East Falls are the ruins of a hydroelectric plant operated in the 1920s by the Elyria Milling and Power Company. Cascade Park has a number of trails with impressive rock formations along the Black River. Both falls are close to buildings in an urban setting, and there is usually debris floating in the water below each of the falls. During cold winters, the falls freeze; the frozen columns and nearby icicles can be interesting subjects for photography. To my eye, the West Falls is the more photogenic of these two urban cascades.

Cedar Falls, Hocking Hills State Park

Location: In Hocking Hills State Park near State Route 374, between State Route 664
(Old Man's Cave) and State Route 56 (Ash Cave) about 12 miles southwest of Logan.
Height: 50 feet

GPS Coordinates: 39.41944N 82.52361W

Cedar Falls is one of the most popular destinations for visitors to the Hocking Hills in southeast Ohio. There is a large parking area nearby, and several trails lead down the wooded hillside to Queer Creek, which flows west towards Old Man's Cave after cascading over Cedar Falls. The top section of the falls splits into two streams of water that rejoin before a final plunge into a pool surrounded by a wide sandy area, where visitors gather for an excellent view of the waterfall. Early settlers misnamed Cedar Falls; most of the large trees nearby are eastern (Canadian) hemlocks. A few hundred yards north of the falls, along State Route 374, The Inn at Cedar Falls provides luxury cabin and cottage accommodations and fine dining in an 1840s log-cabin restaurant.

A short trail from State Route 374 ends at the top of the falls—an excellent vantage point for photography. Below the falls, the footbridge over Queer Creek is a good viewpoint, and from there you can include a section of the creek in your photograph. Cedar Falls is in shade early and late on sunny days, but a

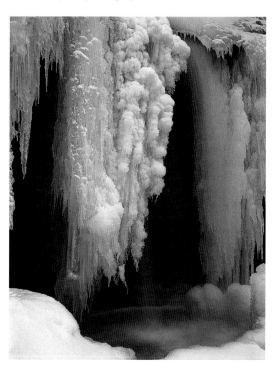

cloudy day provides the most even lighting for photography. As well as head-on views taken from the beach directly in front of the falls, try some wide-angle views from the rock walls on either side of the waterfall. The area around the base of Cedar Falls gets terribly crowded at weekends, so visit quite early if you want to enjoy a little solitude with your photography. Another way to escape the crowds is to hike the trail along Queer Creek, which flows for several miles west of Cedar Falls through a rocky gorge with large hemlocks to Old Man's Cave.

CEDAR FALLS

Chagrin Falls

Location: On Main Street in the village of
 Chagrin Falls, about 18 miles east of Cleveland.
Height: 20 feet
GPS Coordinates: 41.43111N 81.3925W

This attractive waterfall is smack-dab in the center of Main Street, Chagrin Falls, in the eastern suburbs of Cleveland. A wooden staircase descends from the street to a viewing area close to the waterfall. When you have viewed the waterfall, you can savor a cup of coffee at Starbucks or ice cream at the Chagrin Falls Popcorn Store, both located next to the falls, or enjoy a meal at one of several cafes and restaurants along Main Street. Chagrin may be named for a French trader, Sieur de Saguin, or it may stem from "Sha-ga-rin," an Erie Indian name for "Clear Water."

The viewing area near the falls is a good vantage point for photography, or you can scramble down to the base of the falls and include some of the rocks below the cascade or the bridge on Main Street above it in your photograph. The falls face west, so afternoons usually provide the best lighting.

CHAGRIN FALLS

Charleston Falls, West Charleston

Location: In West Charleston, on Ross Road between State Route 202 and the Great
 Miami River.
Height: 37 feet
GPS Coordinates: 39.919633N 84.147469W

Charleston Falls is an attractive falls in a scenic 216-acre preserve a few miles north of Interstate 70 northeast of Dayton. The falls are best visited after a good rain, preferably in spring, when there are redbud and dogwood trees in bloom in the surrounding woodlands. A viewing area overlooks the falls, or you can hike down into the limestone cove to view the falls from several vantage points below the cascade.

CHARLESTON FALLS

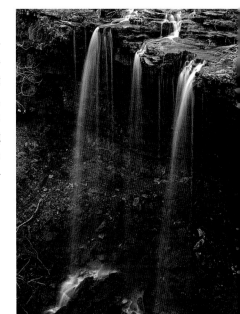

Columbia Road Park Falls, Bay Village

Location: Along the Lake Erie shoreline, in a small
 beach park near the intersection of Columbia Road
 (State Route 252) and Lake Road (State Route 6)
 in Bay Village, about 12 miles west of Cleveland.
Height: 25 feet
GPS Coordinates: 41.4866N 81.9016W

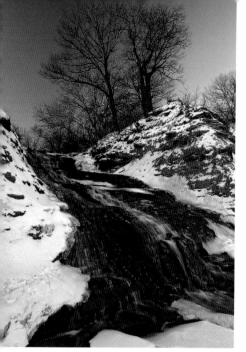

COLUMBIA FALLS

I discovered this delightful waterfall a couple of years ago while visiting my niece and her husband at their home in Bay Village in Cleveland's western suburbs. From a parking area at the intersection of Columbia Road and Lake Road, a short path leads to a stairway down to a beach and the waterfall, which cascades over the shale cliffs that flank the shoreline of Lake Erie in this area. I first visited the falls in January, when snow covered the ground around the falls, which were partly frozen and extremely photogenic.

There is a viewing area at the top of the falls, but the best vantage point for photography is the beach near the base of falls, which face Lake Erie to the north. A clear blue sky makes a wonderful background for photographs of this waterfall, preferably early in the morning or late in the afternoon so you will not be shooting directly into the sun.

Hayden Run Falls, Columbus

Location: In Griggs Reservoir Park near Hayden Road in the western suburbs of Columbus
 near the Scioto River.
Height: 25 feet
GPS Coordinates: 40.067228N 83.110201W

There are only a few waterfalls in the Columbus area, and Hayden Falls is the largest and most attractive, a 25-foot falls in a secluded limestone gorge south of Dublin. From a parking area on the south side of Hayden Road just west of the bridge over the Scioto River, a stairway leads down into the gorge, where a trail takes you to a boardwalk and viewing area near the base of the falls. You can photograph the waterfall head-on from the viewing area, but I prefer the view from the rocks near the cliffs to the right of the falls. During

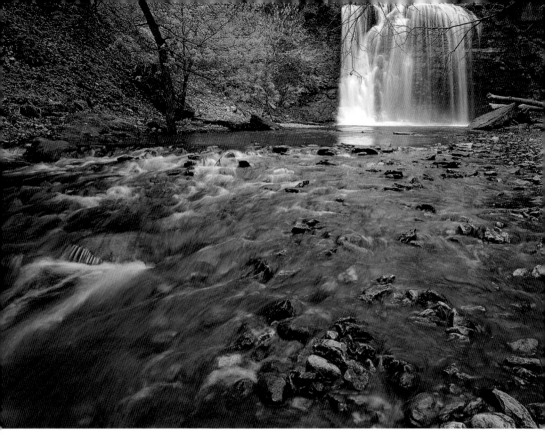

summer droughts, most of the waterfall dries up, except for a small ribbon of water on the left of the falls.

North of Hayden Run, in Dublin, is another 20-foot waterfall, Indian Run Falls, also known as Shawan Falls, located in a park on Shawan Falls Drive.

Ludlow Falls

Location: On State Route 48 in Ludlow Falls, about 20 miles north of Dayton
Height: 25 feet
GPS Coordinates: 39.998N 84.3374W

Ludlow Falls is the best-known waterfall in the Stillwater River area north of Dayton in western Ohio. Several tributaries of the Stillwater River have cut their way through the limestone rock in this region, resulting in numerous waterfalls. In winter, visitors come from miles around to enjoy the spectacle

95

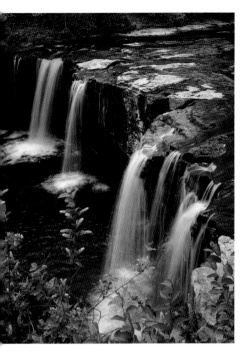

LUDLOW FALLS

of Ludlow Falls festooned in thousands of Christmas Lights. The lighting display began years ago as a Boy Scout project, but today the event is used as a fundraiser for the village fire department; they spend weeks stringing the lights under and around the waterfall.

There is a parking area on the west side of State Route 48, with a path that leads to the north side and a good view of the falls. A set of concrete steps leads down to the edge of Ludlow Creek below the falls. On sunny days when the sun is high, the shadows of the State Route 48 bridge are superimposed on the falls, so visit the falls on a cloudy day or early on a sunny day to avoid this hindrance.

Mill Creek Falls, Garfield Heights

Location: Near Warner Road in the village of
 Garfield Heights south of Cleveland.
Height: 48 feet
GPS Coordinates: 41.44528N 81.62528W

One of Ohio's most impressive waterfalls can be found along Mill Creek, less than 6 miles south of Public Square in downtown Cleveland. Mill Creek is the second-largest tributary of the Cuyahoga River, and Mill Creek Falls is the largest waterfall in Cuyahoga County. The area around the falls is now managed as a park by the Cleveland Metroparks, and a parking area and the Mill Creek Falls History Center are located near Warner Road in Garfield Heights. This waterfall is also known as Cataract Falls. The Mill Creek Falls History Center, in the historic Brilla House near the falls, is also the home of the Slavic Village Historical Society, which preserves the culture of Slavic Village in the Newburgh Township area.

The main viewing area above the falls provides an attenuated view of the cascade, and a more distant overlook closer to the parking area offers a different angle. It is possible to scramble down into the gorge for a more head-on view of Mill Creek Falls, but signs along the rim of the gorge discourage this practice.

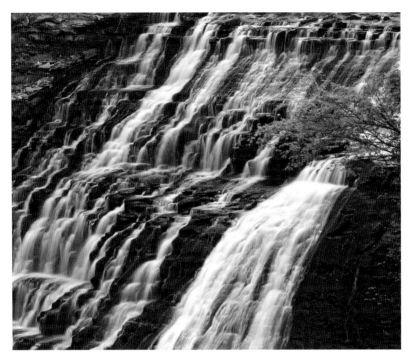

MILL CREEK FALLS

Upper and Lower Falls, Old Man's Cave, Hocking Hills State Park

Location: Near State Route 664, about 10.5 miles southwest of State Route 33 near
 Logan.
Height: 15–50 feet
GPS Coordinates: 39.4346N 82.5416W

The Old Man's Cave area is the most popular destination in Hocking Hills State Park, and after a heavy spring rain, there are probably more waterfalls here than in any other place in Ohio. In addition to several main waterfalls, dozens of smaller torrents cascade over the steep sandstone cliffs along the gorge that is the main feature of this area. But during periods of summer drought most of the waterfalls are dry or reduced to a trickle.

From the north end of the main parking area, walk across the road to the head of the gorge, where the stream flows over a small falls, under a stone bridge, and over the Upper Falls, which are about 25 feet high. The trail descends to a beach and a pool below the falls, then follows the gorge, crossing the

97

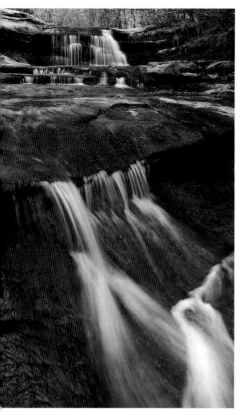

stream several times and passing a whirlpool called the Devil's Bathtub on its way to Old Man's Cave, which is an overhanging sandstone recess 120 feet high, 200 feet across, and 90 feet deep. There is a small waterfall below the cave, which is named for Richard Roe, a fugitive from West Virginia who lived here following the Civil War. You can follow a trail that returns to the parking area from the cave, or continue downstream over a bridge and through a tunnel to the 40-foot Lower Falls, flanked by huge boulders that were created when a section of the cliff face collapsed. From here, the trail continues for several miles along Queer Creek to Cedar Falls, or you can return to the visitor center by a steep trail that ascends some steps and leads through a tunnel high on the cliffs.

You can easily spend a day exploring and photographing the waterfalls, hemlock trees, and rock formations in this rugged gorge. If possible, try to avoid weekends, when the area can be crowded, and pick a cloudy, damp day to avoid contrast problems.

UPPER FALLS, OLD MAN'S CAVE

West Milton Falls, Miami County

Location: Behind the Kitchen and Bath Store at the northeast corner of the junction of
State Route 571 and State Route 48 in West Milton, about 16 miles NNW of Dayton.
Height: 20 feet
GPS Coordinates: 39.9648N 84.3278W

This beautiful waterfall is tucked away behind a furniture store in the center of West Milton. A gazebo near the parking area provides a view of the falls, or you can walk down some concrete steps to another viewing area close to the lower section of the falls, which face east. The limestone rock is quite slippery when wet, so watch your footing if you venture onto the rocks below the falls.

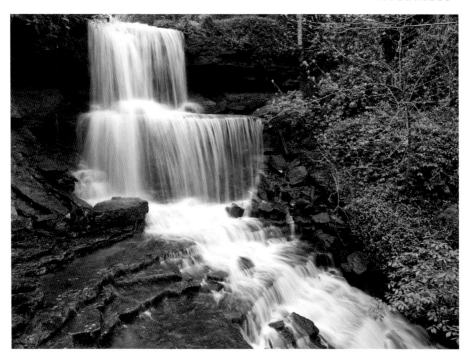

WEST MILTON FALLS

PHOTOGRAPHING ICICLES AND FROZEN WATERFALLS

In midwinter each year, I join a group of intrepid photography enthusiasts for an exciting hike into the icy depths of Stebbins Gulch at the Holden Arboretum in northeast Ohio's Lake County. Stebbins Creek flows through the gulch over a series of small waterfalls, and the gorge is lined with steep cliffs up to 75 feet high. During cold winters, the waterfalls are partially or completely frozen, and icicles up to twenty feet in length hang from the sandstone cliffs along the edge of the gorge. If the conditions are right, Stebbins Gulch is transformed into a winter wonderland for snow and ice photography.

In Ohio, January and February usually offer the best conditions for photographing icicles and frozen waterfalls. Because icicles form on overhanging cliffs, gorges with extensive rock outcroppings are the best places for icicle photography. My favorite icicle locations in Ohio include the Cuyahoga River Gorge in my hometown of Cuyahoga Falls, the Cleveland and Summit County

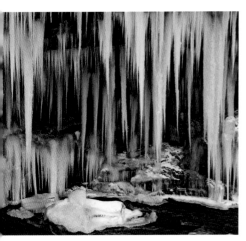

ICICLES, CUYAHOGA RIVER GORGE

(Akron) Metroparks, Mill Creek Park near Youngstown, Stebbins Gulch at the Holden Arboretum, and the Hocking Hills in southeast Ohio.

The Cuyahoga River Gorge has a spectacular display of icicles, some of which can be seen from observation platforms at the Sheraton Suites Akron/Cuyahoga Falls, located in downtown Cuyahoga Falls at 1989 Front Street. Next to the hotel, Highbridge Glens Park includes a newly renovated observation bridge over the river and a walkway to a viewing area halfway down the cliffs opposite the main display of icicles, which hang from the steep cliffs directly under the Route 8 expressway next to the river. Some of the icicles are brown from mineral deposits leaching out of the cliffs.

The deep gorges at Cedar Falls and Old Man's Cave in the Hocking Hills can also be great places to photograph icicles and frozen waterfalls if conditions are right. The trails here can be extremely icy in winter, so be sure to wear Yaktrax or similar devices on your hiking boots to help maintain your footing.

Unlike ice on Lake Erie and other open bodies of water, which can be photographed well on sunny days, icicles and frozen waterfalls are usually best photographed on overcast days, when the diffuse light from the cloudy sky minimizes the contrast in gorges. The visual complexity of most icicle formations is rarely enhanced by direct sun, which creates bright highlights and deep shadows with a dynamic range that can be hard to capture, even with the latest digital camera technology. The use of bracketed raw exposures and High Dynamic Range software, such as Photomatix, can be helpful when photographing icicles, even on cloudy days.

Finally, remember that icicles can fall—don't stand directly under them!

REFERENCES

Great Lakes Waterfalls and Beyond: http://gowaterfalling.com.
Karle, Tina M. 200 *Hikeable Waterfalls of Ohio*: available at www.lulu.com.
——. 70 *Waterfall Hikes around Dayton, Ohio*: available at www.lulu.com.

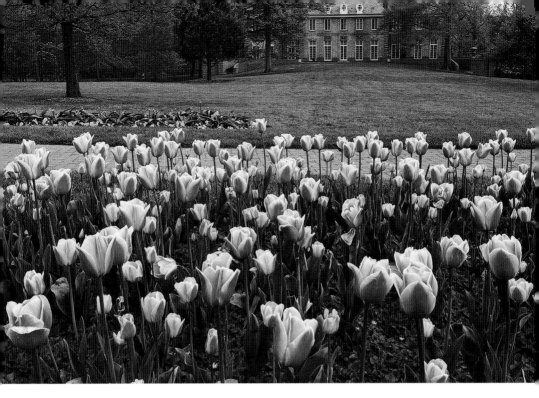

Public Gardens and Arboretums

I have a special fondness for Ohio's public gardens and arboretums. Many of the photographs I have taken in these horticultural havens have appeared in Browntrout's *Wild & Scenic Ohio*, *Ohio Nature*, and *Ohio Places* calendars, and four institutions—Stan Hywet Hall and Gardens, the Holden Arboretum, Cleveland Botanical Garden, and the Ohio Governor's Residence and Heritage Garden—have honored me with commissions to produce photographs for exhibit-format books that celebrate the history and beauty of these gardens. Another of my books, *The Art of Garden Photography*, includes many photographs taken in Ohio's public gardens and arboretums over the past twenty years.

Ohio's public gardens and arboretums are facing financial challenges during the current economic recession, and a few are struggling to survive. Some have already been forced to lay off staff and cancel major events and other

101

KINGWOOD CENTER—TULIPS

activities. If you value the beauty, serenity, and educational and photographic opportunities these horticultural havens provide, there are many ways you can help them weather the current economic climate. Become a member, attend events, volunteer your services, or make a donation. Each of these contributions will help Ohio's public gardens and arboretums endure and continue to be an inspiration for future generations of Ohioans.

GARDEN PHOTOGRAPHY TIPS

The Art of Garden Photography provides detailed instruction on every aspect of the art and craft of garden photography. The following summarized tips and guidelines will help you maximize your photographic opportunities when you visit Ohio's public gardens and arboretums.

Before you go to a garden, it pays to do some planning. Check out the garden's website to get an idea of the lay of the land, the hours the garden is open, and the plants likely to be in bloom during your visit. Some Ohio public gardens have written policies regarding photography, including restrictions on the use of tripods and how photographs taken at the gardens may be used. These photography rules can usually be found on the garden's website. Some Ohio public gardens are open year-round, whereas others are open during the peak blooming seasons of spring, summer, and fall but close for a few months in winter.

Good lighting is a hallmark of fine garden photography, so be sure to check the weather forecast for the garden's neighborhood on the day you plan to visit. In general, try to avoid the period from midmorning to late afternoon on bright sunny days, when the lighting will be harsh and the garden is likely to be crowded with visitors. In open areas of the garden, early morning and late evening light on a sunny or partly cloudy day, when contrast is lowered and shadows are long, can be quite attractive for garden photography, but you may need permission to access the garden at these times. For close-up photography of flowers, and in wooded areas, the diffuse light from a cloudy sky helps minimize shadows and is my favorite lighting for most of my garden photography.

Always try to eliminate blank white skies from your garden photos; they distract the viewer and are a waste of good picture space. Try shooting from a more elevated viewpoint, or switch your camera from a vertical to a horizontal orientation, or simply lower the camera angle, but purge those blank white skies from your garden photographs.

The first time you enter a garden, pick up a map from the visitor center and devote some time to exploring the garden and getting to know its major features. I like to carry an SLR camera with a wide-angle zoom lens, such as the 16–85mm Nikkor (DX) or the 24–70mm Nikkor (FX), and scout locations for scenic views, attractive combinations of plants, or individual flowers that may be good subjects for close-up photography. When you are composing garden vistas with a wide-angle lens, include strong foreground elements and use paths, fences, walls, or other linear garden features to lead the viewer's eye into the scene. Most public gardens do an excellent job of sweeping paths and removing litter, but you may have to pick up the occasional cigarette butt or candy wrapper prior to taking a photograph. Of course, you can also practice your Photoshop skills by removing these visual distractions electronically, as part of your digital workflow.

Add a 70–200mm telephoto zoom lens to either of the wide-angle zooms listed above and you will be able to cover most of the photo opportunities in a garden, though you may wish to add close-up filters, extension tubes, or a macro lens if you plan to take many close-up portraits of flowers or other subjects. As I've mentioned, I have a strong preference for a 180mm or 200mm macro lens when taking close-ups, and this is also a great lens for photographing butterflies in conservatories, such as those at Cleveland Botanical Garden, Stan Hywet Hall and Gardens, and Franklin Park Conservatory.

A circular polarizing filter is another useful accessory for garden photography, allowing you to minimize or eliminate reflections from the surface of lakes, ponds, or other wet subjects as well as increase color saturation in the photograph. I no longer use warming filters or graduated neutral-density filters when photographing gardens, because the effect of these filters can easily be duplicated, with much more precision, using Photoshop or other image editing software.

Cleveland Botanical Garden

Location: 11030 East Blvd., Cleveland, OH 44106. Tel: (216) 721-1600
Website: http://www.cbgarden.org
GPS Coordinates: 41.5111N 81.6094W

Cleveland Botanical Garden is one of the main attractions of the University Circle area east of downtown Cleveland. The garden, which was founded in 1930, moved to its present Wade Oval location in 1966 and has expanded to 10 acres, including the impressive Eleanor Squire Glass House, which opened in 2003. I have carried out a variety of photography assignments for Cleveland

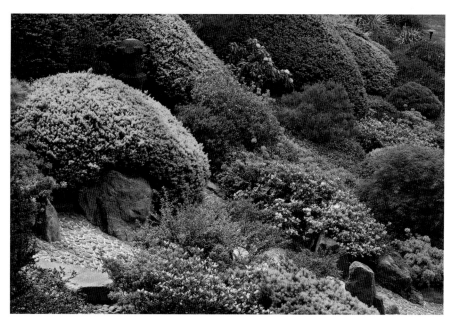

CLEVELAND BOTANICAL GARDEN — JAPANESE GARDEN

Botanical Garden, including a collaboration with Cleveland photographer Jennie Jones and writer Diana Tittle on *A Paradise in the City: Cleveland Botanical Garden* (Orange Frazer Press 2005), which celebrates the seventy-fifth anniversary of the Garden. There is always something in bloom at this multifaceted horticultural oasis, which is open throughout the year.

From mid-April through May, there is a fine bulb display, and white and pink azaleas bloom in late spring in the elegant Japanese Garden, designed by David Slawson. Late May to early June is usually the peak of bloom in the Rose Garden, and at this time every two to three years, the Cleveland Botanical Garden hosts the largest outdoor flower show in the country, inspired by the Chelsea Flower Show held annually by the Royal Horticultural Society in London, England. Other key garden areas include the Western Reserve Herb Society Garden, one of the largest herb gardens in America, a woodland garden, a restorative garden, and several theme gardens that are updated every few years. Want to get great photos of your kids in a garden? Take them to the Cleveland Botanical Garden's Hershey Children's Garden, a delightful place complete with a tree house, worm bin, wetland, and scrounger's garden that help children connect with nature, learn about the importance of plants, and have plenty of fun.

The 18,000-square-foot Eleanor Squire Glass House showcases two unique habitats, the Spiny Desert of southwest Madagascar and the tropical rain forest of Costa Rica. Giant chameleons and several species of native birds roam the Madagascar exhibit, and honeycreepers, red-eyed tree frogs, leaf-cutter ants, and more than twenty kinds of tropical butterflies may be seen in the Costa Rica exhibit. The butterflies are approachable and easy to photograph with a telephoto lens, but tripods aren't allowed in the Glass House because of the narrow walkways. Switch on image stabilization if your camera provides it, set the ISO on your digital camera to 400 or higher, brace yourself or lean against a convenient object, and you should be able to get sharp photos hand-holding your camera in this environment. Because the temperature and humidity in the Glass House are high, you'll need to wait a few minutes after entering the conservatory to allow the condensation on your camera lens to clear.

Cox Arboretum, Dayton

Location: 6733 Springboro Pike, Dayton, OH 45449. Tel: (937) 434-9005
Website: http://www.metroparks.org/Parks/CoxArboretum/Home.aspx
GPS Coordinates: 39.652035N 84.224033W

Cox Arboretum is a 189-acre public garden and park a few miles south of Dayton, founded in 1962 on land donated by the James M. Cox family. The arboretum, which has free admission and is open year-round, was gifted to the Five Rivers (Dayton) Metroparks in 1972.

Major features of Cox Arboretum include a shrub garden in which shrubs are arranged in alphabetical order to make learning about them easier; a children's maze; and herb, perennial, woodland wildflower, and water gardens. There is also a fine rock garden, with a peak blooming period in April and May.

A recent addition to the arboretum is the Butterfly House, which showcases butterflies and moths that are native to southwest Ohio, including painted lady, red admiral, monarch, and several swallowtail species, as well as luna, cecropia, and polyphemus moths. The Butterfly House is open from late June through Labor Day.

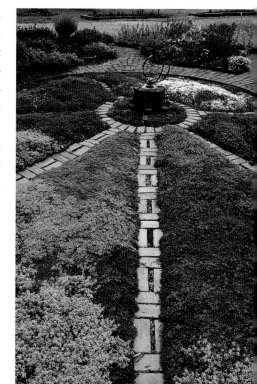

COX ARBORETUM — HERB GARDEN

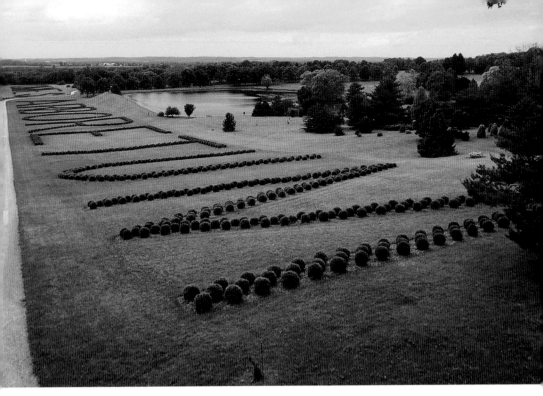

DAWES ARBORETUM — SIGN

Dawes Arboretum, Newark

Location: 7770 Jacksontown Road SE, Newark, OH 43056. Tel: (800) 443-2937
Website: http://www.dawesarb.org
GPS Coordinates: 39.9802N 82.4131W

Dawes Arboretum, 6 miles south of Newark in Licking County, was founded in 1929 by industrialist Beman Dawes and his wife, Bertie. This large arboretum covers 1,800 acres and has 8 miles of hiking trails and a 4-mile auto tour. Admission is free and the arboretum is open year round. I recommend taking the one-way auto tour as a great way to explore the arboretum with minimal effort.

Highlights of Dawes Arboretum, which has more than 15,000 trees and shrubs, include one of the northernmost bald-cypress swamps in North America and a Japanese Garden, established in 1963 to complement the arboretum's extensive Bonsai collection, which numbers over a hundred plants. Several other gardens surround Daweswood House, a restored 1866 Italianate farmhouse that was the summer home of the Dawes family.

At the southeast corner of the arboretum, a 36-foot-high observation tower allows visitors to view a 2,040-foot-long display of hedge lettering that spells

out "Dawes Arboretum." The tower faces west, so mornings will provide the best directional lighting for photographing the hedge lettering.

Fellows Riverside Gardens, Mill Creek Park, Youngstown

Location: 123 McKinley Avenue, Youngstown, OH 44509. Tel: (330) 740-7116
Website: http://www.millcreekmetroparks.org
GPS Coordinates: 41.100643N 80.676734W

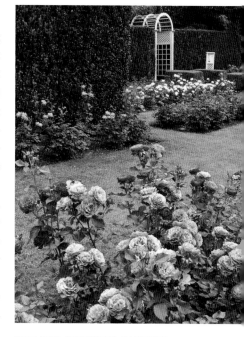

FELLOWS RIVERSIDE GARDENS—
ROSES

Youngstown, in northeast Ohio's Mahoning County, is best known for the steel mills that once dominated the Mahoning River valley in this area, the heart of Ohio's "rust belt." But tucked away in the western suburbs of the city at the northern end of Mill Creek Park is a delightful 10-acre horticultural sanctuary, Fellows Riverside Gardens. Admission is free and the gardens are open dawn to dusk, year-round.

Fellows Riverside Gardens were established on land donated to Mill Creek Park in 1958 by Elizabeth Rudge Fellows, who also left money to establish a free public garden as a " . . . beauty spot for all to enjoy." The new D.D. and Velma Davis Education and Visitor Center offers excellent facilities for visitors, including a horticultural library, art gallery, gift shop, garden café, and an observation deck with a fine view of Lake Glacier in Mill Creek Park.

Highlights for garden photography include seasonal bulb plantings, an ornate gazebo popular with wedding parties, and an extensive modern rose garden that showcases, from June to October, more than 1,300 hybrid tea, floribunda, and grandiflora roses, including the most recent All-America Rose Selection winners.

Franklin Park Conservatory, Columbus

107

Location: 1777 East Broad Street, Columbus, OH 43203. (614) 645-8733
Website: http://www.fpconservatory.org
GPS Coordinates: 39.965858N 82.953098W

Franklin Park Conservatory is a botanical landmark within 88-acre Franklin Park, located a couple of miles east of downtown Columbus. An entrance fee is charged, and the conservatory is open year round.

FRANKLIN PARK CONSERVATORY

Highlights of Franklin Park Conservatory include more than 400 exotic plants from the Himalayas, tropical rain forests, deserts, and Pacific islands. There are also bonsai and orchid collections and a butterfly exhibit during the warmer months. The crown jewel of the conservatory is the Palm House, an 1895 glass building patterned after the Victorian 1893 Chicago Columbian Floral Exhibition. The Palm House displays forty-three species of palms from around the world, including many rare and endangered species, and a fiddle-leaf fig that is more than 110 years old. A large collection of Dale Chihuly glass artwork is on permanent display inside the conservatory.

In Franklin Park, a variety of botanical gardens with sculptures, flowering trees and shrubs, conifers, and seasonal displays of annual and perennial plants surround the conservatory. During the Christmas holiday season, Franklin Park has a lighting show and a display of more than a hundred varieties of poinsettias.

Gardenview Horticultural Park, Strongsville

Location: 16711 Pearl Road, Strongsville, OH 44136. Tel: (440) 238-6653
Website: http://dir.gardenweb.com/
 directory/ghp/
GPS Coordinates: 41.296326N
 81.832445W

Many of Ohio's well-known public gardens and arboretums were endowed by wealthy families or individuals, but Gardenview Horticultural Park in Strongsville, about a half-hour drive southwest of Cleveland, has much more humble origins. Gardenview is the brainchild of Henry Ross, a master gardener with no money but a passion for plants and a fierce determination to create a beautiful English cottage garden in northeast Ohio.

GARDENVIEW, STRONGSVILLE — IRIS

INNISWOOD METRO GARDENS — OAK TREE AND TULIPS

After visiting country gardens in England, Ross carried out a single-handed transformation of 6 acres of vacant land into a magnificent garden that *Horticulture* magazine described in a 2004 article as one of the ten most inspirational gardens in America. Gardenview is open on weekends and by appointment, from April to mid-October. A nominal entrance fee is charged, and donations to the endowment fund that is the only source of funding for Gardenview will be gratefully accepted. You can tour the gardens on your own or join Henry Ross for a guided tour.

Spring is the best season to visit Gardenview, where the emphasis is on rare and unusual plants—especially those with variegated, gold, or silver foliage. Although you can find beautiful vistas in this garden, the creative combinations of plants with unusual textures, flower color, and foliage are the main focus for photography here, so bring your close-up gear or macro lens and explore the myriad of opportunities for close-up photography in this unusual and beautiful cottage garden.

Inniswood Metro Gardens, Westerville

Location: 940 South Hempstead Road, Westerville, OH 43081. Tel: (614) 895-6216
Website: http://www.inniswood.org
GPS Coordinates: 40.102606N 82.897861W

Sisters Grace and Mary Innis donated their 37-acre estate to the Franklin Metro Parks in 1972, and Inniswood Metro Gardens has since blossomed into a 121-acre garden, located in the eastern suburbs of Columbus. Entrance is free, and the gardens are open throughout the year.

KINGWOOD CENTER — REDBUD

During April and May, there is a fine display of native wildflowers and shrubs, along with daffodils, tulips, and annuals. Later in the year, the rose, herb, and woodland rock gardens offer additional photo opportunities. A recent addition to Inniswood is the 2.8-acre Sisters Garden, which honors the memory of Grace and Mary Innis by celebrating the complexity of nature and the natural curiosity of children.

Kingwood Center, Mansfield

Location: 900 Park Avenue West, Mansfield, OH 44906. Tel: (419) 522-0211
Website: http://www.kingwoodcenter.org
GPS Coordinates: 40.760361N 82.549008W

Kingwood Center is the 27-acre former estate of industrialist Charles King, ex-president of the Ohio Brass Company. The estate is located 2 miles west of downtown Mansfield in north-central Ohio. The garden is open spring through fall but closed due to funding limitations during the winter. There is a small admission fee.

My favorite time of year to visit Kingwood Center, one of Ohio's premier public gardens, is in early spring, when the woodlands near the mansion house are filled with crocuses, daffodils, and gladioli. Later in spring, tens of thousands of tulips blossom in the flowerbeds around the mansion, and hundreds of shrubs bloom around the gardens.

Kingwood Center has an extensive display of perennials, a rose garden, a woodland shade garden with many varieties of hostas, and a charming herb garden near an *allée* that leads to a fountain. An ornamental pond harbors several species of waterfowl, and peacocks stroll the grounds. Extensive collections of irises and daylilies bloom in early summer.

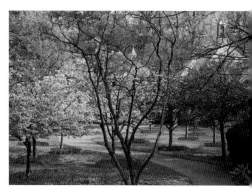

KINGWOOD CENTER—CRABAPPLES

The 1926 manor house makes a good backdrop for many of the garden vistas, and inside is an unusual collection of lifelike ceramic mushrooms.

Krohn Conservatory, Eden Park, Cincinnati

Location: 1501 Eden Park Drive, Cincinnati, OH 45202. Tel: (513) 421-5707
Website: http://www.cincinnatiparks.com/krohn-conservatory/index.shtml
GPS Coordinates: 39.115455N 84.49038W

Krohn Conservatory, located in Eden Park just east of downtown Cincinnati, was built in 1933 during the height of the Art Deco era. Inside the conservatory are Palm, Tropical, Desert, and Orchid Houses, containing more than 35,000 plants from all over the world.

A beautiful 20-foot waterfall is the centerpiece in the Palm House. Outside the conservatory is a floral clock that really works, and nearby is a 172-foot-high stone water tower that makes a great background for the daffodils and tulips that carpet this area in spring. Krohn Conservatory is open every day of the year and admission is free.

Eden Park is one of the jewels of the Cincinnati Park System. Within its 186 acres, in addition to Krohn Conservatory, are the

EDEN PARK—KROHN CONSERVATORY

111

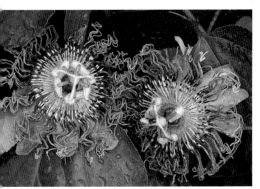

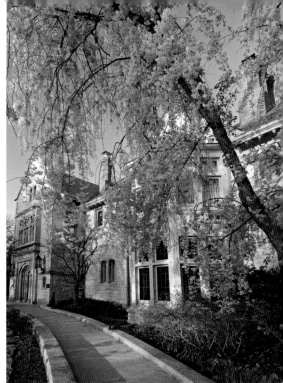

OHIO GOVERNOR'S
RESIDENCE

ABOVE, PASSIONFLOWERS
RIGHT, WEEPING CHERRY

Cincinnati Art Museum, the Cincinnati Playhouse in the Park, an elaborate gazebo, pools, fountains, and several overlooks with expansive views of the Ohio River and northern Kentucky. When I'm in the area, I often begin my photographic day at the Eden Park overlooks, hoping for a fine sunrise over the Ohio River, then drive to nearby Mount Adams to shoot early-morning views of downtown Cincinnati.

Ohio Governor's Residence Heritage Garden, Bexley

Location: 358 North Parkview Avenue, Bexley, OH 43209. Tel: (614) 644-7644
Website: http://www.governorsresidence.ohio.gov
GPS Coordinates: 39.976876N 82.939945W

Early in 2006, I received an invitation from Hope Taft, Ohio's First Lady, to provide the photography for a book on the Ohio Governor's Residence and Heritage Garden in Bexley, about 3 miles east of downtown Columbus. I worked on this exciting project for the remainder of 2006 and 2007, and *Our First Family's Home: The Ohio Governor's Residence and Heritage Garden* was released by Ohio University Press in 2008.

The Ohio Governor's Residence is a 1925 Jacobethan Revival mansion surrounded by a unique, 3-acre Heritage Garden that showcases the geologi-

cal and ecological history of Ohio in a collection of gardens based on the five major physiographic areas of the Buckeye State: Unglaciated Appalachian Plateau, Central Till Plains, Bluegrass, Lake Plain, and Glaciated Appalachian Plateau. Trees, shrubs, and flowers native to each of these regions can be found in the Heritage Garden, together with rock samples, statuary, and a variety of artifacts that highlight the rich diversity of the Buckeye State.

Guided one-hour tours of the Heritage Garden and the interior of the Residence are offered throughout the day on Tuesdays. Tours must be scheduled two weeks in advance, and cameras are welcome in the Heritage Garden. Spring is an excellent time to enjoy the flowering magnolias, redbuds, weeping cherries, crabapples, lilacs, and wisteria, plus an extensive display of native Ohio wildflowers, many transplanted into the Heritage Garden as wildflower rescues from housing sites around the state. In late summer and early fall, the prairie garden dominates the scene with prairie grasses and wildflowers up to 10 feet tall. When you visit, be sure to check out the red-eared slider turtles in the water garden.

Park of Roses, Whetstone Park, Columbus

Location: 3923 N. High Street, Columbus, OH 43214. Tel: (614) 645-3350
Website: http://www.clintonville.com/parkrec/rosegarden.html
GPS Coordinates: 40.04352N 83.027707W

The Park of Roses is in Clintonville, about 7 miles north of downtown Columbus in the center of 136-acre Whetstone Park, which provides jogging and walking trails, picnic areas, shelter houses, and athletic fields. Nestled in the middle of this municipal facility is the 13-acre Park of Roses, founded in 1952 by members of the Columbus Rose Club and Central Ohio Rose Society, who wanted to establish a rose garden in the Columbus area.

There are several other garden areas here, including a daffodil display featuring hundreds of varieties that peak during mid-April, but the centerpiece of the Park of Roses is the rose garden, which contains 11,000 rose bushes, including the latest All-American Rose Society selections. Mid-June and mid-September are usually the peak blooming times for the roses. There are many

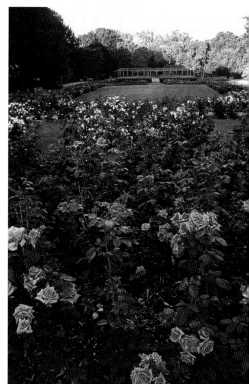

PARK OF ROSES, WHETSTONE PARK

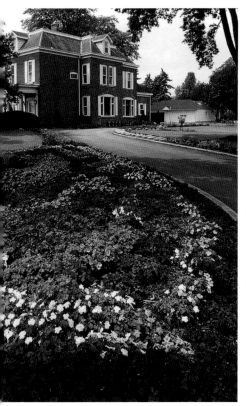

vantage points from which you can capture vistas of the rose display with a wide-angle lens, and opportunities for taking close-up portraits of the roses are endless. To make sure that you get pinpoint color accuracy in your rose close-ups, carry a calibrated gray card, such as a WhiBal, or a small Macbeth ColorChecker, and include these in a few of your close-ups so you can easily color-correct the photos in Photoshop later as part of your digital workflow.

Schedel Arboretum and Gardens, Elmore

Location: 19255 West Portage River South Road,
 Elmore, OH 43416. Tel: (419) 862-3182
Website: http://www.schedel-gardens.org
GPS Coordinates: 41.468507N 83.304724W

Thousands of travelers on the Ohio Turnpike whizz past the exit at the small town of Elmore in rural Ottawa County each day without realizing that one of Ohio's most delightful public gardens is close at hand, near a bend in the Portage River. Schedel Arboretum and Gardens

SCHEDEL GARDENS — HOUSE

was made possible by the generosity of Joseph and Marie Schedel, who purchased 100 acres and established a foundation to administer the 17-acre gardens after they passed away in the 1980s.

The gardens are on two levels, and some of the best vantage points for photography are along the wall at the upper level, where you can look down on the beautiful Japanese Garden that is the signature feature at Schedel Arboretum. Spring is my favorite time to visit, when 15,000 annuals bloom and the flowering trees and shrubs are at their showy best. It's not unusual to see bald eagles, which nest in the nearby marshes.

Secrest Arboretum, Wooster

Location: Ohio Agricultural Research and Development Center, The Ohio State University, 1680 Madison Avenue, Wooster, OH 44691. Tel: (330) 263-3761
Website: http://secrest.osu.edu
GPS Coordinates: 40.78352N 81.917585W

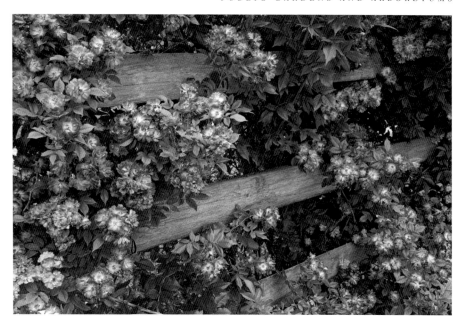

SECREST ARBORETUM — ROSE GARDEN

Secrest Arboretum, tucked into the grounds of the sprawling campus of the Ohio Agricultural Research and Development Center (OARDC) near Wooster, is another Ohio public garden that deserves to be better known. There has been an arboretum here since 1908, when the Forest Arboretum was established, and in 1950 it was renamed in honor of Dr. Edmund Secrest, the father of Ohio forestry. The gardens are open year round from dawn to dusk, and admission is free.

The Secrest Arboretum covers 115 acres, and one of the nation's largest collections of crabapple trees flowers there in April and May. Secrest also has more than fifty specimens of dawn redwood, a deciduous tree that was discovered in China in 1944, and several Ohio champion trees. There is a rhododendron garden and a prairie garden, and in May and June, five hundred varieties of heirloom roses bloom in the Garden of Roses of Legend and Romance.

On Friday, September 17, 2010, at 5:30 p.m., a tornado caused extensive damage to the OARDC campus and Secrest Arboretum. Many buildings were destroyed, and dozens of large trees were toppled. Please contact the arboretum before visiting to find out if the facility is open.

Spring Grove Cemetery and Arboretum, Cincinnati

Location: 4521 Spring Grove Ave., Cincinnati, OH 45232. Tel: (513) 681-7526
Website: http://www.springgrove.org/sg/arboretum/arboretum.shtm
GPS Coordinates: 39.173945N 84.524907W

Spring Grove Cemetery and Arboretum, founded in 1845, is the second-largest cemetery in the United States. Adolph Strauch, a renowned landscape architect, created this 733-acre "garden cemetery," full of lakes, trees, and shrubs. In addition to extensive plantings of flowers and shrubs, Spring Grove is also home to two national and twenty-one state champion trees. Many famous local political and industrial figures, with names like Taft, Kroger, Proctor, Gamble, and Lytle, are buried here, along with more than forty Civil War generals, memorialized with spectacular obelisks, chapels, crypts, tombstones, and mausoleums, many resembling elaborate cottages or cathedrals. Perhaps the most impressive is the Gothic Revival Dexter Memorial, shaded by a magnificent weeping beech tree.

An elaborate system of paved roads allows you to wander through the cemetery, and a map can be downloaded from the Spring Grove website. Spring is my favorite time here, with a succession of redbud, dogwood, weeping cherry, azalea, and many other flowering trees and shrubs, plus acres of naturalized daffodils and other spring bulbs.

Stan Hywet Hall and Gardens, Akron

Location: 714 N. Portage Path, Akron, OH 44303. Tel: (330) 836-5533
Website: http://www.stanhywet.org
GPS Coordinates: 41.118504N 81.549071W

During the late 1990s, I joined forces with Cleveland architectural photographer Barney Taxel and *Akron Beacon Journal* writer Steve Love to create a book titled *Stan Hywet Hall and Gardens*, which was published by the University of Akron Press in 2000. The book celebrates the life and times of F. A. Seiberling, the founder of the Goodyear Tire and Rubber Company, and the magnificent sixty-five-room Tudor Revival Mansion called Stan Hywet—the Old English term for "stone quarry"—that he built in Akron's northwest suburbs from 1912 to 1915. Stan Hywet Hall is the fifth-largest private home ever built in the United States and is a National Historic Landmark. The estate is open from April 1 through December 31, and an entrance fee is charged. Photography for personal use is allowed, but tripods are not permitted on the grounds.

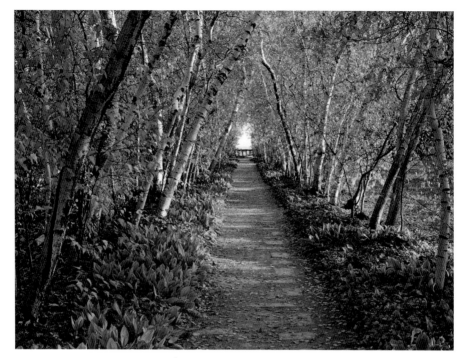

STAN HYWET HALL — BIRCH ALLÉE

When you visit, obtain a walking guide from the Carriage House Visitor Center, and enjoy a stroll around the 70 acres of manicured gardens, orchards, and scenic overlooks to become familiar with the layout of the estate. You can photograph the enormous Manor House from the outside, but cameras are not permitted inside the building. The best views of the Manor House are from the driveway area near the main entrance on the east side and from the gardens near the West Terrace overlook.

One of the showpieces at Stan Hywet is the English Garden, designed by Ellen Biddle Shipman, one of America's most famous garden designers. Visit this sunken garden in late spring or summer when the floral plantings are in bloom. Nearby, the West Terrace overlook has a fine view of the Cuyahoga Valley, as well as a pool with ornamental fountains. Another "must see" garden feature is the Birch Allée, an avenue of gray birch trees on the north side of the Manor House that leads to another overlook at the Tea Houses. To the east is the new Corbin Conservatory, a re-creation of the original glass building designed by estate architect Charles Schneider.

117

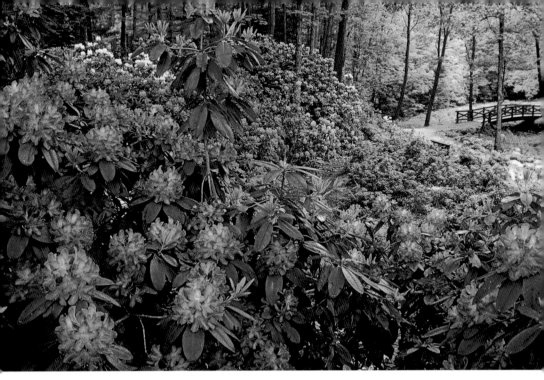

The Holden Arboretum, Kirtland

Location: 9500 Sperry Road, Kirtland, OH 44094. Tel: (440) 946-4400
Website: http://www.holdenarb.org
GPS Coordinates: 41.61218N 81.30089W

During 2001 and 2002, I teamed up again with *Akron Beacon Journal* writer Steve Love to create a book about Holden Arboretum in Lake and Geauga Counties. *The Holden Arboretum,* published by the University of Akron Press in 2002, showcases one of my favorite nature- and garden-photography destinations in northeast Ohio. I've also undertaken a number of photography assignments for the arboretum and have taught more than forty photography workshops there during the past twenty years.

The Holden Arboretum covers more than 3,500 acres, making it one of the largest arboretums in the United States. Much of this acreage consists of natural areas that include woodlands, wetlands, a river corridor, and Stebbins Gulch, a narrow canyon with waterfalls and tall sandstone cliffs that are covered with icicles in winter. Holden's woodlands are filled with native wildflowers from late April through the end of May, and the fall color here is

spectacular in mid-October. Carver's Pond has a grand display of water lilies in mid-June, and Little Mountain is home to one of the few remaining stands of old-growth white pine in the Buckeye State.

Holden's extensive display gardens feature a fine show of flowering crabapples in early spring and lilacs a little later, followed by an equally impressive parade of rhododendrons and azaleas in late May and early June. In August and September, the Butterfly Garden near the Corning Visitor Center takes center stage. Probably the finest collection of rhododendrons and azaleas in the Midwest peaks in late spring at Holden's David Leach Research Station in Madison, where the late David Leach, one of the world's experts on breeding rhododendrons, carried out much of his groundbreaking research in hybridizing rhododendrons and other shrubs.

The myriad of opportunities for photography at Holden can be a little overwhelming until you become familiar with the place. The first time you visit, spend half an hour leafing through the pages of *The Holden Arboretum* in the library in the Corning Visitor Center. Then chat with the knowledgeable staff and find out what's in bloom. Holden also offers guided hikes and classes on nature and horticulture, and you can attend one of the three or four photography workshops I conduct at Holden each year if you want to fine-tune your photography skills and enjoy the company of other photography enthusiasts.

Toledo Botanical Garden

Location: 5403 Elmer Drive, Toledo, OH 43615. Tel: (419) 356-5566
Website: http://www.toledogarden.org
GPS Coordinates: 41.666222N 83.672156W

Founded in 1964 on 20 acres donated by George P. Crosby, Toledo Botanical Garden has grown to more than 60 acres and is now managed as part of the Toledo Metroparks. The garden, 7 miles west of downtown Toledo, is open year round, with free admission.

In the woodland garden, wildflowers and many rhododendrons and azaleas bloom in spring. Other interesting and attractive features are an ornamental pond, an herb garden, a rose garden, and acres of annuals and perennials. A pioneer garden surrounds a log cabin once owned by Peter Navarre, one of Toledo's earliest settlers.

Nearby are the Oak Openings, encompassing more than a dozen parks and nature preserves that are home to more kinds of rare and endangered plants than any other region of Ohio.

119

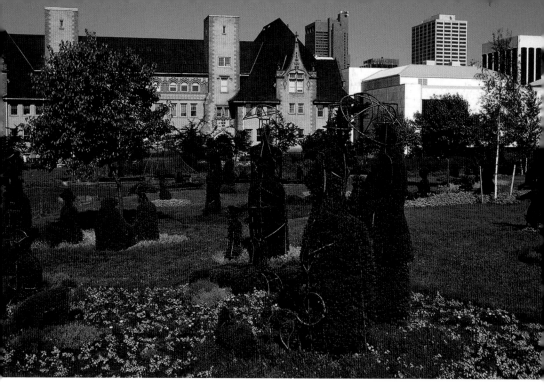

The Topiary Park, Columbus

Location: 480 E. Town Street, Columbus, OH 43215. Tel: (614) 645-0197
Website: http://www.topiarygarden.org
GPS Coordinates: 39.961502N 82.987894W

A few blocks east of the Ohio Statehouse in downtown Columbus is an unusual 7-acre garden known as Topiary Park, containing the only known topiary interpretation of a painting, the brainchild of local sculptor James T. Mason. With support from his wife, Elaine, Mason designed and created a monumental topiary, based on French impressionist George Seurat's famous pointillist painting *A Sunday Afternoon on the Isle of la Grand Jatte*, which depicts Parisians enjoying a leisurely afternoon on a popular island in the River Seine near Paris. Seurat completed the painting in 1886, a few years before his death at age 31 in 1891.

The topiaries comprise several varieties of yew trees, supported on bronze frames set in concrete. The largest figure is 12 feet tall, and the topiary includes fifty-four human figures, eight boats, three dogs, a cat, and a monkey.

Mason completed the sculpture in 1988; the topiary was completed in 1992. A viewing area on a hill near the east side of the park allows you to "see" the topiary as if you were looking at the painting.

Early morning light works well when photographing this garden, and a misty morning is even better, as the mist helps evoke the mood of Seurat's painting and masks the tall buildings in the background next to the park. Topiary Park is open from dawn to dusk and admission is free.

REFERENCES

Adams, I. 2005. *The Art of Garden Photography.* Portland: Timber Press.

Adams, I., and S. Love. 2002. *The Holden Arboretum.* Akron: University of Akron Press.

Adams, I., B. Taxel, and S. Love. 2000. S*tan Hywet Hall and Gardens.* Akron: University of Akron Press.

Adams, I., J. Jones, and D. Tittle. 2005. *A Paradise in the City: Cleveland Botanical Garden.* Wilmington: Orange Frazer Press.

I Love Gardens.com: http://www.ilovegardens.com—A comprehensive list of public and private gardens, organized by state.

Mairose, M., ed., and I. Adams. 2008. *Our First Family's Home: The Ohio Governor's Residence and Heritage Garden.* Athens: Ohio University Press.

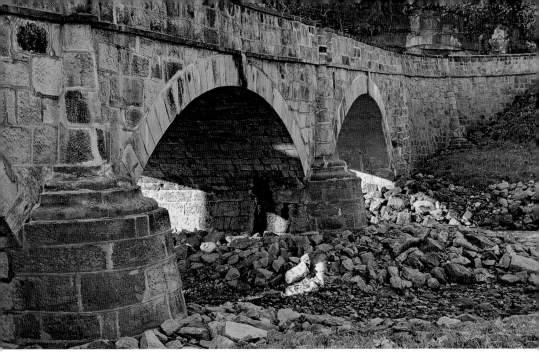

Barns, Bridges, Mills, and Rural Areas

"Those who seek the spirit of America might do well to look first in the countryside," wrote historian Eric Sloane in his book, *An Age of Barns.* Our pioneer forefathers had a deep and enduring relationship with the land, and Ohio's rural landscapes are filled with examples of finely crafted structures of wood, brick, iron, and stone they built to meet the needs of the farming communities around the Buckeye State. Many of these structures—barns, gristmills, and bridges—are still used, and in a few areas of Ohio, notably the Amish Country centered in Holmes County, the rural landscape has remained remarkably unchanged for more than a century.

Many old barns remain standing in America, a testament to our agrarian roots and the construction skills of our pioneer ancestors, and they are irresistible subjects for artists and photographers. Perhaps it's the way they stand tall,

BLAINE HILL BRIDGE, BELMONT COUNTY.

defying the elements for a century or more. Perhaps it's the varied patterns of the weathered wooden boards or the intricate framing of the huge oak beams that support the barn. Or perhaps it's the small army of creatures, great and small—horses, cows, goats, dogs, cats, rats and mice, barn owls, songbirds, bats, and insects—that inhabit the barn. "Barns," wrote Eric Sloane, "are the shrines of a good life, and ought to be remembered."

Ohio has as varied an assortment of barns as most states, and although dozens of them succumb to the ravages of time each year, thousands of barns more than a century old still exist throughout the state, many of them still in use. Some are Pennsylvania bank barns, built on a slope or with a ramp entrance, with an overhanging roof, called a forebay, on the opposite side. Others are Dutch barns, Appalachian crib barns, Wisconsin dairy barns, English barns, ramp-shed barns, and even round and polygonal barns. Especially common in the Buckeye State are Mail Pouch barns, reminders of a time when tobacco was king and chewing tobacco had not lost its social respectability.

Just as the barn was the focal point for many farming activities, the gristmill was often the centerpiece of the rural village, and the miller was one of the most important people in the community. Most gristmills incorporated a waterwheel to provide power to turn the millstones used to grind grain into flour and meal, which required that they be located on rivers, streams, or lakes. In the mid-1800s, Ohio was home to hundreds of working mills, but today there are fewer than a dozen operating gristmills in the state. Several are featured in this chapter.

Few scenes evoke America's pioneer past as vividly as a freshly painted covered bridge spanning a river or stream. Many country roads followed waterways, and geographers have estimated that as many as 12,000 covered bridges once existed in the United States. Today only about 800 remain, mostly in the Northeast and Midwest. Pennsylvania has the most, with about 230 covered bridges, and Ohio is second, with about 140.

Why were the bridges covered? One fanciful explanation was that the cover made the bridge look like a barn, which made it less threatening to horses and cattle passing over the bridge. A more likely reason was to protect the wooden structure of the bridge so that it wouldn't rot, or as one old bridge builder remarked, "Our bridges were covered, my dear sir, for the same reason that belles wore hoop skirts and crinolines—to protect the structural beauty that was seldom seen but nevertheless appreciated!"

No two covered bridges are identical. Of special interest is the design of the sides of the bridge, which support the roof and transfer the weight of the moving vehicle to the bridge abutments. This part of the bridge is called the truss, and covered bridges in the United States feature eighteen distinct truss designs, many of which can be found in Ohio. Some trusses, like the Howe and multiple kingpost, are common. Other designs, such as Wernwag, Haupt, and Bowstring trusses, have only a few remaining examples.

In addition to covered bridges, Ohio has dozens of historic iron, steel, and concrete bridges, as well as a few sandstone bridges that are more than two hundred years old. Several of these interesting and photogenic old bridges are featured in this chapter.

Although Ohio has lost more than a third of its farmland in the past century, there are still 76,000 farms in Ohio, occupying 14 million acres, or more than 50 percent of the total land area of the state. Corn, soybeans, dairy products, chickens, eggs, and hogs are the main products of Ohio farms, but you can also find orchards, berry farms, mushroom farms, vegetable farms, and tobacco farms, as well as ranches that raise beef cattle, sheep, bison, llamas, and alpacas. Some areas of the state, including north-central and western Ohio, are largely rural, and farms of more than a thousand acres are not uncommon. In eastern and southern Ohio, where the terrain is more rugged and soils are thin and poor, smaller hill farms dominate the countryside.

Ohio is also home to the world's largest group of Amish-Mennonite farmers, with more than 55,000 Amish concentrated in and around Holmes County in north-central Ohio and Geauga County in northeast Ohio. The Amish practice traditional farming methods little changed from those of their sixteenth-century German and Swiss ancestors. They avoid electricity and modern farming technology in favor of horse-drawn machinery and manual labor, and they can be seen driving their horse-drawn black buggies through pastoral countryside that in some parts of Ohio is reminiscent of a Currier and Ives print. Although many visitors view the Amish as "quaint," their lifestyle is family-centered, efficient, and profitable. In 2001, I attended an Amish barn raising near Mount Hope in Holmes County, during which several hundred Amish carpenters erected a huge dairy barn in little more than half a day. An Amish friend noted that if the "English" (non-Amish) were faced with the same task, it would take at least a month to figure out who should be on the planning committee that would decide how to build the barn.

TIPS ON PHOTOGRAPHING BARNS, BRIDGES, AND MILLS

Though serendipity will occasionally present you with unexpected photo opportunities, it is no substitute for research and planning. I have included numerous references at the end of this chapter that will help you locate many of Ohio's most picturesque barns, bridges, and gristmills; use these resources as an aid to planning your rural photo trips.

In addition to a high-quality Ohio gazetteer, such as the DeLorme, and perhaps a copy of this book, a good pair of binoculars is an excellent investment for the rural photographer. They are invaluable for spotting and examining barns and other structures from a distance, as well as for birding and general nature study. In a pinch, you can use your camera and a telephoto lens, but they are not as comfortable or convenient for prolonged use as a good pair of binoculars.

Most bridges on public roads are easily accessible, but barns and mills are usually on private property and you should always get permission before taking photographs. If you think the photographs may have potential as stock images, try to obtain a property release from the owner or his or her representative.

When you first visit a barn, bridge, or gristmill, take time to walk around the structure and examine it from all directions, previewing different angles with a handheld camera, preferably equipped with a wide-angle zoom lens such as the 16–85mm (DX) or 24–70mm (FX) Nikkors. If you own a GPS unit, use it to record the location of the structure for future reference.

Take along a full complement of lenses for rural photography; I have used everything from a 12mm wide-angle to a 600mm telephoto lens to photograph barns, bridges, and rural scenes. A polarizing filter can also be quite useful for suppressing unwanted reflections and intensifying colors.

Perspective control is an important aspect of photographing structures such as barns and mills. Whenever you tilt your camera away from an axis that is perpendicular to the building, you create perspective distortion to some extent, and the edges of the building will converge. The more you tilt the camera up or down, the more convergence will occur. You can use this convergence to deliberately distort the planes of the barn, bridge, or mill to create a desired effect in your photograph. Or, you can ensure that your camera is positioned at ninety degrees to the plane of the wall, so that vertical surfaces will remain vertical in the photograph. The choice is yours.

125

Sometimes you must photograph from above or below the structure, and some degree of convergence is unavoidable. If you have deep pockets, you can purchase a "tilt-shift" lens, such as the Nikon 24mm, 45mm, and 85mm PC-E, or the Canon 17mm, 24mm, and 90mm TSE lenses. These amazing lenses allow you to raise or lower the lens relative to the direction the camera is pointing, which corrects perspective convergence, and you can also tilt the lens to help maximize (or minimize) depth-of-field. Tilt-shift lenses are useful if you plan to do a great deal of architectural photography, but they are expensive ($2,000 or more).

Another approach is to use the "Crop" command in Photoshop, together with the "Transform" option, to correct the perspective digitally on your computer. Because you will lose part of the image on the left and right when applying this technique, make sure you use a wider-angle lens setting or step back a little to be sure you have extra coverage at the perimeter of the barn or bridge to compensate for the edge cropping that results when you adjust the digital image in this manner.

Rural photographers are always chasing the best light, which usually occurs during the first and last hours of the day. I live about an hour's drive from the world's largest Amish population in Holmes County, Ohio, and my photographic forays into this pastoral domain are invariably timed so that I arrive at least a half hour before dawn. I'm hoping for a beautiful sunrise or a calm morning when layers of fog fill the hollows. Great light is capricious and fleeting, especially on clear days in summer, when the finest lighting is often gone by an hour after sunrise and won't return until late in the evening.

When photographing rural scenes, I generally avoid white skies, though overcast weather can be great for close-ups of details of barns and bridges, as well as for portraits of farmers and their livestock. In winter, when farmland is snow covered, a white sky may impart a quiet mood to the scene. Overcast lighting is also fitting for barns or bridges that are surrounded by heavy foliage, which on bright clear days produces a checkerboard of harsh highlights and shadows.

On sunny days, try to avoid photography from midmorning to midafternoon, when glare and stark lighting will prevail. By all means, take record shots, and scout the scene for good angles and compositions, but if possible plan to return when the light is more conducive to expressive photography. Frontal lighting is flat, creating a "picture postcard" look, and most rural structures favor sidelight, in which shadows add depth. I also favor farm vistas that are

backlit, a lighting that emphasizes the lay of the land and can impart a magical mood to the scene. When shooting directly into the light, be sure to use a lens hood and shade the lens with your hand to avoid getting flare spots in the picture.

16-Sided Barn, Freeport, Harrison County

Location: 75540 Skull Fork Road, Freeport, OH 42973. Tel: (740) 658-3891
Website: www.visitharrisoncounty.org/PointsOfInterest.htm
GPS Coordinates: 40.192728N 81.271377W

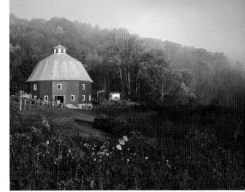

About a mile and a half south of Freeport along Skull Fork Road in rural Harrison County stands one of only three 16-sided barns in America. The barn was built in 1924 and received a new roof and a bright red paint job in 2008. This is one of the most distinctive barns in Ohio and well worth a visit if you are in the Freeport area.

There is often a jumble of odds and ends stacked outside the barn, and to my eye this barn is best photographed from the lane about a hundred feet south, where a pasture and old fence make good foreground elements and help hide some of the clutter around the barn entrance.

16-SIDED BARN, HARRISON COUNTY

Early morning or late afternoon are good times to photograph this unusual barn, which looks good against a blue sky. If you enjoy covered bridges, you may want to visit the Skull Fork Bridge, about a mile south of the 16-sided barn, near Skull Fork Road.

Amish Country

Location: Holmes and Geauga Counties (mostly)
Website: http://www.visitamishcountry.com
GPS Coordinates: Multiple sites

The epicenter of Ohio's Amish population is Holmes County; smaller numbers of Amish also live in Stark, Wayne, Tuscarawas, Coshocton, and Knox Counties. This is hilly terrain, with a few major roads, mainly State Route 39, State Route 241, and State Route 62, along with many smaller paved roads and hundreds of narrow unpaved dirt roads that can be tricky to drive in snowy winter weather. The major towns along State Route 39 in

127

Holmes County are Millersburg, Berlin, Walnut Creek, and Sugarcreek, and these towns are usually crowded with tourists from midmorning through late afternoon during summer, especially on weekends. From a photographic viewpoint, you will do well to avoid these tourist traps and spend your time exploring the quieter areas and dirt roads around Charm, New Bedford, Fredericktown, Mount Hope, and Kidron. The hilly country around Charm and New Bedford is especially scenic, and a morning or afternoon photographing in this area, followed by a hearty lunch or dinner at an Amish restaurant, is one of Ohio photography's finest experiences. When you drive the narrow dirt roads, always be on the lookout for Amish buggies, and adjust your speed accordingly.

Ohio's second-largest Amish community is clustered around Burton, Bundysburg, Huntsburg, Mesopotamia, and Middlefield in eastern Geauga and northern Trumbull Counties. The terrain is flatter and less pastoral here than in Holmes County, from which most of the Geauga and Trumbull Amish originally came. Much smaller Amish communities can be found in a few other Ohio locations, notably Allen County in northwest Ohio and Adams County in southern Ohio.

As a landscape photographer, there are few things I enjoy more than spending a day photographing the countryside in Holmes County during spring, when the Amish are plowing and planting, or during summer and fall, when they are harvesting their crops. Many of the images I take are wide-angle views of farms or pictures of livestock in pastures, destined for use in a book project or my next *Ohio Places* calendar, but I also enjoy using a 70–200mm or 200–400mm image stabilized zoom lens to discretely photograph Amish people engaged in their daily lives. Occasionally, I compose an attractive view that includes a road, and wait for an Amish buggy to come along the road so I can include it in the scene. Usually, I hand-hold the camera and wait to photograph from the driver's seat of my vehicle, rather than set up a tripod in the middle of the road.

The Amish reject "Hochmut" (pride) and value "Demut" (humility), which is at odds with the egocentric individualism that runs rampant in modern American culture. The Amish are also strong believers in the biblical commandment from Exodus 20:4, "Thou shalt not make unto thee any graven image," and, as a result, Amish adults do not like to be photographed, though they do not usually object to visitors taking pictures of their farms, livestock, or children. I have taken photographs of the Amish farm country around Ohio for more than twenty years and have never experienced a problem, but I am

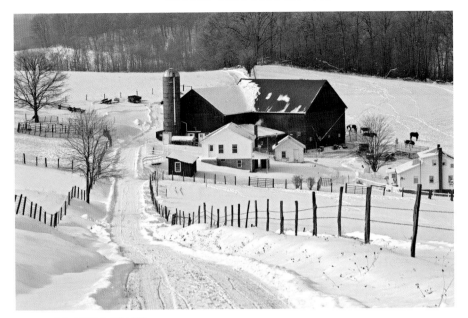

AMISH FARM NEAR CHARM

careful to respect their beliefs and never ask Amish adults to "pose" for a photograph. When photographing Amish men and women engaged in plowing, harvesting, or other farming tasks, I always photograph them from behind, or from a distance so that their faces will not be easily recognizable. Please follow these guidelines when you are photographing in Ohio's Amish Country.

Covered Bridge Scenic Byway, Washington and Monroe Counties

Location: Along State Route 26 for 44 miles between Woodsfield and Marietta.
Website: www.byways.org/explore/byways/2321/
GPS Coordinates: Multiple sites

Tucked away in the hills of Washington and Monroe Counties in the southeast corner of Ohio is the Covered Bridge Scenic Byway, a 44-mile stretch of winding blacktop road along State Route 26 that twists and turns through the forested hills of the Wayne National Forest and along the banks of the Little Muskingum River between Woodsfield and Marietta. Along the way you'll encounter Mail Pouch barns, farms, and five covered bridges, each painted red to delight the eye of the painter or photographer.

The northernmost bridge, the Foraker Bridge, is off the beaten track in Monroe County, about 4 miles from State Route 26. Farther south in Monroe County, the Knowlton Bridge, one of my favorites and one of the longest

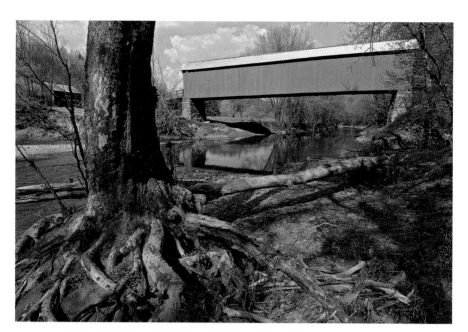

HUNE COVERED BRIDGE, WASHINGTON COUNTY

covered bridges in Ohio, is in a park about 0.3 miles from State Route 26. Next in line, spanning the Little Muskingum River close to State Route 26 in Washington County, are the Rinard, Hune, and Hills-Hilldreth covered bridges. During 2004, Rinard Bridge was washed off its stone base by heavy rains in the aftermath of a hurricane, but the bridge has been carefully restored and is once again open for use.

You can drive the Covered Bridge Highway in either direction, and the bridges are photogenic in every season. There are also several Mail Pouch barns, with yellow lettering painted on a black background by the late Mail Pouch barn painter Harley Warrick. Several more covered bridges can also be found west of Marietta in Washington County.

Ashtabula County Covered Bridges

Location: Various
Website: http://en.wikipedia.org/wiki/List_of_Ashtabula_County_covered_bridges
GPS Coordinates: Multiple sites

Ashtabula is Ohio's largest county, and it has seventeen covered bridges, more than any other county in the Buckeye State. Eleven of the bridges date from the late 1800s and early 1900s, but six of the bridges have been

built since 1983, under the direction of covered-bridge enthusiast John Smolen, Ashtabula County's former county engineer.

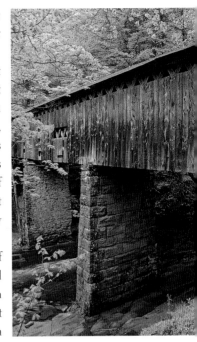

The latest, the new Smolen-Gulf bridge, is the longest covered bridge in the United States and features a Pratt truss design. Engineering and structural design is by John Smolen and architectural design is by Timothy Martin, who is the current county engineer. This bridge was dedicated August 26, 2008, is 613 feet long, and stands 93 feet above the Ashtabula River. With a clear width of 30 feet and height of 14½ feet, the bridge will support two lanes of full legal-load traffic and has a life expectancy of 100 years.

You can easily spend a full day or more visiting all of Ashtabula County's covered bridges, and there are several websites with additional information and maps you can download to help you plan your visit. The bridges are at their most photogenic in the fall or in winter after a fresh snowfall. A covered-bridge festival is held in Ashtabula County in late October, but this event attracts thousands of visitors and the bridges are usually too crowded for good photography.

COVERED BRIDGE NEAR WINDSOR, ASHTABULA COUNTY

Ashtabula Harbor Lift Bridge

Location: On West Fifth Street in Ashtabula, over the Ashtabula River.
Website: http://ci.ashtabula.oh.us/
GPS Coordinates: 41.900499N 80.797525W

Ashtabula is derived from an Algonquin Indian name for the local Ashtabula River that means "river of many fish." Spanning the river in Ashtabula harbor on State Route 531 is a bascule (French for "seesaw") lift

bridge, one of only two in the Buckeye State. The bridge has an elevated counterweight that balances the span as it rotates around a fixed axle called a trunnion. The Ashtabula harbor lift bridge was built in 1925, restored in 1986, and repaired and repainted during 2008 and 2009.

The bridge is painted light gray, which tends to blend in with a cloudy sky but stands out nicely

BASCULE LIFT BRIDGE, ASHTABULA, OHIO

against a blue sky. You can walk along the edge of the Ashtabula River just south of the bridge and try out a variety of camera angles. This side of the bridge receives good light for photography from morning to evening on a sunny day. While you are in Ashtabula, explore the historic buildings that line Bridge Street, and admire the view of the bascule bridge and Ashtabula Harbor from Point Park on Walnut Street. Also worth a visit, adjacent to Point Park, is the Great Lakes Marine and Coast Guard Memorial Museum.

Aullwood's Farm, Dayton

Location: 9101 Frederick Pike, Dayton, OH 45414. Tel: (937) 890-7360
Website: http://aullwood.center.audubon.org
GPS Coordinates: 39.880722N 84.271301W

Aullwood Audubon Center was created in 1957 by Mrs. John Aull as a place for children to learn about natural history. Mrs. Aull donated 70 acres of land to the Audubon Society, creating one of the first nature centers in the Midwest. In 1962, a nearby farm became Aullwood Children's Farm. Today, there are 5 miles of trails and 350 acres of prairies, woodlands, meadows, wetlands, and farm pastures. More than 80,000 visitors, including many schoolchildren, visit Aullwood each year.

There are acres of spring wildflowers along the woodland trails, and prairie plants bloom in midsummer. A menagerie of farm animals can be photographed at the farm, which practices sustainable farming and is a certified organic farm. This is a great place to combine nature and rural photography during a single visit.

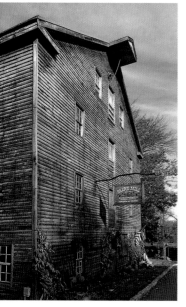

Bear's Mill, Greenville, Darke County

Location: 6450 Arcanum-Bear's Mill Road, Greenville, OH 45331.
 Tel: (937) 548-5112
Website: http://www.bearsmill.com
GPS Coordinates: 40.106775N 84.541974W

A few miles east of Greenville in Darke County, near where sharpshooter Annie Oakley was born in 1860, stands one of Ohio's few remaining water-powered gristmills. Pennsylvania miller Gabriel Baer moved here in 1848, and in 1849, construction of Bear's Mill was completed. Today the mill is still in use, grinding cornmeal and whole-wheat and rye flour. Water from Greenville Creek powers the two turbines that turn the buhrstone wheels used for grind-

BEAR'S MILL, DARKE COUNTY, OHIO

ing. Bear's Mill was added to the National Register of Historic Places in 1977, and the millrace and nearby Greenville Creek are also a wildlife sanctuary. You can buy flour and tour the interior of the mill, which is sheathed in weathered American black walnut siding. While you are there, admire the beautiful raku pottery made by mill co-owner Julie Clark.

The entrance and front of the mill face east, so morning light is preferable for shots of the front of the mill from across the road. South of the mill is an attractive millrace, lined with tall trees and redbud that blooms in early spring. Good angles to include the millrace in your photos can be found in morning and afternoon. You may also want to take some photos of the interior of the mill, which is supported by hand-hewn timber frames up to 50 feet long.

Blaine Hill Bridge on National Road, Belmont County

Location: In Blaine, over Wheeling Creek, 8 miles west of Wheeling, West Virginia.
Tel: (937) 324-7752
Website: http://www.byways.org/explore/byways/15641/places/36987/
GPS Coordinates: 40.066777N 80.820753W

The Blaine Hill Bridge in Belmont County, 8 miles west of Wheeling, West Virginia, is Ohio's oldest stone bridge. The three-arch sandstone S-bridge over Wheeling Creek was built in 1828 along the Historic National Road, the first interstate road funded by the federal government. It was much easier to build a stone bridge at a 90-degree angle to a stream or creek than at a more acute angle. Two curved ramps were then added on each side of the bridge, generating the shallow "S" shape. Several S-bridges were built along the eastern section of the National Road in Ohio, and the 345-foot Blaine Hill Bridge is the longest.

By the early 1930s, the old S-bridge was no longer able to handle the 2,700 vehicles that used the National Road daily, and a much larger steel and concrete arched bridge, which today carries U.S. Route 40, was built next to the Blaine Hill Bridge. During the 1990s, the Blaine Hill Bridge began to crumble, but it has been painstakingly restored and was designated as Ohio's official Bicentennial Bridge in 2003.

133

Early morning or late afternoon are my preferred times to photograph this historic bridge, which is in the shadow of the Route 40 bridge during much of the day. Be sure to walk out onto the bridge to view the inscriptions in the bricks used to pave the surface of the bridge. Photograph the Blaine Hill Bridge on its own with hills in the background from the south side, or shoot

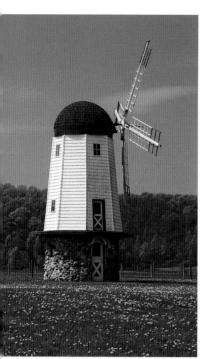

BOB EVANS FARM, RIO GRANDE
—WINDMILL

from the north side and include part of the larger Route 40 bridge to highlight the two eras of bridge construction in Ohio.

Bob Evans Farm, Rio Grande

Location: 791 Farmview Road, Bidwell, OH 45614.
 Tel: (800) 994-3276
Website: http://www.bobevans.com/ourfarms/bobevansfarm
GPS Coordinates: 38.882158N 82.367765W

The late Bob Evans, famed restaurateur and sausage maker, lived for twenty years with his wife, Jewel, and their six children in an 1825 brick house called The Homestead, near Rio Grande in Gallia County. I had the pleasure of meeting Evans a few years ago with Amish farmer David Kline, when the subject was grass-fed dairy farming, a practice much espoused by Evans and the Amish. A restaurant was built near The Homestead in 1961, and today the property is maintained by Bob Evans Farms, Inc., as an active farm and history center. Be sure not to miss the windmill, given to Bob Evans Farms by its original owner, bourbon entrepreneur Jim Beam. Also on the farm are a gristmill, sorghum mill, Ohio bicentennial barn, and a log cabin village. A farm festival is held every year in October, with farm and craft demonstrations, hayrides, entertainment, and many other activities you may wish to photograph. Visit at other, quieter times of year to shoot the farm fields and buildings without crowds of visitors.

Carriage Hill Farm and Park, near Dayton

Location: 7800 Shull Road, Huber Heights, OH 45424. Tel: (937) 278-2609
Website: http://www.metroparks.org/Parks/CarriageHill/
GPS Coordinates: 39.87449N 84.091364W

Daniel and Catherine Arnold and their five children moved to the Huber Heights area north of Dayton in 1830 from Rockingham County, Virginia, and the family moved into a new house in 1836. The Arnold's youngest son Henry built a bank barn near the house in 1878. Dayton (now Five Rivers) Metroparks acquired the farm in 1968 from Ernest Foreman, who had renamed the property Carriage Hill Farm. Today Carriage Hill Farm operates

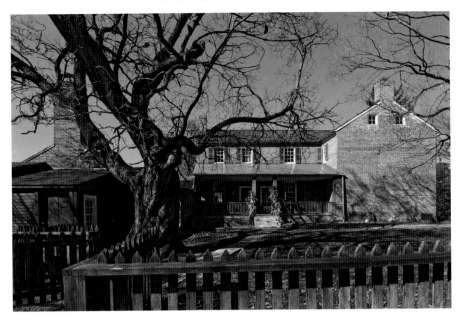

CARRIAGE HILL FARM, NEAR DAYTON

as a living farm, surrounded by several hundred acres of woodlands and prai-
ries, featuring a lake and a pond. The park is open from 8:00 a.m. to 10:00 p.m.,
and the farm's hours are 10:00 a.m. to 5:00 p.m.

Both the Arnold House and the large red bank barn are best photographed
in the morning, but you can find interesting photographs at Carriage Hill
Farm at any time of day. In addition to the house, barn, and several other farm
buildings, there are horses, dairy cows, sheep, goats, pigs, and farm cats ga-
lore. Various educational programs are held each month at Carriage Hill Farm,
including a re-created 1880s county fair in late September, featuring agricul-
tural demonstrations, sorghum processing, and a pie baking competition.

Cleveland's Cuyahoga River Bridges

Location: West and south of downtown Cleveland along the Cuyahoga River
Website: http://ech.cwru.edu/ech-cgi/article.pl?id=B19
GPS Coordinates: 41.490234N 81.693571W (Hope Memorial Bridge)

The Cuyahoga River slices through Cleveland about midway between
the high bluffs on the west side and the plateau of the east side, making the
city highly dependent on bridges that span the "Crooked River." You can take
a boat ride along the Cuyahoga on the *Goodtime III*, Cleveland's largest

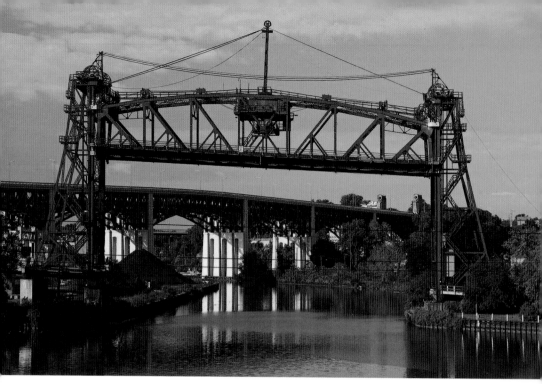

BRIDGES IN FLATS, CLEVELAND

excursion boat, which claims to show passengers more kinds of bridges in a two-hour cruise than any other place in America.

Many of the most interesting bridges are in the Cleveland Flats on the west side and south side of the city, and a drive through this area will reveal more than twenty bridges along the twists and turns of the Cuyahoga River between Lake Erie and Interstate 490 just north of the Industrial Flats. There are huge concrete and steel arch bridges, several types of lift bridges, and a swing bridge.

Try to photograph these bridges on a sunny or partly sunny day, which creates interesting shadows of the bridges that you may want to include in your compositions. The bridges look good against a blue sky, but not against a white, overcast sky. If you are photographing the bridges from land, use a sturdy tripod to ensure stability, maximum flexibility, and image quality. If you are on a boat, leave your tripod behind, because the vibrations on deck from the boat's engines will make the tripod ineffective. Make sure image stabilization is turned on if your camera or lens provides it, and shoot at the

lowest ISO value that will still produce a sharp photograph. Try some wide-angle photos that show the entire bridge, perhaps with some of the city sky-scrapers in the background, or some telephoto views of sections of the bridge that are more abstract.

Clifton Mill, Greene County

Location: 75 Water Street, Clifton, OH 45316. Tel: (937) 767-5501
Website: http://www.cliftonmill.com
GPS Coordinates: 39.794175N 83.825851W

Thirty miles east of Dayton, in the village of Clifton in Greene County, stands the 190-year-old Clifton Mill, one of the largest and most scenic old gristmills in the United States. Rising six stories above the gorge of the Little Miami State Scenic River, the 1820s Clifton Mill is today the only operating gristmill in Greene County, which had as many as seventy mills during the 1800s. The mill's siding is painted an attractive deep red color, and an authentic covered bridge, also painted red, spans the gorge nearby and provides a great view of the mill. Also on the grounds is a 1940s Gas Station Museum, deco-rated with many signs from yesteryear.

As if those attractions aren't enough to draw the artist or photographer, Clifton Mill also hosts an incredible Christmas lighting display from Thanksgiving Day to January 3, when an astounding 3.5 million lights festoon the mill,

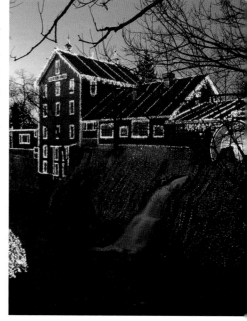

CLIFTON MILL CHRISTMAS LIGHTS

covered bridge, riverbanks, and gorge. There is also a Christmas village and a Santa Claus museum with a collection of more than three thousand Santas, some dating back to 1850. Nearby is Clifton Gorge State Nature Preserve, which offers one of Ohio's finest displays of spring wildflowers.

A visit to Clifton Mill is a must for photographers and Americana fans. The classic shot is a wide-angle morning view from the covered bridge, look-ing west to the mill with the rocky gorge in the foreground and a blue sky to complement the red mill. There is another view from a bridge farther west over the Little Miami Gorge, but in summer a tangle of foliage tends to block

137

the view of the mill from this vantage point. Another great angle is from the south side of the river, but you will need to get permission to go there from the staff at the mill. The Christmas lighting display attracts hordes of visitors on weekends, so visit during the evening on a weekday if possible, preferably on a clear day that will provide a dark blue sky just after sunset. You will need long, multisecond time exposures when shooting the Christmas lights, so be sure to bring a sturdy tripod.

Dickinson Cattle Company, Belmont County

Location: 35500 Muskrat Road, Barnesville, OH 43713. Tel: (740) 758-5050
Website: http://www.texaslonghorn.com
GPS Coordinates: 40.044N 81.1782W

"If Texas Longhorns become a bore, or they eat too much, you can eat them. This is something you can't do with a boat, dog, or a hamster," wrote cattle breeder Darol Dickinson in his book *Fillet of Horn*.

As you're driving east along Interstate 70 in eastern Ohio, at mile marker 200 a giant blue billboard shaped like a long-horned cow appears on the brow of a hill to the south, announcing the Dickinson Cattle Company, which raises up to 1,600 Texas Longhorn, African Watusi, and Dutch Buelingo cattle on 5,000 acres of land that was once strip-mined for coal. Founded by Darol Dickinson and his wife, Linda, in the 1960s, the company is now run

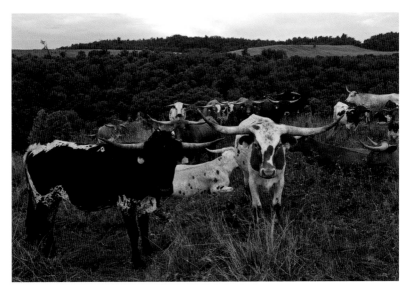

DICKINSON CATTLE COMPANY, BELMONT COUNTY

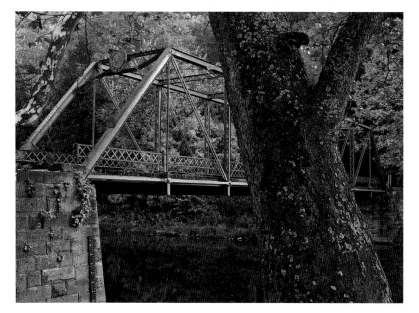

ECHO DELL BRIDGE, BEAVER CREEK

by their children Joel, Kirk, Chad, and Dela. The Dickinson Cattle Company is one of the world's largest producers of Texas Longhorn breeding stock, herd sires, and lean, range-fed beef.

Photographers are welcome, and you can take a 75-minute tour to learn some of the finer points of cattle ranching. Or simply drive along Muskrat Road and admire the herds of cattle from the roadside. If you're a meat lover, be sure to visit the Longhorns Head to Tail store and check out their beef products.

Echo Dell Iron Bridge, Beaver Creek State Park, Columbiana County

Location: In Beaver Creek State Park, on Echo Dell Road, over Little Beaver Creek.
Tel: (330) 385-3091
Website: www.dnr.state.oh.us/tabid/714/Default.aspx
GPS Coordinates: 40.7278N 80.61161W

The Echo Dell Bridge spans Little Beaver Creek in Beaver Creek State Park, located north of East Liverpool in Columbiana County, Ohio. The 129-foot iron bridge was built in 1910 and is based on a Pratt truss design, originally patented by Thomas and Caleb Pratt in 1844. The Pratt truss is identified by its diagonal members which, except for the end ones, all slant down and in toward the center of the bridge. The diagonal members are in tension, and the vertical members are in compression. The Pratt truss is an efficient design,

139

and many Pratt truss bridges built more than a century ago are still in daily use today. The Echo Dell Bridge was repaired and repainted in 2008, and a new roadway was installed.

A large American sycamore near the southwest corner of the Echo Dell Bridge makes a nice foreground for a wide-angle photograph. Nearby are hiking trails along beautiful Little Beaver Creek, which is one of Ohio's State Scenic Rivers. Next to the bridge is a restored lock on the Sandy and Beaver Canal and a pioneer village that includes log buildings, a blacksmith's forge, a schoolhouse, and Gaston's Mill, a restored 1830s gristmill with a water wheel. A few miles west of Beaver Creek State Park is Lusk Lock, featuring curved stonework, one of the most intact locks remaining from the nineteenth-century Sandy and Beaver Canal.

Everett Road Covered Bridge, Cuyahoga Valley National Park

Location: 2370 Everett Road, Peninsula, half a mile west of Riverview Road.
Tel: (216) 524-1497
Website: http://www.nps.gov/cuva/historyculture/everett-road-covered-bridge.htm
GPS Coordinates: 41.204083N 81.583524W

As a resident of Cuyahoga Falls, I'm blessed to live within a few miles of the Cuyahoga Valley National Park, which is home to one of Ohio's most picturesque covered bridges, located on Everett Road, south of Peninsula.

The original Everett Road Covered Bridge, which spans Furnace Run, was built in the 1870s, one of more than 2,000 covered bridges that were built in Ohio—more than in any other state. Today, Ohio has about 140 covered bridges. The original Everett Road Bridge was repaired several times, but, in 1975, a heavy flood lifted the bridge from its stone foundations and the wreckage was deposited farther downstream. The Cuyahoga Valley Association, with help from many other local organizations, raised the funds needed to rebuild the bridge, which was completed by the National Park Service in 1986. The bridge has a Smith truss design.

The bright-red bridge can be photographed from upstream in the afternoon or downstream in the morning. Winter is my favorite time, when snow-covered rocks and trees are a fine contrast with the red bridge and a blue sky. Bring your rubber boots so you can wade in the stream if necessary to explore different angles. If the light is still good when you've finished photographing the bridge, drive a mile south on Everett Road to explore the photo opportunities at Hale Farm and Village.

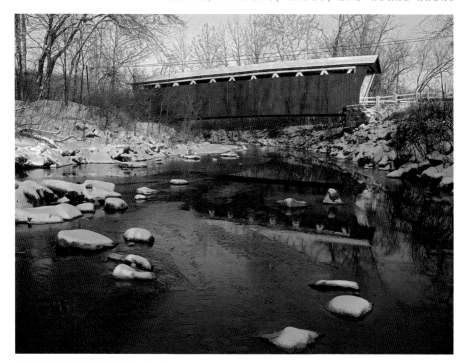

EVERETT ROAD COVERED BRIDGE

Hale Farm and Village, Bath, Summit County

Location: 2686 Oak Hill Road, Bath, OH 44210. Tel: (330) 666-3711
Website: http://www.wrhs.org/index.php/hale
GPS Coordinates: 41.193602N 81.59236W

Hale Farm and Village, a part of the Western Reserve Historical Society, offers a look at life in a 1820s Ohio pioneer settlement, complete with period buildings, livestock, and artisans. Hale Farm and Village is close to Cuyahoga Valley National Park, midway between Cleveland and Akron.

The founder of the village, Connecticut businessman Jonathan Hale, purchased the 500-acre farm for $1,250 in 1810, and in 1820 completed the elegant Federal-style brick farmhouse that still stands. His family continued to operate the farm for three generations. Today, Hale Farm and Village is a working farm and village, with costumed artisans who demonstrate glass blowing, basketry, spinning and weaving, candle making, and blacksmithing. A two-day

141

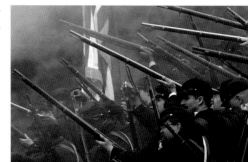

HALE FARM — CIVIL WAR REENACTMENT

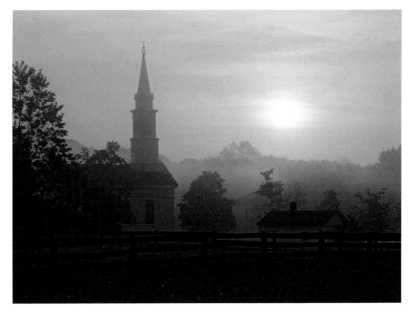

HALE FARM SUNRISE

Civil War Reenactment takes place at Hale Farm each year in mid-August. The farm is open from late spring through fall, and an entrance fee is charged.

The Jonathan Hale House and several of the other buildings can be photographed well from Oak Hill Road, which runs through the center of Hale Farm and Village. The front of the Jonathan Hale House faces east, and is best photographed in the morning. Photography for personal use is allowed, but you may not use any of the photographs for commercial purposes without permission from the Western Reserve Historical Society. The costumed artisans provide excellent opportunities to practice your people-photography skills, and the Civil War Reenactment, which includes a "battle" between Union and Confederate forces, is a wonderful chance to photograph men and women in period and military dress, as well as genuine Civil War artifacts and armaments.

Interurban Bridge, Farnsworth Metropark, Wood County

Location: 8505 S. River Road (U.S. 24), Waterville, OH 43566. Tel: (419) 407-9700
Website: http://www.metroparkstoledo.com
GPS Coordinates: 41.486307N 83.728334W

When the Interurban railroad bridge was built over the Maumee River near Waterville in 1908, it ranked as the longest reinforced concrete bridge in the world. Its construction was controversial, however, because part of a his-

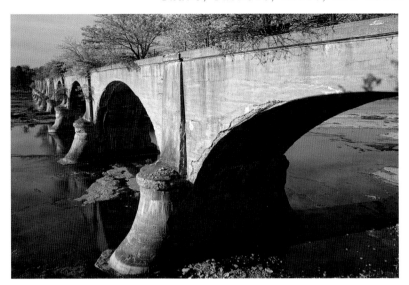

INTERURBAN BRIDGE

toric rock outcrop in the middle of the river, called Roche de Bout (also spelled Roche de Boeuf), was destroyed in the process. The rock had been a traditional meeting place for generations of American Indians, and the local tribes had gathered there before the battle with General "Mad" Anthony Wayne in 1794. The railroad went out of business in 1937, and the bridge was abandoned, an ambivalent monument to engineering prowess and corporate vandalism.

The Interurban Bridge runs north–south across the Maumee River, and is best photographed from the east side in the morning or the west side in the afternoon. The easiest way to approach the bridge is from South River Road on the north bank of the Maumee River, just east of U.S. Route 24 and a mile south of Waterville.

Lake Metroparks Farmpark, Lake County

Location: 8800 Euclid Chardon Road, Kirtland, OH 44094. Tel: (440) 256-2122
Website: www.lakemetroparks.com/select-park/farmpark.shtml
GPS Coordinates: 41.576565N 81.328336W

In a March 2007 article, *USA Today* named Farmpark one of the "ten great places to dig up old dirt on farming." Farmpark is about 25 miles east of Cleveland, on 235 acres that have been used as a dairy farm, an orchard, and an Arabian horse farm. Today, Farmpark operates as a rural educational facility

and science center and is visited each year by more than 200,000 people, including 45,000 schoolchildren. Farmpark is part of the Lake County Metroparks system, and is open year-round.

More than 100 farm animals, encompassing 50 livestock breeds, can be photographed, and dozens of events are scheduled each year, including maple sugaring, sheep herding, horse- and tractor-drawn wagon rides, festivals, and a Christmas lighting display. Be sure to check out the giant tomato, which is 8 feet in diameter!

Lanterman's Mill, Mill Creek Park, Youngstown

LAKE FARMPARK,
TOMATO EXHIBIT

Location: 980 Canfield Road, Youngstown, OH 44511.
 Tel: (330) 740-7115
Website: http://www.millcreekmetroparks.com
GPS Coordinates: 41.066816N 80.682157W

Youngstown lawyer Volney Rogers was the driving force behind the founding of Ohio's first park system in 1891, when Mill Creek Park was established in the western suburbs of Youngstown. The centerpiece of the park is Lanterman's Mill, a gristmill built in 1845–46 by German Lanterman and Samuel Kimberly. The mill was restored from 1982 to 1985 and today grinds corn, wheat, and buckwheat. A scenic waterfall, Lanterman's Falls, can be viewed from an observation deck, and a covered bridge spans Mill Creek a short distance upstream from the mill.

LANTERMAN'S MILL

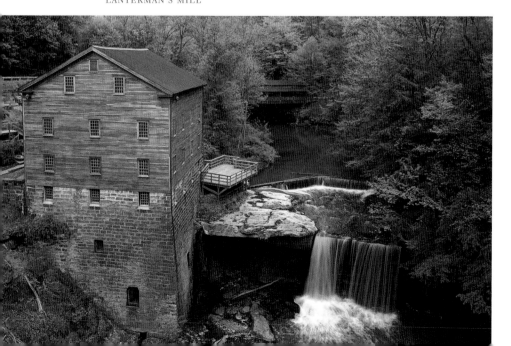

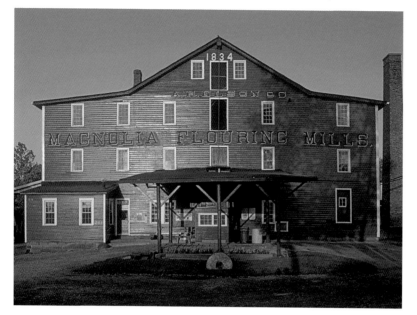

MAGNOLIA FLOURING MILLS

There is an excellent view of Lanterman's Mill, the waterfall, and the covered bridge from Mill Creek Bridge, a concrete arch bridge that spans Mill Creek just north of the mill on State Route 62 (Canfield Road). You will be looking due south, so early morning or late in the afternoon will usually provide the best lighting for this vista, which needs a wide-angle lens to include the mill, waterfall, and covered bridge in the picture.

Magnolia Flouring Mills, Stark County

Location: 261 Main Street, Magnolia, OH 44643. Tel: (330) 477-3552
Website: www.starkparks.com/park.asp?park=9
GPS Coordinates: 40.652845N 81.299226W

Near the southeast border of Stark County, close to the border of Carroll County, sits the town of Magnolia, home to one of Ohio's most picturesque old gristmills. The Magnolia Flouring Mills, also known as Elson's Flouring Mill, was built in 1834 by Richard Elson, whose great-grandson, Mack Elson, manages the mill today. This large mill stands near the remains of a section of the 73-mile Sandy and Beaver Canal, built over the course of two decades from 1828 to 1848, which connected Bolivar on the Ohio and Erie Canal with the Ohio River at Glasgow, Pennsylvania. The canal's middle section, east of

145

Magnolia, was flooded in 1852 and the canal fell into disrepair and was abandoned, but the mill remains and today operates as a feed mill.

The mill is painted a photogenic red, with white trim, and there is a parking area across from it. The front of the mill, which draws most photographers, faces due east, and early morning with a clear blue sky is my favorite time to take pictures from this angle. There is a nice view over the millrace, north of the mill along Main Street, but ugly power lines intrude into the scene. The mill is quite large, and you will need a wide-angle lens to include the entire structure in your picture.

Malabar Farm State Park, Richland County

Location: 4050 Bromfield Road, Lucas, OH 44843. Tel: (419) 892-2784
Website: http://www.malabarfarm.org/
GPS Coordinates: 40.652223N 82.399126W

Pulitzer-winning author and screenplay writer Louis Bromfield built a "Big House" in the rolling farm country of Richland County at Malabar Farm during the 1930s. "Malabar" is a corruption of the Arabic *ma'bar*, meaning, "a place one passes through." Among the many Hollywood celebrities who visited Malabar were Shirley Temple, Errol Flynn, and Dorothy Lamour, as well as Lauren Bacall and Humphrey Bogart, who married and honeymooned at Malabar in May 1945.

In his book *Pleasant Valley*, Bromfield wrote, "Every inch of it [the house] has been in hard use since it was built and will, I hope, go on being used in the same fashion so long as it stands. Perhaps one day it will belong to the state together with the hills, valleys and woods of Malabar Farm." Bromfield's wish was granted in August 1972, when the state of Ohio accepted the deed to Malabar and pledged to preserve the beauty and ecological value of the farm for future generations of Ohioans.

There is a wonderful vista of Malabar Farm from the top of Mount Jeez, reached by a dirt road about a mile east of the farm along Pleasant Valley Road. You'll be looking west to the farm in the distance, and you'll need a 200–400mm lens to isolate the Big House, barn, and other Malabar Farm buildings in your picture. This is a great spot in mid-October, when the hillsides blaze with fall color. Down on the farm, there is a petting zoo, tours of the Big House, several miles of hiking trails, plowing demonstrations in the fields in mid-May, a fall festival, and a host of other photogenic events and activities throughout the year. Malabar receives many visitors, especially on

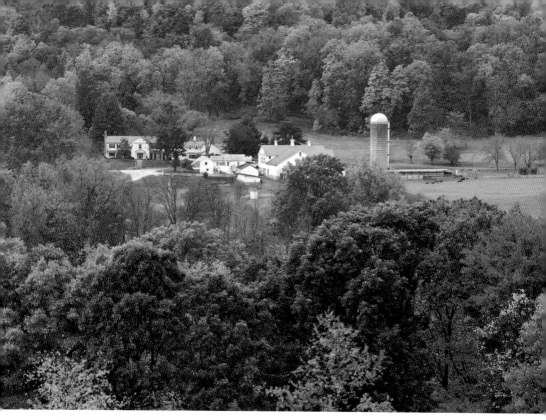

MALABAR FARM STATE PARK FROM MOUNT JEEZ

the weekends during warm weather, so you may want to go there during the week to avoid the crowds.

Manchester Round Barn, Auglaize County

Location: 29249 State Route 385, Lakeview, OH 43331.
Website: N/A
GPS Coordinates: 40.558827N 83.891335W

The J. H. Manchester barn in Auglaize County in northwest Ohio is one of the finest examples of round barns in America. Built by Horace Duncan in 1908, this famous domed barn has served the Manchester farm for five generations. Echoing an eighty-year-old Shaker design, hay and feed were stored in the center for livestock housed around the circumference. With a diameter of 102 feet, the barn is the largest round barn east of the Mississippi River. The entrance faces west and the barn is best photographed in the afternoon. The

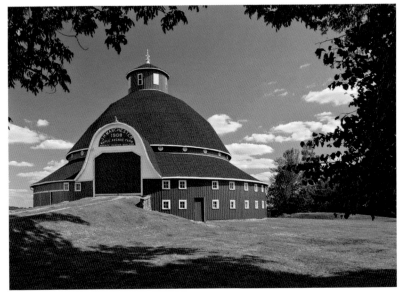

MANCHESTER ROUND BARN, AUGLAIZE COUNTY

Manchester family currently uses the barn for storage. In 2008, to celebrate the centennial of the barn, it was repainted bright red.

Because the barn is on private property, be sure to knock on the door of the main house to introduce yourself and obtain permission from the Manchester family to photograph their magnificent barn.

Ohio Bicentennial Barn, Defiance County

Location: 18622 Lane St., Defiance, OH 43512.
Website: http://www.ohiobarns.com/ohbarns/obicbardef.html
GPS Coordinates: 41.17N 84.3083W

The Ohio Bicentennial Committee commissioned Ohio barn painter Scott Hagan to paint the state's bicentennial logo on a barn in each of Ohio's eighty-eight counties. Hagan, a resident of Belmont County, obtained advice on painting barn murals from fellow Belmont County resident Harley Warrick, the legendary Mail Pouch barn painter, who bequeathed some of his barn painting equipment to Hagan prior to his death in 2000. From 1997 to September 2002, when he completed the last barn mural, Hagan traveled 65,000 miles around the Buckeye State in his pickup truck and used 100 paintbrushes and 645 gallons of paint. No two barns are alike, and Hagan had to paint a second barn in Ottawa County after the first barn was leveled by a tornado in 1998.

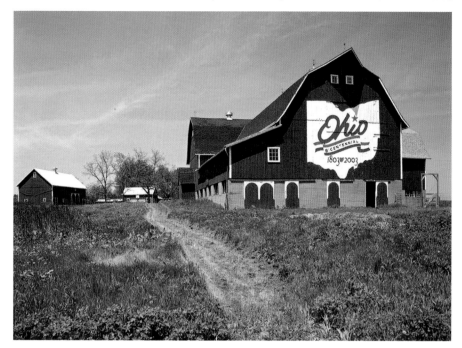

OHIO BICENTENNIAL BARN, NEAR DEFIANCE

Many of the Ohio Bicentennial barn structures are unexceptional, but a few are striking, including the Defiance County barn, which has two logos painted on a double barn, and the Delaware County barn near Interstate 71 north of Columbus. Several books of photographs and paintings of Ohio's eighty-eight bicentennial barns have been produced, and a website, listed at the end of this chapter, provides locations and photographs for each of the barns. Check out these references and make your own decision as to which barns you would like to visit and photograph.

Ohio State and County Fairs

Location: Columbus and all Ohio counties
Website: http://www.ohioexplorer.com/Fairs/
GPS Coordinates: Various

Ohio held its first state fair in Cincinnati in 1850, and for the next twenty-five years the event was held in a variety of locations around the state. In 1874, the Ohio State Fair moved to its permanent site in the state capital, Columbus. Today the Ohio State Fair is one of the largest in the United States, drawing more than 800,000 visitors in 2006 and boosting the Ohio economy by

more than $250 million. The Ohio State Fair lasts almost two weeks and is held in late July and early August at the Ohio Expo Center in Columbus.

Each of Ohio's eighty-eight counties also holds an annual fair some time between late June and late September. The primary focus is agriculture, but many fairs have expanded to include a variety of entertainment and other family activities.

Tripods attract too much attention at county fairs and are best left in your vehicle. A wide-angle to medium telephoto zoom lens, such as the 16–85mm Nikkor, plus a 70–200mm zoom lens, will cover all your photography needs at a county fair. Switch on image stabilization if your camera/lens provides it, set your ISO to 400–800, and take plenty of memory cards—there's much to photograph at county fairs. Llamas and alpacas rub shoulders with massive Percheron and Belgian horses, mules, cows, goats, pigs, chickens, rabbits, and other farm critters. Enjoy an abundance of food offerings, including 4-H chicken dinners, corn dogs, barbecue, ice cream, pies, and lemonade. Point your camera at vintage tractors, steam engines, farm machinery, rodeo events, and hundreds of farm kids competing in the livestock competitions.

Roebling Suspension Bridge, Cincinnati

Location: Between Cincinnati, Ohio, and Covington, Kentucky, over the Ohio River
Website: www.cincinnati-transit.net/suspension.html
GPS Coordinates: 39.09337N 84.509972W

The Covington–Cincinnati Suspension Bridge across the Ohio River has been a major Cincinnati landmark since it was completed in 1866. In 1984, the bridge was renamed the John A. Roebling Suspension Bridge after the innovative engineer who designed it. To protect the city's important river trade, an 1849 charter required that no piers be built in the river, and the technology to build the bridge did not exist prior to Roebling's design. When the bridge was finished in December 1866, the 1,037-foot central span was the longest in the world.

The bridge can be photographed from either end, but the view from Covington includes the Cincinnati skyline and is my

ROEBLING BRIDGE — CINCINNATI

SAUDER VILLAGE — LAUBER'S GENERAL STORE

favorite vantage point. The bridge runs north–south, so the eastern side receives morning light and the western side is illuminated best in the afternoon. In addition to wide-angle photos of the entire bridge and Cincinnati skyline, try using a telephoto lens to isolate some of the intricate features of the piers and cables.

Sauder Village, Archbold, Fulton County

Location: 22611 State Route 2, Archbold, OH 43502. Tel: (800) 590-9755
Website: www.saudervillage.org
GPS Coordinates: 41.543667N 84.299065W

Erie Sauder was raised on a small farm in the Northwest Ohio Mennonite town of Archbold, where he founded Sauder Woodworking in 1934; today the company is the world's largest manufacturer of ready-to-assemble furniture. Sauder was also a local history buff, and during the 1970s, he began collecting cabins, tools, and farm implements used by his Amish-Mennonite ancestors to drain the Great Black Swamp, which covered much of northwest Ohio in presettlement times. His collection is housed at Historic Sauder Village, Ohio's largest living-history farm. Today, the third generation of the Sauder family oversees the village, which includes a 350-seat restaurant, a bakery, a campground, a 98-room country inn, and an exhibit/performance center, Founder's Hall. The farm is a great place to practice photographing dairy

151

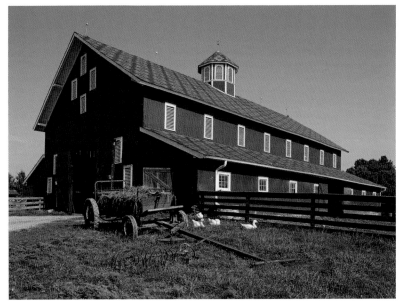

SLATE RUN FARM — BANK BARN

cows, horses, goats, chickens, and other farm animals, as well as log cabins occupied by artisans who demonstrate glassmaking, pottery, basketry, woodworking, quilting, spinning, and weaving.

Slate Run Living Historical Farm, Pickaway County

Location: 1375 State Route 674 N., Canal Winchester, OH 43110. Tel: (614) 833-1880
Website: www.metroparks.net/ParksSlateRunFarm.aspx
GPS Coordinates: 39.753932N 82.849898W

Slate Run Living Historical Farm is a working reenactment of an 1880s central-Ohio farm. The gothic revival farmhouse was built in 1856 and has been restored by the Columbus Metro Parks, which operates Slate Run Farm. The handsome red multibay 1881 barn, with its octagonal cupola and monitor roof extensions, was built by Samuel Oman, the fourth owner of Slate Run Farm, and was restored by Amish carpenters. The farm staff and volunteers dress in period costumes and carry out the daily chores that were part of farm life in the 1880s. This is a wonderful place to bring children to learn about our pioneer farming history. There are miles of trails in the woodlands, fields, and wetlands that surround the farm in Slate Run Metropolitan Park. Slate Run is open throughout the year and admission is free.

Trees shade the farmhouse, and it photographs well on a cloudy day. The gable and entrance to the barn face south, and the handsome barn can be photographed at any time of the day, though morning or evening light would be my preference.

REFERENCES

Barns:

Dregni, M., ed. 2002. *This Old Barn: A Treasury of Family Farm Memories.* Stillwater, MN: Voyageur Press. This heartwarming anthology of stories, photographs, and artwork celebrates the glorious barns of yesteryear. I'm honored to have some of my best barn photographs included in this book.

Ensminger, R. F. 1992. *The Pennsylvania Barn: Its Origin, Evolution, and Distribution in North America.* Baltimore: Johns Hopkins University Press. A well-researched book about bank barns, many examples of which can be found in Ohio.

Friends of Ohio Barns: http://www.ohiobarns.osu.edu. Promotes awareness of Ohio's historic barns.

Noble, A. G., and R. K. Cleek. 1990. *The Old Barn Book: A Field Guide to North American Barns and Other Farm Structures.* Chapel Hill: Rutgers University Press.

Noble, A. G., and H. G. H. Wilhelm, eds. 1995. *Barns of the Midwest.* Athens: Ohio University Press. Describes the log barns, bank barns, round barns, mural barns, and other types of barns found in the Midwest.

Ohio Barns: http://www.ohiobarns.com. A useful website with locations and photographs of Mail Pouch barns, round barns, mural barns, Ohio bicentennial barns, and covered bridges in the Buckeye State.

Sloane, E. 1990. *An Age of Barns.* New York: Henry Holt. A wonderful compendium of paintings, drawings, and information about rural life by the dean of Americana.

Bridges:

Ohio Historic Bridge Association (OHBA): http://www.oldohiobridges.com. OHBA promotes the study and preservation of Ohio's historic bridges.

Wood, M., and D. Simmons. 2007. *Covered Bridges: Ohio, Kentucky, West Virginia.* Wooster OH: The Wooster Book Company. This book offers encyclopedic coverage of Ohio's covered bridges, with photography by Bill Miller.

Mills:

Fralish, L. A., ed. 2000. *Historic Mills of America.* Cedarburg, WI: Landmark Publishing. Includes photographs and information on eleven Ohio mills.

Society for the Preservation of Old Mills (SPOOM): http://www.spoom.org. SPOOM's members include mill owners, old mill buffs, museum curators, writers, teachers, photographers, and mill equipment suppliers.

Rural America:

Brown, R. W. 1991. *Pictures from the Country: A Guide to Photographing Rural Life and Landscapes.* Elizabethtown, NY: Camden House Publishing. Richard Brown is my favorite rural photographer, and nobody has succeeded better in capturing the elusive soul of the New England countryside, especially Vermont, that quintessential symbol of American rural life. Savor his photographs, absorb his sage photographic advice, and chuckle at his tongue-in-cheek Yankee humor.

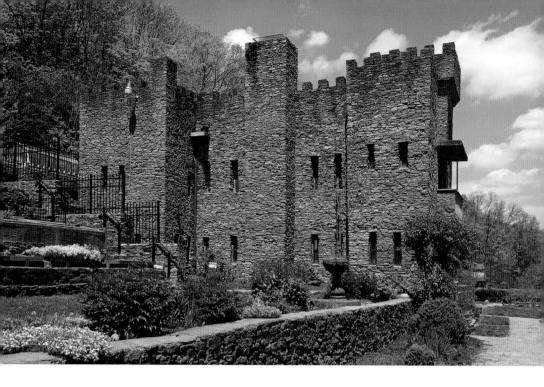

Buildings and Murals

Ohio is blessed with an extensive and diverse collection of architecture. Thousands of buildings, from humble log cabins to imposing Romanesque courthouses to towering city skyscrapers, provide the architecture aficionado with enough material to last a lifetime. More than 3,800 of these structures are listed in the National Register of Historic Places, ranking Ohio third of all the states.

An essential reference for the student of Ohio's architecture is *Building Ohio* by Jane Ware, published by Orange Frazer Press. Volume 1 is a traveler's guide to Ohio's urban architecture, and volume 2 describes rural architecture in the Buckeye State. I was privileged to contribute several photographs to these books, which include information on hundreds of Ohio's buildings compiled during eight years of dedicated research by Ware.

Although I have occasionally photographed power plants, steel plants, and other industrial buildings for clients or for use in book and calendar projects,

155

I have not included any of these privately owned structures in this guide. You should contact the public relations department of the company to obtain written permission before photographing any of these industrial plants. Setting up a tripod and camera to photograph an industrial works, even from a public highway, will attract immediate attention and a visit from the plant security personnel in short order. In these days of heightened security and terrorism alerts, it's especially important to obtain clearance from the appropriate authorities before attempting any industrial landscape photography.

As many older buildings in Ohio fall to the wrecking ball to make way for housing, office buildings, parking lots, shopping malls, and industrial facilities, history-conscious communities around Ohio have commissioned artists to create murals that provide a link to the past by conjuring visions of the architecture, industry, and other human accomplishments of yesteryear. More than twenty-five large murals decorate the walls of buildings in downtown Steubenville, known as the "city of murals." Sixty-six murals stretching over 2,000 feet cover the floodwall along the Ohio River in Portsmouth. Other Ohio cities with noteworthy murals include Bucyrus, Cincinnati, Marion, and Massillon.

Remember that a mural on a building is a copyrighted work of art. I have not encountered any problems using mural photographs editorially in a calendar or a book project, but you should never use a photograph of a copyrighted piece of art in a product advertisement or any other commercial use without first obtaining permission from the mural artist.

TIPS ON PHOTOGRAPHING BUILDINGS AND MURALS

The challenges facing the architectural photographer are similar to those involved in photographing barns and bridges, so the reader is referred to page 125 for a discussion of lighting, perspective control, and other photographic concerns.

Photographing an outdoor mural presents challenges similar to photographing a painting, but on a larger scale. Try to position your camera at right angles to the plane of the mural to minimize perspective problems, and use a lens that is wide enough to cover the entire mural. If you are fortunate enough to own a tilt-shift lens, the shift controls can be used to raise or lower the lens to maintain the correct perspective.

Shadowless lighting is critical when photographing murals. An overcast sky provides diffuse lighting and no shadows. I have also photographed murals that are sunlit, but glare and shadows cast by vehicles, buildings, or other nearby objects can be a problem. I almost always use a polarizing filter to minimize specular reflections from the painted surface of the mural, and it's a good idea to take a couple of photos of the mural with a calibrated gray card, such as a WhiBal, to provide a color reference that can be used to color correct your digital mural photo later.

Belmont County Courthouse, St. Clairsville

Location: 101 West Main Street, St. Clairsville, OH 43950. Tel: (740) 695-9623
Website: http://www.stcchamber.com/index.shtml
GPS Coordinates: 40.081048N 80.900105W

The Belmont County Courthouse was designed by architect Joseph W. Yost and constructed from 1885 to 1888. This imposing Second Empire building sits on the highest point in St. Clairsville and can be seen from many vantage points nearby. The historic National Road passes through St. Clairsville, and Ohio's oldest stone bridge, at Blaine, is about 5 miles east just north of U.S. Route 40.

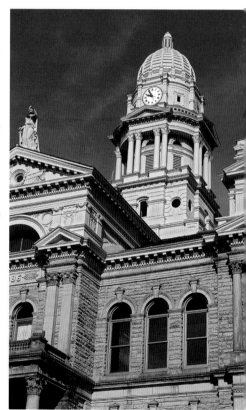

The front of the courthouse faces south, and good photographs can be taken any time during the day if the sky is clear or partly cloudy. There is plenty of traffic along Main Street in St. Clairsville during the day, so try to arrive early or late to minimize the chance that vehicles parked along Main Street will block the view of the courthouse. You'll need a wide-angle lens to photograph the entire building and a telephoto lens to pick out interesting architectural details.

BELMONT COUNTY COURTHOUSE

Chateau Laroche (Loveland Castle), Warren County

Location: 12025 Shore Road, Loveland, OH 45140. Tel: (513) 683-4686
Website: http://www.lovelandcastle.com/
GPS Coordinates: 39.283531N 84.266256W

Chateau LaRoche, known to locals as Loveland Castle, was built by "Sir" Harry Andrews, a committed medievalist who served in World War I as a medic. Andrews visited many castles in Europe and spent fifty years, from 1929 until his death at age ninety in 1981, single-handedly building a castle along the banks of the Little Miami River at Loveland. He used 2,600 sacks of cement, 54,000 five-gallon buckets of dirt, 32,000 quart milk cartons for making concrete bricks, and 56,000 pails of stone, most of them gathered along the banks of the river nearby. Since his death, the castle has been maintained by local boy scouts; Andrews dubbed them "Knights of the Golden Trail."

I like the views of the castle from the southwest best, making morning light on a sunny day optimal for photography. The castle is surrounded by attractive gardens, and be sure to tour the interior of the castle, as well. There is also a waterfall nearby—ask the castle staff for directions.

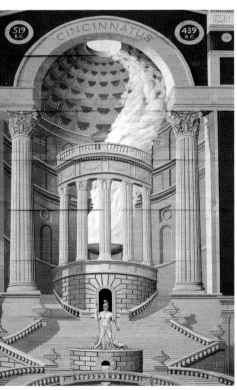

Cincinnatus Mural, Cincinnati

Location: Intersection of Central Parkway and
 Vine Street, Cincinnati
Website: N/A
GPS Coordinates: 39.106956N 84.514709W

Cincinnati gets its name from Lucius Quinctius Cincinnatus, an early Roman military hero and namesake of the Revolutionary War Officers' Society of the Cincinnati. The Kroger Company, which is headquartered in Cincinnati and celebrated its centennial in 1983, commissioned muralist Richard Haas to create a mural depicting Cincinnatus on the north wall of the Cincinnatus Building, formerly the Brotherhood Building (1923). In the mural, Cincinnatus is standing under a baroque staircase leading up

CINCINNATUS MURAL

to a Pantheon-like dome. The wall painting is a superb example of *trompe l'oeil*, in which it is hard to tell what is real and what is painted on the building.

The Cincinnatus mural is more than 100 feet tall, covering most of the north wall of the building, and you will need a wide-angle lens to include the entire mural in your photograph. You will also need to stand across the street, on the north side of Central Parkway. If you own a Canon 17mm or 24mm TS-E tilt/shift lens or a Nikon 24mm PC-E tilt/shift lens, you will be able to use the lens shift function to correct the perspective and keep the wall of the building and mural vertical in your photo; otherwise, take the widest view your lens will allow and use the Crop tool and Transform option in Photoshop to correct the perspective electronically. Because the mural faces north, it is usually shaded, but I still prefer to photograph it on a cloudy day, using a polarizer to eliminate any specular reflections from the surface of the mural.

Cutler Hall, Ohio University, Athens

Location: On the College Green at Court and Union Streets, Ohio University, Athens
Website: http://www.ohio.edu/athens/bldgs/cutler.html
GPS Coordinates: 39.326236N 82.100276W

Cutler Hall is the centerpiece of Ohio University's attractive campus, and is named for Manasseh Cutler, one of the founders of Ohio University. The Federal-style Cutler Hall, which opened in 1819, is the oldest college building west of the Alleghenies and north of the Ohio River. Each day at 8:00 a.m., noon, and 6:00 p.m., chimes in the bell tower play "Alma Mater, Ohio."

Cutler Hall is flanked by Wilson Hall and McGuffey Hall and dominates the view of College Green, where stately American sycamore trees tower over the brick paths that crisscross the green. In the southeast corner of College Green is the octagonal redbrick Galbreath Memorial Chapel, which features four Doric columns and a conical spire rising from a cupola.

CUTLER HALL, OHIO UNIVERSITY CAMPUS

Cutler Hall faces north-northwest and receives frontal light only in early morning or late evening, so arrive early or late if you want to photograph the imposing front of the hall in good light or the College Green area when it is not inundated with students walking to class. Mid-April, when daffodils, tulips, and the many dogwood trees around College Green are in flower, is my favorite time to photograph here, and I prefer a sunny or partly cloudy day. Allow time for a leisurely stroll around this historic section of the Ohio University campus, where you will find many other picturesque subjects for photography.

If you enjoy impressive architecture, be sure to visit Lin Hall at The Ridges, a monumental High Victorian Gothic structure perched on a hill above the Hocking River that took six years to complete. It was completed in 1874 and served as the centerpiece of the Athens Lunatic Asylum for more than 75 years. Today it is part of Ohio University and home to the Kennedy Museum of Art, next door to Ohio University Press, which designed and published this book.

Hope Furnace and Moonville Tunnel, Vinton County

Location: From the dam at the south end of Lake Hope, drive northeast on State Route 278 for 1.2 miles to the Hope Furnace parking area on the north side of the road. To visit the Moonville Tunnel, retrace your steps along State Route 278 to the Lake Hope dam and turn left (east) on Wheelabout Road (County Road 3). After 0.2 miles, Wheelabout Road bears to the right and Shea Road continues east. Follow Shea Road, which becomes Hope-Moonville Road, about 2.3 miles to an iron bridge over Raccoon Creek in Zaleski State Forest. Park here, and follow a hiking trail south along the east side of Raccoon Creek to another short trail that goes up a hill to the old railroad bed. Turn left to reach the Moonville Tunnel.

Website: http://www.oldindustry.org/OH_HTML/OH_Hope.html (Hope Furnace)

GPS Coordinates: 39.332034N 82.340128W (Hope Furnace)
39.30725N 82.322275W (Moonville Tunnel)

Vinton County is the least-populated county in Ohio, and much of the terrain is wooded hills, including Zaleski State Forest and a section of Wayne National Forest. Coal has been mined here, and during the nineteenth century much of the nation's iron was manufactured here in southern Ohio and northern Kentucky in an area known as the Hanging Rock Iron Region, using sandstone blast furnaces charged with a mixture of iron ore, limestone, and charcoal made from trees in the area. The Hope Furnace operated from about 1854 to 1875, and it is the best-preserved of the six furnaces

known to have operated in Vinton County. The front of the furnace faces southwest, so afternoon lighting is usually optimal for photography.

The Moonville Tunnel, located about 4 miles from Hope Furnace, is also well worth a visit. Walk through the tunnel and keep your eyes peeled for the ghosts that are reputed to live there. The interior of the tunnel is quite dark and makes an excellent subject for practicing your skills in High Dynamic Range (HDR) photography. You can photograph the tunnel from either end, though I find the west end of the tunnel to be more photogenic. In spring, the surrounding woodlands in Zaleski State Forest are full of wildflowers and migrating songbirds, and there are some beautiful scenic vistas along Raccoon Creek.

James A. Garfield Historic Site, Mentor

Location: 8095 Mentor Avenue, Mentor, OH 44060.
 Tel: (440) 255-8722
Website: http://www.nps.gov/jaga/index.htm
GPS Coordinates: 41.664061N 81.350939W

HOPE FURNACE

Seven U.S. presidents were born in Ohio, ranking it second to Virginia's eight. James A. Garfield was born on November 19, 1831, in a log cabin in Orange Township in northeast Ohio. He purchased a nine-room home, Lawnfield, at Mentor in 1876 and expanded it to twenty rooms to accommodate his large family. Thousands of people listened to the speeches Garfield gave from the front porch of Lawnfield during his successful campaign for the presidency in 1880. Following his untimely death from an assassin's bullet in 1881, his widow, Lucretia, continued to add rooms to the mansion, and she established the first presidential library there in 1885. Several other buildings, including a windmill, can be seen at the historic site, which is now managed by the National Park Service.

The main house at Lawnfield faces south and receives good light for photography throughout the day. A white picket fence along Mentor Avenue makes an attractive foreground for wide-angle images.

GARFIELD HOME FROM FENCE

Kirtland Temple, Lake County

Location: 7809 Joseph Street, Kirtland, OH 44094. Tel: (440) 256-1830
Website: http://www.kirtlandtemple.org/
GPS Coordinates: 41.625282N 81.362225W

About a mile south of the Interstate 90/State Route 306 interchange in Lake County is the village of Kirtland. From 1831 to 1838, Kirtland was the headquarters of the Church of Jesus Christ of Latter-Day Saints, led by the prophet Joseph Smith. The magnificent Gothic and Greek Revival Kirtland Temple was built from 1833 to 1836, following a vision by Joseph Smith in which the design of the temple was revealed to him. More than 500 men worked on the temple, which is 59 feet by 79 feet on the outside and has a tower that is 110 feet high. During the 1990s, Historic Kirtland, a replica of the 1830s village, was built along the banks of the East Branch of the Chagrin River north of the temple.

The front of the temple, which is painted white on the outside, faces east and receives morning light. My favorite angles for photographing the temple are from the east and from the south, where a garden with trees, rhododen-

drons, and flower borders provides good foreground subjects for framing wide-angle views of the temple. A blue or partly cloudy sky provides the best background for photographing the temple. Historic Kirtland offers several attractive buildings for photography, and Holden Arboretum and Penitentiary Glen, one of the Lake Metro Parks, are both nearby.

Longaberger Corporate Headquarters, Newark

Location: 1500 East Main Street, Newark, OH 43055.
 Tel: (740) 322-5588
Website: http://www.longaberger.com/
GPS Coordinates: 40.06378N 82.346608W

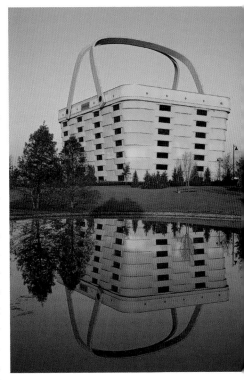

Three miles east of Newark, alongside State Route 16, stands Ohio's most unusual building, a giant seven-story basket, capped with a pair of 150-foot handles and painted in yellow ochre. This Brobdingnagian basket looks like the property of a giant berry picker who has decided to take a snooze. In fact, the building is the corporate headquarters of the Longaberger Company, the world's largest basket manufacturer, and is an exact replica of the company's Medium Market Basket. The company's founder, Dave Longaberger, commissioned the building, which was an architectural challenge to design because it required that the top of the building, like a Medium Market Basket, be wider than the bottom. The 70-ton steel handles are supported by pins, just like a real basket, though these pins are 8 inches in diameter. To ensure that the handles don't drop ice on the glass atrium beneath them, they are heated in winter.

LONGABERGER HEADQUARTERS BUILDING

To the east of the 9,000-ton building is a grassy area and a lake, which provides a nice reflection of the building. At sunrise, the building turns to gold, framed by a blue sky. Since this is a corporate structure, please obtain permission before setting up a tripod to photograph the building, which can also be toured, by appointment, on the inside.

163

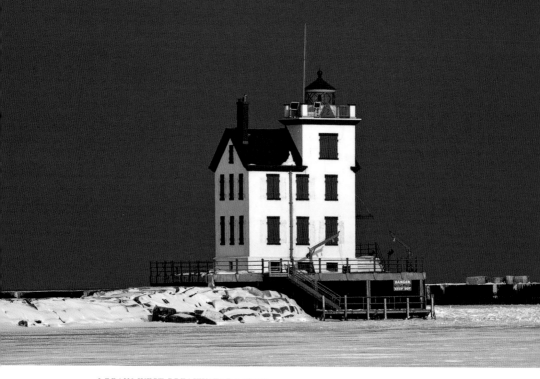

LORAIN WEST BREAKWATER LIGHT

Lorain West Breakwater Light, Lorain County

Location: In Lorain harbor at the end of the West Breakwater
Website: http://www.lighthousefriends.com/light.asp?ID=281
GPS Coordinates: 41.477511N 82.190546W

The picturesque Lorain West Breakwater Light is Lorain's best-known symbol, and local folks call the lighthouse the "Jewel of the Port." The structure was built in 1917 and operated until it was decommissioned in 1965, when a new automated light replaced it. After narrowly escaping demolition on several occasions, the lighthouse was rescued by local citizens and restored; today it is owned by the Port of Lorain Foundation, Inc. The lighthouse is at the northern end of a long breakwater and can be visited only by boat.

The Lorain lighthouse is roughly a half-mile from the nearest point on the mainland where you can view it, so you'll need to use a 400–500mm lens, plus a 1.4X teleconverter, to get a frame-filling image of the light. You will be facing north, more or less, so you can photograph the Lorain West Breakwater Light anytime during the day when the light is good. A blue sky or dramatic

MANTUA CENTER EASTLAWN CEMETERY

clouds contrast well with the building, but avoid flat overcast skies. For a closer look during summer, you can take a $20 boat tour, which includes an hour at the lighthouse, through the Port of Lorain Foundation, Inc.

Mantua Center Historic District, Portage County

Location: At the intersection of State Route 82 and Mantua Center Road in Portage County.

Website: http://www.waymarking.com/waymarks/WM6NXM_Marker_10_67 _Mantua_Center_Historic_District

GPS Coordinates: 41.309374N 81.244085W

Mantua Center Historic District looks like an early New England village green transported to northeast Ohio. In a sense it is; a strip of northeast Ohio 50 miles wide, extending from the Pennsylvania border west for 150 miles, once belonged to Connecticut. This land, known as the Western Reserve, was originally settled by Connecticut Yankees, who patterned their towns and architecture after those in their native New England.

165

The long stone wall on the east side of Mantua Center Road is pure New England, and it is one of my favorite vantage points for photographing the historic district. Beyond the wall is the Eastlawn Cemetery, with gravestones dating to 1812. Next to the cemetery is the 1837 Mantua Civic Center alongside the 1840 Mantua Center Christian Church, with its white steeple. Nearby is the 1840s Mantua Center Town House, which is topped by a cupola.

Spring and fall are my favorite seasons to photograph here, and late afternoon provides good lighting on the stone wall and the main buildings around the village green.

Marblehead Lighthouse, Ottawa County

Location: 110 Lighthouse Drive, Marblehead, OH 43440. Tel: (419) 734-4424
Website: http://www.dnr.state.oh.us/parks/parks/marblehead/tabid/763/Default.aspx
GPS Coordinates: 41.536357N 82.712247W

Marblehead Lighthouse, located about a mile east of the town of Marblehead, is the oldest operating lighthouse on the Great Lakes. Built from local limestone in 1821, the 65-foot beacon is crowned by a red roof and red metal balcony. The lighthouse is said to be the most photographed structure in Ohio, and its image has appeared on a U.S. postage stamp as well as on Ohio vehicle plates. Next to the lighthouse is a picturesque keeper's cottage,

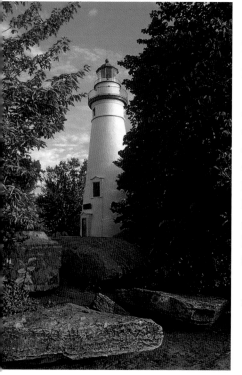

painted white like the lighthouse. The limestone shoreline around the lighthouse makes a good foreground for wide-angle views of this historic beacon. Since 1998, Marblehead Lighthouse has been operated as an Ohio State Park.

Marblehead Lighthouse is a popular tourist destination during the warm months, especially on weekends, so try to avoid these times, especially during the middle of the day, unless you want to photograph the lighthouse surrounded by crowds of visitors. The rocks below the lighthouse are a great place for photographing the sun rising over the Lake Erie horizon, and the lighthouse is photogenic from all four points of the compass.

MARBLEHEAD LIGHTHOUSE

In cold winters, when Lake Erie ices over, the rocks at the base of the lighthouse are one of my favorite locations for photographing the ice as it breaks up in late winter, usually in early March. Sunrise, which occurs around 6:45 a.m. in late winter, is the best time for ice photography here, on clear or partly cloudy days. Be sure to wear Yaktrax on your boots to avoid slipping on the icy rocks, and don't venture out on the ice unless it is extremely thick.

Kelleys Island is about 3 miles north of Marblehead, reached by a twenty-minute ferry ride, and the Lakeside Daisy State Nature Preserve is nearby on Marblehead Peninsula.

WINERY RUINS, KELLEYS ISLAND

Miami County Courthouse, Troy

Location: 215 West Main Street, Troy, OH 45373
Website: N/A
GPS Coordinates: 40.041204N 84.205304W

The magnificent Miami County Courthouse in Troy is one of Ohio's most monumental buildings, with a central dome patterned after the U.S. Capitol, smaller domes on each corner of the roof, elaborate arches over entrances and windows, soaring Corinthian columns, and a 160-foot clock tower. The interior is just as grand, with inlaid tile floors and splendid woodwork and frescoes. Architect Joseph Warren Yost designed the building, which was completed in 1888 and underwent a major interior restoration in 1982 and an extensive outdoor renovation in 1998.

Each of the four façades of this grand building is photogenic, and both morning and afternoon lighting will reveal attractive compositions for your lens. One of my favorite views is from the roof of the municipal building just south of the courthouse, which provides an elevated vantage point that highlights the upper details of the courthouse.

Piqua, a larger Miami County town about 10 miles north of Troy, waged a bitter battle with Troy about which of the two towns should be the site for the county courthouse. Troy won the contest, but there are many distinctive

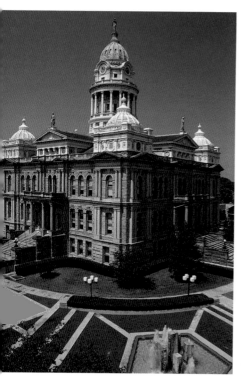

buildings preserved in the Piqua Caldwell Historic District, and the town is well worth a visit. The Piqua Historical Area, 3 miles north of Piqua just east of State Route 66, includes the home and farm of Indian agent John Johnston, as well as the General Harrison, a replica of a canal boat drawn by mules, which operates on a restored section of the Maumee and Erie Canal. A set of staircase locks on this canal are preserved a few miles east, in the village of Lockington.

Oberlin, Lorain County

Location: 12 miles south of Lorain, on State Route 58.
 Tel: (440) 774-7722
Website: http://www.oberlin.edu/external/EOG/
 gbslides/AShortHistory.html
GPS Coordinates: 41.293006N 82.218806W
 (Tappan Square)

The modest size of Oberlin, with a population of only 8,200, and its rural location about 12 miles south of Lorain, belie the town's importance as the site of Oberlin College, a bastion of liberal radicalism, coeducation, and racial equality. The late Geoffrey Blodgett, Professor of History at Oberlin, observed that "Oberlin often seems about ten miles from everywhere: ten miles from Elyria, ten miles from original sin, and ten miles from normal American society."

Oberlin College's reputation as a hotbed of intellectual activism is matched by the originality and diversity of the town's architecture, designed by such architectural luminaries as Cass Gilbert, Robert Venturi, Frank Lloyd Wright, Minoru Yamasaki, Frank Weary, and George Kramer. Massive Richardsonian Romanesque buildings such as Weary and Kramer's Peters Hall, built from local sandstone quarried in Amherst, rub shoulders with elegant Renaissance Romanesque buildings like the Allen Memorial Art Museum, one of five campus buildings designed by Cass Gilbert, and Oberlin's famous Conservatory of Music, a Classical and Modern Gothic design by Minoru Yamasaki.

Most of these buildings are clustered around or near Tappan Square in the center of Oberlin, which provides a fine collection of trees, flowering shrubs,

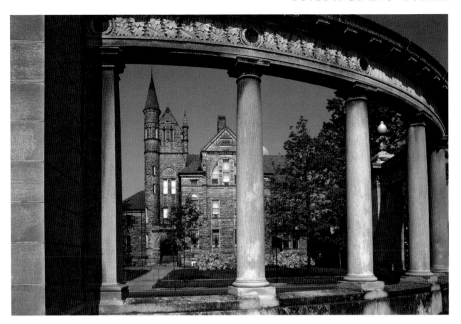

OBERLIN ARCH AND PETERS HALL

and other plantings to complement the architectural variety that surrounds the square. Download a copy of the campus map from the Oberlin College website, shoulder your camera gear, and enjoy a stroll around Tappan Square to sample the architectural delights that Oberlin offers. Be sure to take time to visit the new Adam Joseph Lewis Center for Environmental Studies, designed by William McDonough, one of the world's most prominent "green" architects. This building, described as one of the most significant buildings of the twentieth century, generates most of its power from sunlight and recycles its own wastewater.

Ohio State Reformatory, Mansfield

Location: 100 Reformatory Rd., Mansfield, OH 44905. Tel: (419) 522-2644
Website: http://www.mrps.org/
GPS Coordinates: 40.784646N 82.502439W

Remember the prison scenes in the movies *The Shawshank Redemption*, *Air Force One*, and *Tango and Cash*? The imposing Chateauesque buildings shown in those films are part of the Ohio State Reformatory, a 250,000-square-

foot structure north of Mansfield that includes the world's largest freestanding steel cell block. Designed by Cleveland architect Levi T. Scofield, this historic prison housed 155,000 men from its opening in 1896 to its closing in 1990. Today, the prison is a major tourist attraction, drawing movie buffs and ghost hunters from the far corners of America and beyond.

You can take photos of the exterior of the buildings from the parking area in front of the entrance or during a tour around the facility, but the most interesting photo opportunities are in the prison's interior, especially in the enormous cell block, which offers many locations in which you can practice your skill in High Dynamic Range (HDR) photography, needed to balance the interior and exterior lighting in the building. The photos you take here are strictly for personal use, and you are forbidden to take any images that include the working prison that is located just to the north of the Ohio State Reformatory. A fee is charged, and you should check the website of the Mansfield Reformatory Preservation Society to find out when the facility is open for visitors.

While you are in the Mansfield area, be sure to visit Kingwood Center, one of Ohio's finest public gardens.

Ohio State University, Columbus

Location: 1,700 acres north of downtown Columbus
Website: http://undergrad.osu.edu/pdf/WalkingTour.pdf
GPS Coordinates: 40.00032N 83.00936W (Wexner Center for the Arts)

In contrast to the modest size of the Oberlin College campus, the college grounds of Ohio State University, a few miles north of downtown Columbus, occupy more than 1,700 acres and include 463 buildings. With a total enrollment of more than 63,000 students, Ohio State is one of America's largest universities, and its annual budget of more than $4 billion is bigger than the budget of the state of Delaware.

Most of the photogenic buildings at Ohio State are close to the Oval, a large open grassy area with many large trees and crisscrossed with paths at the center of the campus. It's easy to get lost on this vast campus, so download a copy of the OSU Walking Tour from the website listed above to help you navigate around the campus.

I'm fond of geology, and the 1893 Orton Hall, on the south side of the Oval, is an Ohio geologist's dream, because it was built using forty kinds of Ohio stone, arranged in stratigraphic position with the earliest Ohio bedrock used in

OHIO STATE UNIVERSITY—WEXNER CENTER

the basement. The bell tower houses fourteen bells that together weigh more than 25,000 pounds. West of Orton Hall, Mirror Lake is a favorite hangout for OSU students. Northwest of the Oval is the horseshoe-shaped Ohio Stadium, completed in 1922 and nicknamed "The Shoe." This vast stadium was renovated in 2001 and can now hold more than 105,000 Buckeye fans.

The most unusual building on the OSU campus is the Wexner Center for the Arts, completed in 1989, named for Ohio State alumnus, clothing tycoon, and philanthropist Les Wexner and designed by architect Peter Eisenman. A textbook example of deconstructivism, the varied shapes of the buildings have been described as giant chess pieces, and author Spalding Gray has likened it to "the spaceship that crash-landed on the prairie."

171

Ohio Statehouse, Columbus

Location: 1 Capitol Square, Columbus, OH 43215.
 Tel: (614) 752-9777
Website: www.statehouse.state.oh.us/
GPS Coordinates: 39.961418N 82.999061W

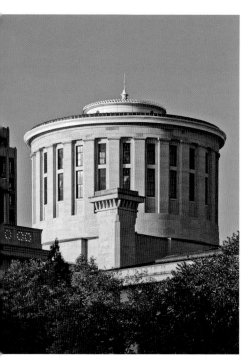

OHIO STATEHOUSE, COLUMBUS

The cornerstone for the Ohio Capitol in Columbus was laid on July 4, 1839, and after twenty-two years of construction the huge, rectangular Ohio Statehouse, built from locally quarried limestone, was completed in 1861. The most distinctive feature of this massive Greek Revival structure, 184 feet wide and 304 feet long, is the circular rotunda that towers 120 feet over the floor of the building. Each side of the statehouse features a recessed porch with Doric columns.

By all means take photographs of the exterior of the statehouse, but it is the interior, especially the rotunda, that I find to be the most interesting subject for photography. You will need a wide-angle lens, at least 24mm (FX) or 16mm (DX), to encompass the entire dome from the floor, which is made up of nearly 5,000 pieces of marble, all laid by hand. Surrounding the rotunda are spiral staircases that are also quite photogenic.

Self-guided tour brochures and audio tour wands, with pre-recorded information on the building, are available at the Statehouse Museum Shop. The Ohio Statehouse is open from 7:00 a.m. through 6:00 p.m. Monday to Friday and 11:00 a.m. through 5: 00 p.m. on Saturday and Sunday. Security is strict, and you and your camera gear will be screened when you enter the building, but I did not encounter any restrictions on using a tripod when I visited.

Ourant School, Harrison County

Location: On Ourant Road, south of Deersville Ridge Road, 12 miles west of Cadiz in
 Harrison County
Website: http://en.wikipedia.org/wiki/Ourant%27s_School
GPS Coordinates: 40.287306N 81.126532W

A century ago, most rural children in Ohio who were not schooled at home learned about reading, writing, and arithmetic in a one-room schoolhouse. There are hundreds of these early school structures remaining in the Buckeye

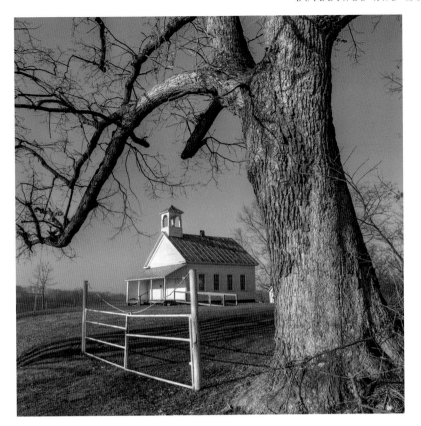

OURANT SCHOOL, HARRISON COUNTY

State, many of them preserved and some converted for use as private homes. In Ohio's Amish Country, one-room schoolhouses are still in active use.

The Ourant School House was built in 1873 on a ridge with a panoramic view of the wooded hills of central Harrison County. The building has wooden siding above a sandstone base, and is painted white with a red roof. The bell tower houses the original school bell. Each spring, local second-grade schoolchildren visit the school to learn how school was taught in the 1800s. The interior of the building is furnished with desks and other equipment from the 1870s.

The front of the schoolhouse faces east, so a morning visit on a sunny or partly cloudy day will provide the best lighting for photography. If you visit in midsummer, be sure to check out the American lotus display at the east end of Tappan Lake, just a few minutes drive to the north.

173

PEOPLE'S FEDERAL SAVINGS & LOAN BANK

People's Federal Savings & Loan Building, Shelby County

Location: 101 East Court Street, Sidney, OH
45365. Tel: (937) 492-6129
Website: http://consumer.discoverohio.com/
searchdetails.aspx?detail=46123
GPS Coordinates: 40.284299N 84.156379W

Architecture aficionados travel from all over the world to admire the elegant 1917 building that stands on the southwest corner of Courthouse Square in Sidney, Shelby County. The People's Federal Savings and Loan Bank was designed by Chicago architect Louis H. Sullivan, one of eight banks he designed late in his career in small Midwestern towns. Sullivan called these banks his "jewel boxes," and the one he designed in Sidney was his favorite. The intricate terra cotta cornice and blue mosaic tiles on the front (northern) side of the building are excellent subjects for photography.

Opposite the bank, the Shelby County Courthouse dominates the square. This 1881 French Second Empire building, with its mansard roof, is an excellent example of the nineteenth-century civic pride that motivated communities to fund elaborate public buildings. West of the courthouse, the impressive 1876 Gothic Monumental Building features a bronze statue, the "Soldier in Blue," high up in an alcove—a tribute to the soldiers who were killed in the Civil War.

When you have finished photographing these architectural treasures, cross the road from the Monumental Building and enjoy a meal at The Spot, a 1941 Art Moderne diner and purveyor of excellent hamburgers.

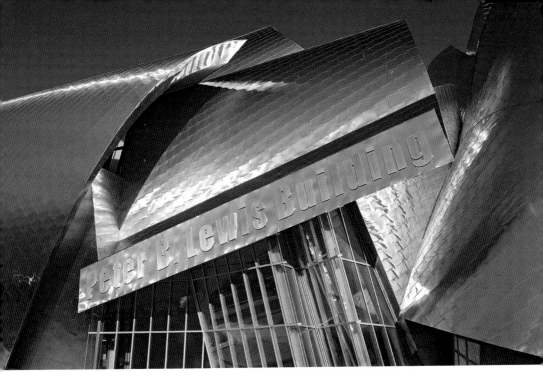

PETER B. LEWIS BUILDING

Peter B. Lewis Building, Case Western Reserve University, Cleveland

Location: 10900 Euclid Avenue, Cleveland, Ohio 44106. Tel: (216) 368-2030
Website: http://weatherhead.case.edu/about/facilities/lewis/
GPS Coordinates: 41.50994N 81.607975W

The Weatherhead School of Management at Case Western Reserve University in Cleveland is housed in the Peter B. Lewis Building, designed by architect Frank Gehry. Billionaire Peter Lewis contributed $37 million of the $62 million cost of the building, which was completed in 2002 and is replete with the stainless steel undulating curves and swirls that are Gehry's trademark.

Although the official address is 10900 Euclid Avenue, the Peter B. Lewis Building is actually located at the intersection of Bellflower Road and Ford Drive. The building is impressive from every direction, so take time to walk around this amazing structure and pick the angle that most catches your fancy. Because the stainless steel is silvery white, it tends to merge tonally with an overcast sky, so a clear day is optimal for photographing this extraordinary building.

While you are in the University Circle area, you may wish to visit the nearby Cleveland Art Museum, Cleveland Botanical Garden, or Cleveland Museum of Natural History.

Piatt Castles, West Liberty, Logan County

Location: East of West Liberty on State Route 245 in
 Logan County. Tel: (937) 465-2821
Website: http://www.piattcastles.org/
GPS Coordinates: 40.258369N 83.716937W (Castle
 Piatt Mac-O-Chee)
 40.251096N 83.726884W (Castle Piatt Mac-A-Chee)

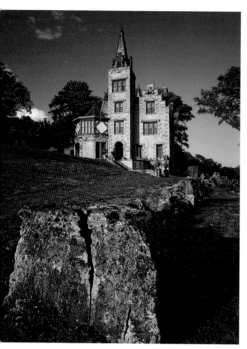

CASTLE PIATT MAC-O-CHEE

In the rolling hills of Logan County a couple of miles east of West Liberty, two eccentric brothers, Colonel Donn Piatt and General Abram Sanders Piatt, built themselves castles a mile apart in the mid-1800s. Castle Piatt Mac-A-Cheek, named for a local Shawnee Indian settlement, was built in 1871 and is patterned after a Norman French chateau. Donn Piatt's Castle Mac-O-Chee, the more fanciful of the two buildings—a three-story Flemish affair with two towers—rises a mile farther east and was completed in 1881. Both castles are owned by descendants of the Piatt family and are open for tours from mid-April through the end of October.

Castle Piatt Mac-O-Chee is the more imposing of the two buildings and the easiest to photograph, preferably in the afternoon when it receives the best lighting. Castle Piatt Mac-A-Cheek sits on a hill surrounded by trees and is hard to photograph when the foliage has leafed out. Both castles have splendid interiors with elegant woodwork, furniture, and Piatt family memorabilia.

About 2.5 miles south of the Piatt Castles, on State Route 245, is Ohio Caverns, and another 0.5 mile south in Champaign County is the extremely photogenic 1881 Mount Tabor Church, where frontiersman Simon Kenton worshipped. The gravestones in the cemetery that surrounds the church are tilted at all angles and date back to the early 1800s. Opposite the church is an excellent vista of the Logan/Champaign countryside.

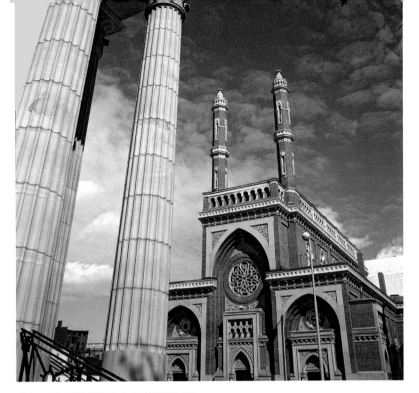

PLUM STREET TEMPLE, CINCINNATI

Plum Street Buildings, Cincinnati

Location: 720 Plum Street, Cincinnati, OH 45202. Tel: (513) 793-2556
Website: http://www.wisetemple.org
GPS Coordinates: 39.103767N 84.518308W

The intersection of West 8th Street and Plum Street is a treasure trove of fine Cincinnati architecture. Within a stone's throw of each other are the magnificent granite and sandstone walls of the 1893 Richardsonian Romanesque City Hall, the limestone Corinthian columns of the 1845 Greek Revival St. Peter in Chains Cathedral, and the red brick Gothic arches and Moorish minarets of the 1866 Isaac M. Wise Temple, known locally as the Plum Street Temple. There's enough subject matter here to keep an architectural photographer occupied for months. The interiors of the three buildings are equally impressive, and architectural historian John Clubbe, in his wonderful book *Cincinnati Observed: Architecture and History*, describes the inside of the Plum Street Temple as "the city's single most arresting space."

The roof of the municipal parking facility adjacent to the Plum Street Temple provides a fine morning view of St. Peter in Chains Cathedral and City Hall. Plum Street Temple is best photographed in the afternoon from a vantage point across Plum Street near the columns of the cathedral.

Plymouth Street, Hanoverton

Location: Just north of the Lincoln Highway (State Route 30) in Hanoverton, Columbiana County
Website: http://www.spreadeagletavern.com
GPS Coordinates: 40.753193N 80.934961W

Hanoverton is a small town on the historic Lincoln Highway (State Route 30) in Columbiana County, about 30 miles southeast of Canton and roughly midway along the route of the old Sandy & Beaver Canal, which flowed from Bolivar in Tuscawaras County to the Ohio River north of East Liverpool. Just north of the intersection of State Route 30 and State Route 9 in Hanoverton is Plymouth Street, a narrow roadway flanked by Federalist buildings built between 1817 and 1900. The most impressive building is the Spread Eagle Tavern, an 1837 inn that has been meticulously restored by the Johnson family. The Spread Eagle Tavern is a favorite stopover for Republican politicians on the campaign trail, and past visitors may have rubbed shoulders with Pat Buchanan, Dan Quayle, John McCain, Newt Gingrich, and George Voinovich. Regardless of your political affiliation, you will be charmed by Plymouth Street, where the "canal era" architecture is virtually unchanged after more than 150 years.

During summer, tree foliage along Plymouth Street obscures many of the buildings, so my favorite seasons for photographing here are early spring, late fall, and in winter after a fresh snowfall. After a photography session, reward yourself with a fine meal at the Spread Eagle Tavern or drive ten minutes east along State Route 30 and enjoy a less expensive but still delicious meal at the Steel Trolley Diner in Lisbon.

Portsmouth Floodwall Murals

Location: Along Front Street north of the Ohio River in downtown Portsmouth. Tel: (740) 353-7647
Website: http://ourohio.org/magazine/2007-2/september-october-2007/2-000-feet-of-art/
GPS Coordinates: 38.730741N 83.004094W

Artist Robert Dafford, a native of Lafayette, Louisiana, and a team of artists have created a monumental series of sixty-six murals, 20 feet tall, stretching

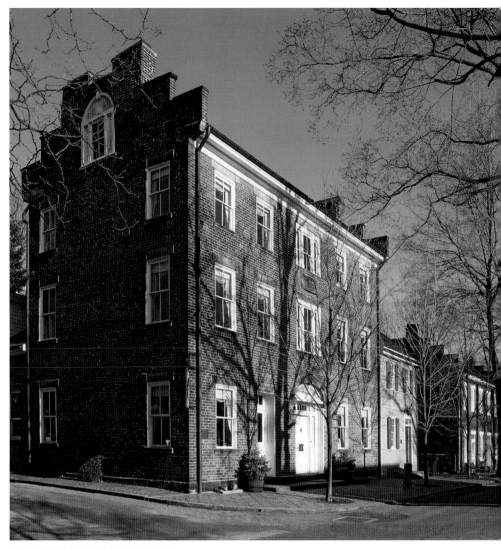

PLYMOUTH STREET, HANOVERTON

for more than 2,000 feet along the concrete floodwall that borders the Ohio River and Front Street in the historic Boneyfiddle district of Portsmouth, in Scioto County. Two thousand years of Portsmouth history are recorded in these brushstrokes, including the city's American Indian inhabitants, early European settlers, industries, farms, churches, hospitals, schools, Civil War combatants, sports teams, and a lengthy list of local celebrities.

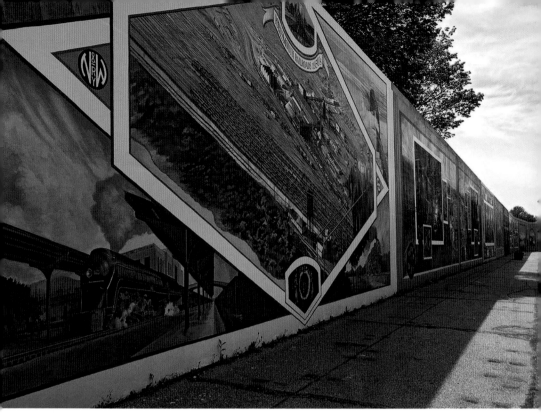

PORTSMOUTH FLOODWALL MURALS

The artworks face north, and parking is allowed in front of them, so arrive early if you would like to have an uninterrupted view of these extensive murals. Portsmouth is only a few miles east of Shawnee State Forest, which is especially scenic in mid- and late April, when dogwoods, redbuds, and hillsides of wildflowers are in bloom.

Pro Football Hall of Fame, Canton

Location: 2121 George Halas Drive NW, Canton, OH 44708. Tel: (330) 456-8207
Website: http://www.profootballhof.com
GPS Coordinates: 40.820656N 81.397192W

Driving south along Interstate 77, as you near the city of Canton, a circular building crowned with a giant football appears on the right—the Pro Football Hall of Fame. This national shrine to America's most popular sporting obsession was opened in 1963. Today, the building has expanded to an 83,000-square-foot complex full of action films, dozens of displays, and gridiron memorabilia. A seven-foot statue of early football hero Jim Thorpe greets visitors to the

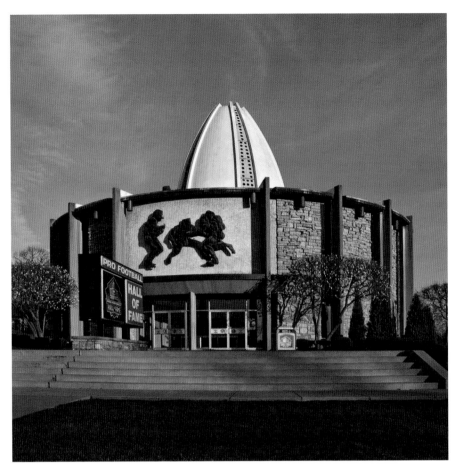

PRO FOOTBALL HALL OF FAME, CANTON

museum, in which the highlight is a spectacular rotating theater, where NFL football scenes are shown on a giant, two-story Cinemascope screen.

The best view of the building is from the grass verge east of the entrance, which is flanked by two magnolia trees that bloom in mid-April. Early morning under a clear blue sky provides ideal lighting for a portrait of this unusual building.

Two other historic buildings in Canton worth a visit are the McKinley Monument and the National First Ladies' Library. The impressive McKinley Monument, a couple of miles south of the Pro Football Hall of Fame, in McKinley Memorial Park, is the final resting place of President William McKinley, the twenty-fifth United States president. Leading up to the 96-foot-high Neoclassical Revival granite tomb are 103 steps, a favorite challenge for

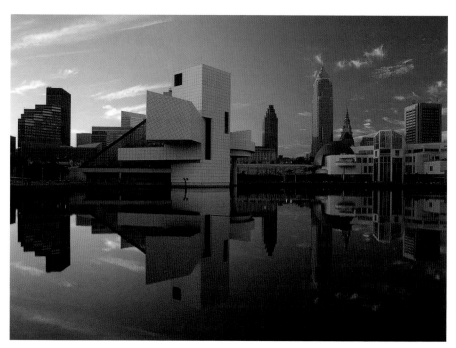

ROCK AND ROLL HALL OF FAME, CLEVELAND

local walkers and joggers. The steps are angled from northwest to southeast and make an effective foreground for wide-angle photographs of the monument that can be taken in the morning or afternoon. The National First Ladies' Library is in downtown Canton at 331 Market Avenue South, at the beautifully restored Ida Saxton McKinley Building, where future President McKinley and his wife lived from 1878 to 1891. The most attractive façade of the Victorian building faces east, and is best photographed from the east side of Market Avenue early in the morning.

Rock and Roll Hall of Fame, Cleveland

Location: On the Cleveland Lakefront near Voinovich Park. 1100 Rock and Roll Blvd.,
 Cleveland, OH 44114 Tel: (216) 781-7625
Website: http://rockhall.com/
GPS Coordinates: 41.508732N 81.695507W

Cleveland's most spectacular building, a 115-foot-high triangular glass pyramid flanked by a rectangular white tower, trapezoidal extension, and white cylinder, stands just south of Voinovich Park at the north end of East Ninth Street. The Rock and Roll Hall of Fame and Museum was completed in 1995,

a testament by world-famous architect I. M. Pei to Cleveland's claim to be the rock and roll capital of the world. Steven Litt, the architecture critic for the Cleveland *Plain Dealer*, described the building as "a beautiful piece of sculpture."

The Rock and Roll Hall of Fame is distinctive from any angle, but my favorite view is from Voinovich Park to the north, which affords a reflection of the building in the water at the edge of Lake Erie. Early morning usually offers the best opportunity for calm water, and a clear sky is needed to maximize the contrast with the white building.

Stan Hywet Hall and Gardens, Akron

Location: 714 North Portage Path, Akron, Ohio 44303. Tel: (330) 836-5533
Website: http://www.stanhywet.org
GPS Coordinates: 41.11869N 81.549025W

Stan Hywet Hall and Gardens is a magnificent country estate in Akron, built between 1912 and 1915 by Frank A. Seiberling, one of the founders of the Goodyear Tire and Rubber Company. The 65-room Tudor Revival Manor House is the largest private home ever built in Ohio, and the sixth largest, based on square footage, in the United States. Seiberling named the estate Stan Hywet, which is Old English for "stone quarry," one of the main features of the estate. During the late 1990s, I photographed the gardens at Stan Hywet for a book titled *Stan Hywet Hall and Gardens*, with text by Steve Love, published by The University of Akron Press in 2000.

As mentioned in the chapter on Ohio's public gardens, you are welcome to take photographs at Stan Hywet Hall and Gardens for personal use, but tripods are not allowed and photography inside the Manor House is prohibited unless special permission is obtained in advance. The best approach is to use a high ISO setting, say 400 or 800, on your digital camera, which will allow you to hand-hold the camera and still obtain sharp images with adequate depth-of-field. The enormous Manor House is photogenic from all points of the compass, and the Gatehouse, Carriage House Visitor Center, and Corbin Conservatory are other Stan Hywet buildings that are attractive subjects for photography.

STAN HYWET HALL — MANOR HOUSE AND WEST TERRACE POOL

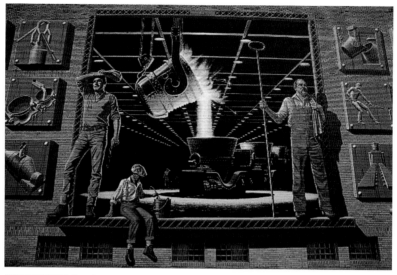

STEUBENVILLE — STEELWORKERS MURAL.

Steubenville Murals, Jefferson County

Location: In downtown Steubenville, Jefferson County. Tel: (800) 510-4442
Website: http://www.visitsteubenville.com/directions/maps.html
GPS Coordinates: 40.359238N 80.613152W (Fort Steuben)

In the mid-1980s, Steubenville civic and business groups were looking for a way to burnish the city's Rust Belt image, and they settled on having large murals painted on city buildings that would highlight the history of the city. Since then, artists from seven U.S. states and Scotland have created more than twenty town murals, featuring subjects that include a 1905 train station, a coal mine, the interior of a 1920s market, a fire house, Ohio River steamboats, Catholic churches, steelworkers, and a steam laundry. As a result of the mural program, Steubenville has become known as the "city of murals."

A Kroger grocery wall high above the downtown area of the city is the canvas for local artist Robert Dever's mural celebrating Steubenville's favorite son, singer and actor Dean Martin. Born Dino Crocetti on June 7, 1917, he became famous as a member of the "Rat Pack" and half of the Dean Martin–Jerry Lewis comedy team.

The murals are scattered throughout the city, and the best way to locate them is to obtain a map from the Steubenville Visitor's Center, located at 120 S. Third Street, Steubenville. This map can also be downloaded from the web-

site listed above. If your schedule permits, drive south along State Route 7 from Steubenville to visit Mingo Junction, a gritty Rust Belt steel town that was the setting for the film *The Deer Hunter*, starring Robert De Niro and Meryl Streep.

Thomas Edison Birthplace, Erie County

Location: 9 Edison Drive, Milan, OH 44846.
 Tel: (419) 499-2135
Website: http://www.tomedison.org/index.html
GPS Coordinates: 41.30005N 82.604469W

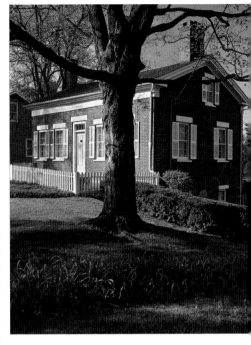

THOMAS EDISON BIRTHPLACE

Prolific inventor Thomas Alva Edison was born in a small brick house in Milan, a few miles south of Lake Erie, in 1847. The house was built by his parents, Samuel and Nancy Edison, near the bank of the Milan and Erie Canal, and Thomas was the youngest of their seven children. Young Tom had a troubled childhood and today might be considered as a poster child for Attention Deficit Disorder. He once sat on goose eggs for hours in a neighbor's barn to see if he could hatch the eggs faster than the mother goose; set a fire that burned down a barn; fell into the canal and had to be rescued; and tumbled into a grain bin at the local docks and almost suffocated. His Milan neighbors may have breathed a sigh of relief when the Edison family moved to Michigan in 1854. Needless to say, Edison redeemed himself after his early childhood escapades with his many inventions, including the first practical lightbulb, the phonograph, the first movie projector, the alkaline storage battery, and the forerunner of the modern electricity distribution system.

The house is best photographed from the east, when morning light favors the front of the building. Edison repurchased the house himself in 1906, and today it is operated as a museum that showcases Edison family memorabilia, including replicas of many of his most important inventions. A few miles west of Milan, south of State Route 113 on Lover's Lane (County Highway 48), is the Milan Wildlife Area, which has beautiful displays of spring wildflowers in the woods along the banks of the Huron River.

185

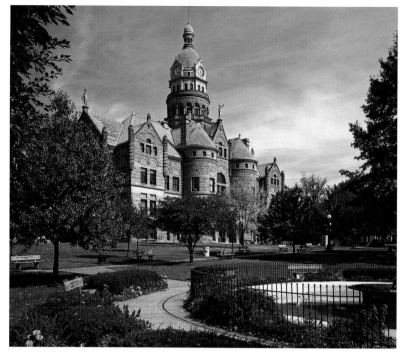

TRUMBULL COUNTY COURTHOUSE

Trumbull County Courthouse, Warren

Location: 161 High Street NE, Warren, OH 44481. Tel: (330) 675-2650
Website: http://www.exploretrumbullcounty.com/placestovisit/historicsites.html
GPS Coordinates: 41.23717N 80.8191W

The Trumbull County Courthouse in Warren is one of America's finest examples of Richardsonian Romanesque architecture. This style was developed by Boston architect Henry Hobson Richardson and is characterized by the use of rough-faced, square sandstone blocks, round towers with cone-shaped roofs, broad "Roman" arches over doorways and arcades, and patterned masonry arches over windows. The Trumbull County Courthouse was completed in 1897 and a new copper roof was installed in 1996. The roof includes four statues of Justice and a four-sided clock tower. The interior of the courthouse, which was also fully restored during the 1990s, features mosaic flooring, magnificent paneled oak woodwork, and Romanesque stairways constructed from pink Tennessee marble.

The courthouse faces south and is located on the north side of an attractive park square in the center of Warren. There are trees and flower borders

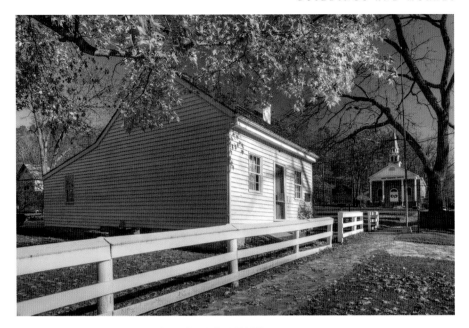

ULYSSES S. GRANT BIRTHPLACE, POINT PLEASANT

that provide excellent material for wide-angle foregrounds and for framing the building. Just west of the courthouse, at 391 Mahoning Avenue NW, is the Perkins Mansion, which also serves as City Hall for Warren.

Ulysses S. Grant Birthplace, Point Pleasant

Location: 1551 State Route 232, Moscow, OH 45153. Tel: (800) 283-8932
Website: http://ohsweb.ohiohistory.org/places/sw08/index.shtml
GPS Coordinates: 38.894474N 84.232621W

Two-term U.S. president Ulysses S. Grant was born in a tiny, three-room cottage in Point Pleasant, east of Cincinnati in Clermont County, on April 22, 1822. The cottage stood next to a tannery where Grant's father worked. After Grant's death, the cottage toured the country on a barge and railroad flat car before returning to be placed in the Ohio State Fairgrounds. It was finally moved back to its original location at Point Pleasant in 1927. A year after his birth, the Grant family moved to Georgetown in Brown County, where Grant's boyhood home may be visited. The Point Pleasant cottage is filled with period furnishings, including a straw bed.

From an architectural viewpoint, the cottage is humble and undistinguished, but it makes an attractive photograph with the Grant Church in the

187

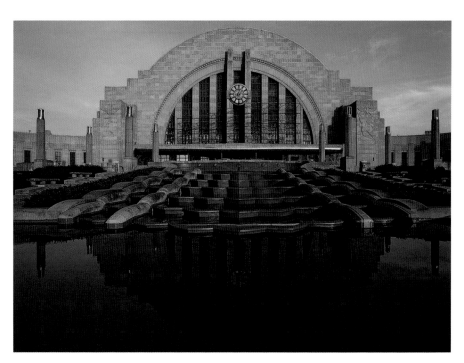

background, close to the banks of the Ohio River. While you are in the area, drive a few miles east to Ripley, and enjoy the grand view of the town and the Ohio River from the Rankin House.

Union Terminal, Cincinnati

Location: 1301 Western Avenue, Cincinnati, OH 45203. Tel: (513) 287-7000
Website: http://www.cincymuseum.org/
GPS Coordinates: 39.110068N 84.537028W

About a mile northwest of the center of Cincinnati stands one of the most magnificent Art Deco buildings in America, the Union Terminal. Originally built in 1933 as the Union Terminal train station, the huge arched building was designated as a National Historic Landmark in 1977. The ten-story limestone and glass east façade is flanked by curved wings, and in front of the building is a large cascading fountain and pool. Inside the terminal, huge glass-tile mosaic murals designed by Winold Reiss stretch around the base of the walls, which are painted orange, brown, and yellow, with silver striping. Today Union Terminal is the home of the Cincinnati Museum Center, an educational and cultural complex that includes the Cincinnati Museum of Natural History, the Cincinnati Historical Society Museum and Library, and the Robert D. Lindner

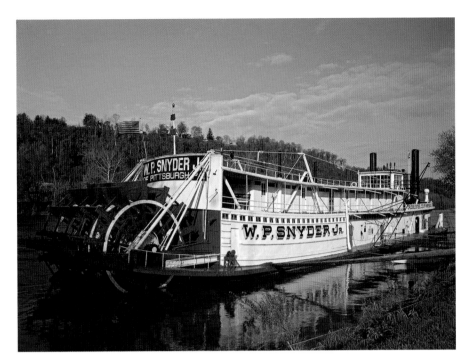

W. P. SNYDER JR. STERNWHEELER

Family OMNIMAX ® Theater. There is an excellent bookstore with a fine selection of books on Cincinnati inside the Museum Center.

The huge arch of the Union Terminal, with the cascading fountain and pool in the foreground, provides a classic wide-angle lens photograph, and is best photographed on a clear day early in the morning before crowds of visitors arrive. The use of a tripod inside the building is discouraged by the Cincinnati Museum staff, so use a high ISO value and hand-hold your camera if you want to photograph the interior murals and other features.

The Cincinnatus mural, described elsewhere in this chapter, is about 1.5 miles east of the Union Terminal.

W. P. Snyder Jr. Sternwheeler, Marietta

Location: Ohio River Museum, 601 Front Street, Marietta, OH 45750.
 Tel: (740) 373-3750
Website: http://www.hmdb.org/Marker.asp?Marker=20632
GPS Coordinates: 39.420284N 81.463453W

The W. P. Snyder Jr. is the only remaining example of the steam-powered, stern-wheeled towboats that moved barges of coal, iron ore, and other industrial products along the Ohio River during the last century. The W. P. Snyder Jr.

was built for the Carnegie Steel Company and launched in 1918 as the *W. H. Clingerman.* The Crucible Steel Company of America bought the boat in 1945 and renamed her the *W. P. Snyder Jr.*, after the company's president. The boat was donated to the Ohio Historical Society in 1955 and today is the show-piece of the Ohio River Museum in Marietta. In November 2009, the boat was towed to South Point on the Ohio River to have her hull replaced, a process that was completed in late 2010.

The *W. P. Snyder Jr.* makes a nice photograph early in the morning on a clear day, with the Ohio River and Harmar Heights in the background. You can also tour the *W. P. Snyder Jr.* to photograph the details on the boat. Nearby is the Campus Martius Museum, which includes a house that was built in April 1788 by Revolutionary War general Rufus Putnam, the founder of Marietta.

Warren G. Harding Memorial, Marion

Location: Intersection of State Route 423 and Vernon Heights Boulevard in Marion.
Website: http://ohsweb.ohiohistory.org/places/c04/
GPS Coordinates: 40.573056N 83.123056W

President Warren G. Harding and his wife, Florence, are buried in a striking Neoclassical Revival memorial near Marion in central Ohio. Harding was a popular president, and after his sudden death in late 1923, contributions flooded in to build a distinctive memorial. The circular colonnade, carved from Georgian marble, stands on an elevated plinth and is 50 feet high and 103 feet in diameter, with 46 columns. A Japanese maple shades the black tombstones of President Harding and his wife. The memorial,

designed by Henry Hornbostel and Eric Wood, was completed in 1927 and occupies a 10-acre site with lawns and floral borders about 1 mile south of downtown Marion.

The front of the memorial faces northwest, and is therefore best photographed during the afternoon. The light marble, almost white, contrasts well with a blue sky but not with an overcast sky. From spring through late summer, beds of flowers around the memorial can be used as attractive foreground elements in wide-angle views.

WARREN G. HARDING MEMORIAL

ZOAR HOTEL

Zoar Village, Tuscarawas County

Location: In Tuscarawas County, 15 miles south of Canton on State Route 212.

 Tel: (330) 874-2646

Website: http://www.nps.gov/history/nr/travel/ohioeriecanal/zoa.htm

GPS Coordinates: 40.615471N 81.422524W

 Zoar was founded in 1817 by a group of two hundred German Separatists, led by Joseph Bimeler, who were fleeing from religious persecution in their European homeland. Zoar, their new settlement near the Tuscarawas River, was named after the biblical place where Lot sought refuge from Sodom. The Zoarites, as they were called, helped dig 7 miles of the nearby Ohio and Erie Canal, which allowed them to pay off the debt owed on the land they had purchased to build their settlement. The community thrived, and by the mid-1800s, the Zoarites had accumulated assets of more than one million dollars. After Joseph Bimeler's death in 1853, the community began to decline, and Zoar was

191

officially disbanded in 1898. Today, ten of the original buildings are managed by the Ohio Historical Society and the Zoar Community Association.

From a photographer's viewpoint, the main attractions at Zoar are the preserved historical buildings and the gardens around the town. The Greek Revival and German Baroque Zoar Hotel, built in 1833 and restored in 2000, is especially photogenic and is best photographed from the west in the afternoon. The central gardens in the town square cover an acre, and costumed interpreters conduct tours of the main buildings during the warm months. South of Zoar at Camp Tuscazoar, the restored Zoarville Station Bridge over the Tuscarawas River is the only Fink Through truss bridge known to exist in the United States.

REFERENCES

Clubbe, J. 1992. *Cincinnati Observed: Architecture and History.* Columbus: Ohio State University Press.

Ware, J. 2002. *Building Ohio: A Traveler's Guide to Ohio's Rural Architecture.* Wilmington, OH: Orange Frazer Press.

———. 2002. *Building Ohio: A Traveler's Guide to Ohio's Urban Architecture.* Wilmington, OH: Orange Frazer Press.

Regional Maps

Northwest Region

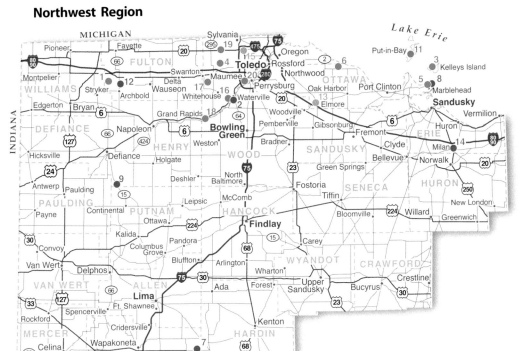

Legend

- Scenic Vista
- Natural Area or Preserve
- Public Garden
- Barn, Bridge, or Rural area
- Building or Mural
- (70) Interstate Highway
- (23) U.S. Highway
- (161) State Road

0 10 20 30 mi

Key to Locations on the Map

1 Goll Woods State Nature Preserve
2 Interurban Bridge, Farnsworth Metropark
3 Kelleys Island, Ottawa County
4 Kitty Todd State Nature Preserve
5 Lakeside Daisy State Nature Preserve
6 Magee Marsh/Ottawa National Wildlife Refuge
7 Manchester Round Barn, Auglaize County
8 Marblehead Lighthouse, Ottawa County
9 Ohio Bicentennial Barn, Defiance County
10 People's Federal S&L Building, Sidney

11 Perry's Victory Memorial, Put-in-Bay
12 Sauder Village, Archbold, Fulton County
13 Schedel Arboretum and Gardens, Elmore
14 Thomas Edison Birthplace, Milan, Erie County
15 Toledo Botanical Garden
16 Toledo Metroparks (Farnsworth)
17 Toledo Metroparks (Oak Openings)
18 Toledo Metroparks (Providence)
19 Toledo Metroparks (Secor)
20 Toledo Metroparks (Side Cut)

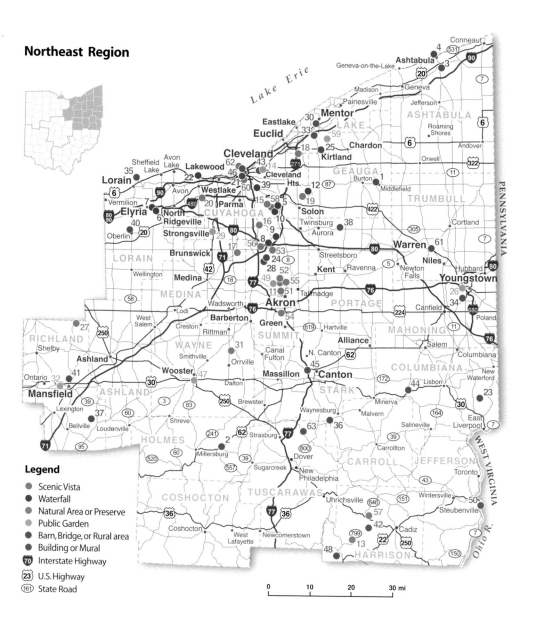

Northeast Region

Lake Erie

PENNSYLVANIA

WEST VIRGINIA

Ohio R.

Legend

- Scenic Vista
- Waterfall
- Natural Area or Preserve
- Public Garden
- Barn, Bridge, or Rural area
- Building or Mural
- 🄷🄾 Interstate Highway
- ㉓ U.S. Highway
- ⑯⓵ State Road

0 10 20 30 mi

Key to Locations on the Map

Central Region

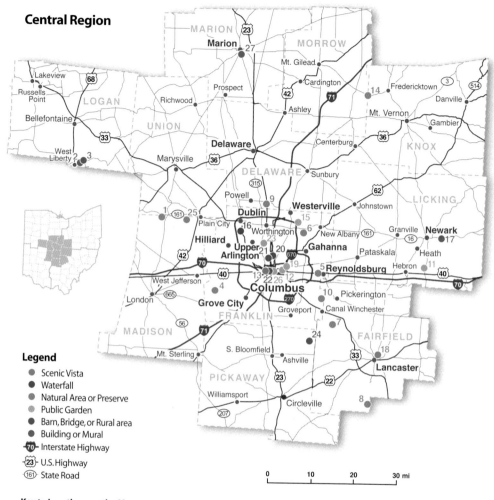

Legend

- Scenic Vista
- Waterfall
- Natural Area or Preserve
- Public Garden
- Barn, Bridge, or Rural area
- Building or Mural
- Interstate Highway
- U.S. Highway
- State Road

Key to Locations on the Map

1 Bigelow Cemetery State Nature Preserve
2 Castle Piatt Mac-O-Chee, West Liberty
3 Castle Piatt Mac-A-Cheek, West Liberty
4 Columbus Metro Parks (Battelle Darby Creek)
5 Columbus Metro Parks (Blacklick Woods)
6 Columbus Metro Parks (Blendon Woods)
7 Columbus Metro Parks (Chestnut Ridge)
8 Columbus Metro Parks (Clear Creek)
9 Columbus Metro Parks (Highbanks)
10 Columbus Metro Parks (Pickerington Ponds)
11 Dawes Arboretum, Newark
12 Franklin Park Conservatory, Columbus
13 Genoa Park, Columbus
14 Guy Denny Prairie, Knox County

15 Inniswood Metro Gardens, Westerville
16 Hayden Run Falls, Columbus
17 Longaberger Corporate Headquarters, Newark
18 Mount Pleasant, Lancaster
19 Ohio Governor's Residence Heritage Garden
20 Ohio State Fair, Columbus
21 Ohio State University, Columbus
22 Ohio Statehouse, Columbus
23 Park of Roses, Whetstone Park, Columbus
24 Slate Run Historical Farm, Pickaway County
25 Smith Cemetery State Nature Preserve
26 The Topiary Park, Columbus
27 Warren G. Harding Memorial, Marion

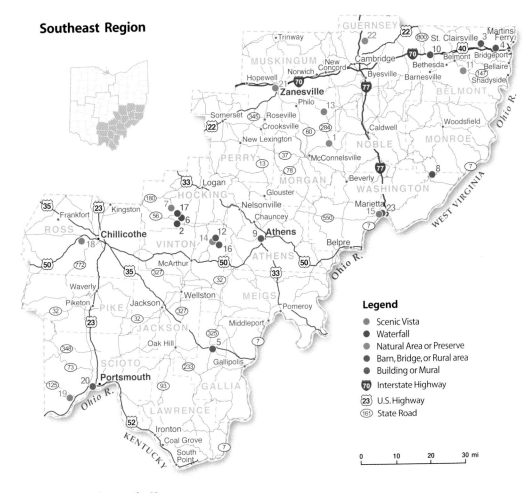

Southeast Region

Legend

- Scenic Vista
- Waterfall
- Natural Area or Preserve
- Barn, Bridge, or Rural area
- Building or Mural
- **70** Interstate Highway
- **23** U.S. Highway
- **161** State Road

0 10 20 30 mi

Key to Locations on the Map

1 AEP Recreation Lands (Miner's Memorial Park)
2 Ash Cave, Hocking Hills State Park
3 Belmont County Courthouse, St. Clairsville
4 Blaine Hill Bridge, Belmont County
5 Bob Evans Farm, Rio Grande
6 Cedar Falls, Hocking Hills State Park
7 Conkle's Hollow State Nature Preserve
8 Covered Bridge Scenic Highway (Rte 26)
9 Cutler Hall, Ohio University, Athens
10 Dickinson Cattle Company, Barnesville
11 Dysart Woods, Belmont County

12 Hope Furnace, Vinton County
13 Jeffrey Point Birding Station, The Wilds
14 Lake Hope State Park, Vinton County
15 Lookout Point, Harmar Heights, Marietta
16 Moonville Tunnel, Vinton County
17 Old Man's Cave, Hocking Hills State Park
18 Paint Creek Overlook, Ross County
19 Picnic Point, Shawnee State Park
20 Portsmouth Floodwall Murals, Scioto County
21 Putnam Hill Park, Zanesville
22 Salt Fork State Park, Guernsey County
23 *W. P. Snyder Jr.* Sternwheeler, Marietta

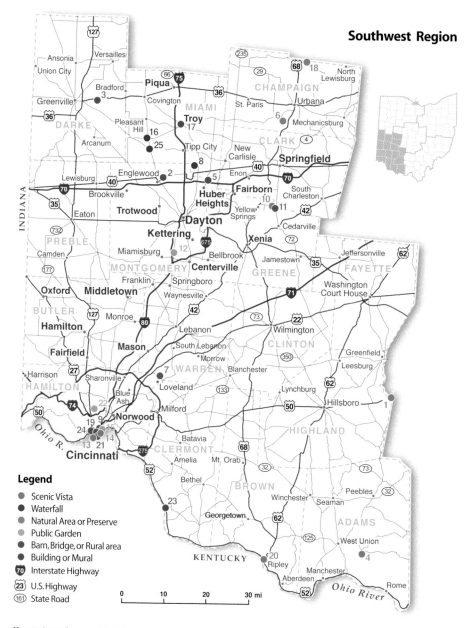

Southwest Region

Ansonia
Union City
Versailles
Bradford
Greenville
3
Covington
Piqua
66 75
36
235
68 18
North
Lewisburg
29
CHAMPAIGN
MIAMI
St. Paris
Urbana
6
Mechanicsburg
36
DARKE
Pleasant
Hill
16
Troy
17
Arcanum
25
Tipp City
New
Carlisle
CLARK
4
Springfield
8
40
70
Lewisburg
40
Englewood
2
5
Enon
Huber
Heights
Fairborn
South
Charleston
70
35
Brookville
10
11
42
Eaton
Trotwood
Dayton
Yellow
Springs
732
Kettering
Xenia
72
Cedarville
Miamisburg
12
675
Bellbrook
Jamestown
35
Jeffersonville
62
Camden
177
MONTGOMERY
Centerville
GREENE
FAYETTE
Franklin
Springboro
Washington
Court House
Oxford
Middletown
Waynesville
71
BUTLER
127
Monroe
42
73
Hamilton
80
Lebanon
22
Wilmington
Fairfield
Mason
South Lebanon
CLINTON
Greenfield
Morrow
350
Leesburg
Harrison
27
7
WARREN
Blanchester
HAMILTON
Sharonville
Loveland
133
Lynchburg
62
Blue
Ash
Milford
50
Hillsboro
1
50
22
Norwood
19 9
Batavia
HIGHLAND
24
13 21
14
Ohio R.
Cincinnati
CLERMONT
275
Amelia
Mt. Orab
32
73
52
Bethel
BROWN
Peebles
32
23
Winchester
Seaman
ADAMS
Georgetown
62
125
West Union
4
KENTUCKY
20
Ripley
Manchester
Aberdeen
Rome
Ohio River
52

Legend
- Scenic Vista
- Waterfall
- Natural Area or Preserve
- Public Garden
- Barn, Bridge, or Rural area
- Building or Mural
- **70** Interstate Highway
- **23** U.S. Highway
- **161** State Road

0 10 20 30 mi

Key to Locations on the Map

1 Arc of Appalachia (Rocky Fork Gorge)
2 Aullwood's Farm, Dayton
3 Bear's Mill, Greenville, Darke County
4 Buzzardroost Rock, Adams County
5 Carriage Hill Farm & Park, Huber Heights
6 Cedar Bog State Nature Preserve
7 Chateau LaRoche (Loveland Castle)
8 Charleston Falls, West Charleston
9 Cincinnatus Mural, Cincinnati
10 Clifton Gorge State Nature Preserve
11 Clifton Mill, Greene County
12 Cox Arboretum, Dayton
13 Devou Park, Kentucky

14 Holy Cross Immaculata Church, Mount Adams
15 Krohn Conservatory, Eden Park, Cincinnati
16 Ludlow Falls, Miami County
17 Miami County Courthouse, Troy
18 Ohio Caverns, Champaign County
19 Plum Street Buildings, Cincinnati
20 Rankin House State Memorial, Ripley
21 Roebling Suspension Bridge, Cincinnati
22 Spring Grove Cemetery, Cincinnati
23 Ulysses S. Grant Birthplace, Point Pleasant
24 Union Terminal, Cincinnati
25 West Milton Falls, Miami County

Index

Page numbers in boldface type refer to illustrations.